The Living Sea

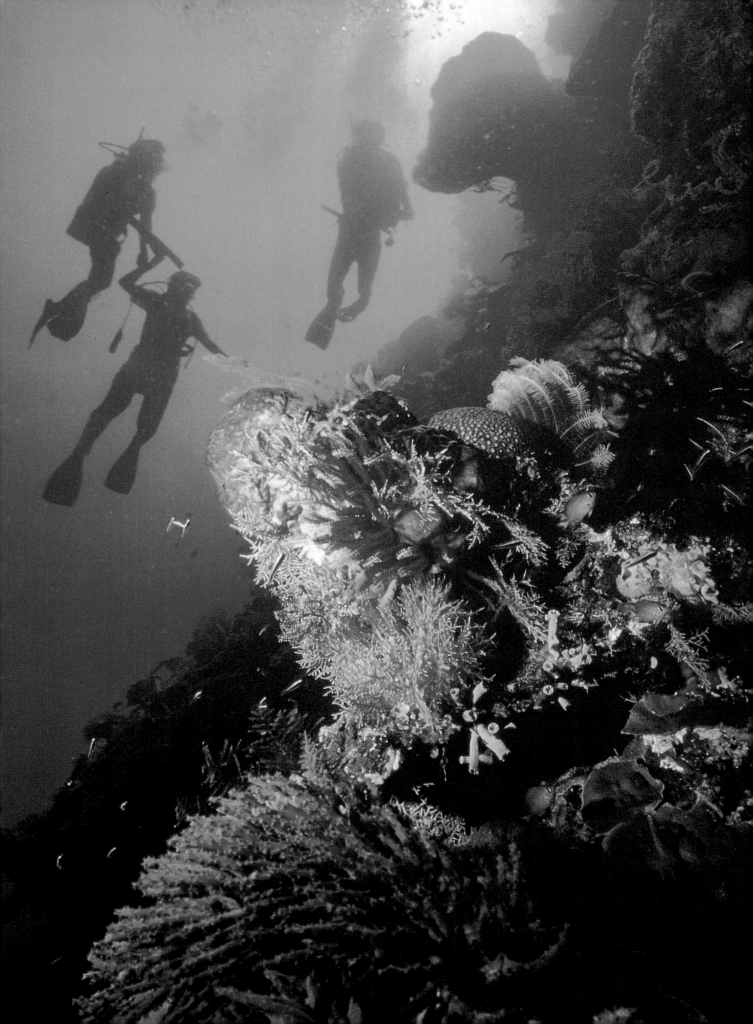

The Living Sea

A
*Photographic
Exploration
of
Life in the Sea
by*

Linda Pitkin

*Designed & Edited
by
Grant Bradford*

FOUNTAIN PRESS

For my husband, Brian, my mother Zena,
and in memory of my sister, Diane

Published by
FOUNTAIN PRESS LIMITED
FOUNTAIN HOUSE
2 GLADSTONE ROAD
KINGSTON-UPON-THAMES
SURREY KT1 3HD

Designed & Edited
by Grant Bradford

Typeset & Planned
by Phillip Kashdan

Colour Reproduction
by Erayscan

Printed & Bound
by Star Standard
Singapore

Typeset in Monotype Perpetua

ISBN 0 86343 321 9

Introduction

A school of more than five hundred barracudas cast a grey shadow against the reef edge in Sipadan, Borneo. Our hearts pounded as we swam into their midst, hoping that they would not disperse while we fumbled with our camera settings. In perfect synchrony, hundreds of steel-grey bodies swirled around us, circling. Some veered off to stream along the reef, others followed their lead, then flowed back to rejoin the circle. For a while I pivoted at the centre, turning to pan their movement with my camera, until I reeled, hypnotised by hundreds of unblinking eyes. Dropping down, I distanced myself from the throng and surveyed the spectacle from below. I could not fathom their emotion but mine was of pure elation.

In more than a decade of diving experiences around the world, usually with my husband Brian, many exhilarating moments stand out. Encounters with huge manta rays in the Maldive Islands, and with Pacific white-sided dolphins off Vancouver Island in Canada, vie with the thrill of seeing shoals of hammerhead sharks in the South China Sea. Inquisitive grey seals have followed us in the gullies of St Kilda, Scotland, and sea lions chased playfully around us in the Galapagos Islands.

The diversity of marine life is endlessly fascinating, from the largest fishes and sea mammals to the tiniest invertebrates. The ease of viewing colourful tropical fishes in abundance, in the clear warm waters around coral reefs, has an obvious appeal to divers and underwater photographers but temperate seas should not be overlooked. They offer a different but equally interesting range of fishes and other animals, some of which are as brightly coloured as their tropical counterparts.

A seemingly dull patch of reef may be teeming with activity on closer inspection. If you stay in one spot for a while, perhaps to look at a fish sheltering under an overhang, you may then notice cleaner shrimps in attendance. The glowing colours and exquisite details of other small animals might catch your eye. A sea-slug crawls along a branching sponge, and a brittle-star entwines its arms around the stem of a soft coral. A large sea anemone hosts a whole community of small inhabitants at the base of its tentacles. The longer you remain the more you become aware of the habits and interactions of the various creatures. Getting to know something about their lifestyles: where they live, what they do, and when they are active, enables you to find a wide range of animals that might otherwise be passed by. Some hide away in particular places and others that live in the open are often well camouflaged. Knowledge of their behaviour may also help you to approach them without provoking them or scaring them away. Time spent underwater, even if your dives last for two hours as mine sometimes do, is never long enough. There is always the need for the next dive, to slip back under once more amongst the fishes and other animals of the sea.

This book aims to give some insight into the varied ways of life in the sea, and the diverse adaptations of fishes and other animals to their environment. Their beautiful or bizarre forms, and their behaviour, are dictated by the needs of survival. Spectacular instances include fishes that change sex, others whose modified fins form a lure to attract prey, and sea-slugs that are armed with a battery of stinging cells taken from the animals they prey on.

Linda Pitkin

Contents

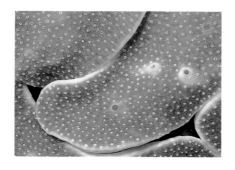

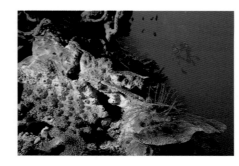

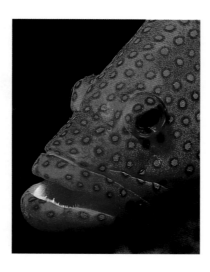

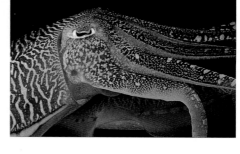

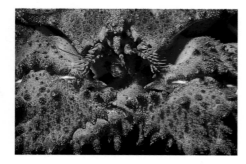

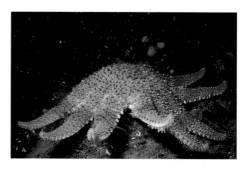

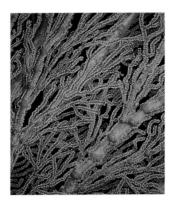

Colour Codes *114*

WARNING COLORATION:
MIMICRY : COLOURFUL
LURES: MISLEADING
PATTERNS: RED
NOCTURNAL ANIMALS:
COLOUR AND SEX:
JUVENILE COLOURS:
CHANGING COLOUR:
COMPLEX SIGNALS:
AFTER DEATH

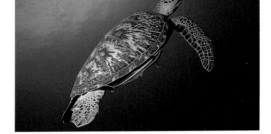

Guests & Squatters *164*

FIRMLY ATTACHED: ENCRUSTING ANIMALS:
REFUGES: FEEDING TOGETHER: CLEANERS:
SYMBIOSIS WITH ALGAE

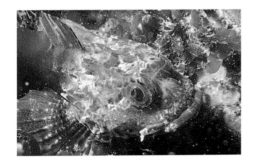

Disguise *134*

DISGUISED AS ROCK OR SAND: LURES:
AMBUSH: BOLD DISGUISES: HIDING IN THE
OPEN: TRANSPARENT OR COLOURFUL:
CULTIVATING A COVER

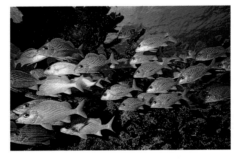

Conservation *180*

THREATENED
ENVIRONMENT:
PROTECTING
THE OCEANS:

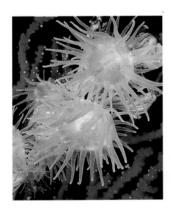

Nightshift *146*

CHANGING SHIFTS:
NOCTURNAL FISHES: NIGHT-
FEEDING CORALS: GRAZERS
AND PROWLERS: SHARKS:
LUMINESCENCE

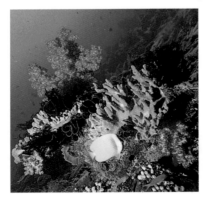

Locations *183*

UNITED KINGDOM: BRITISH
COLUMBIA: GALAPAGOS ISLANDS:
CAYMAN ISLANDS: RED SEA:
MALDIVE ISLANDS: EAST MALAYSIA:
INDONESIA

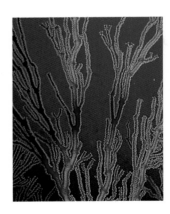

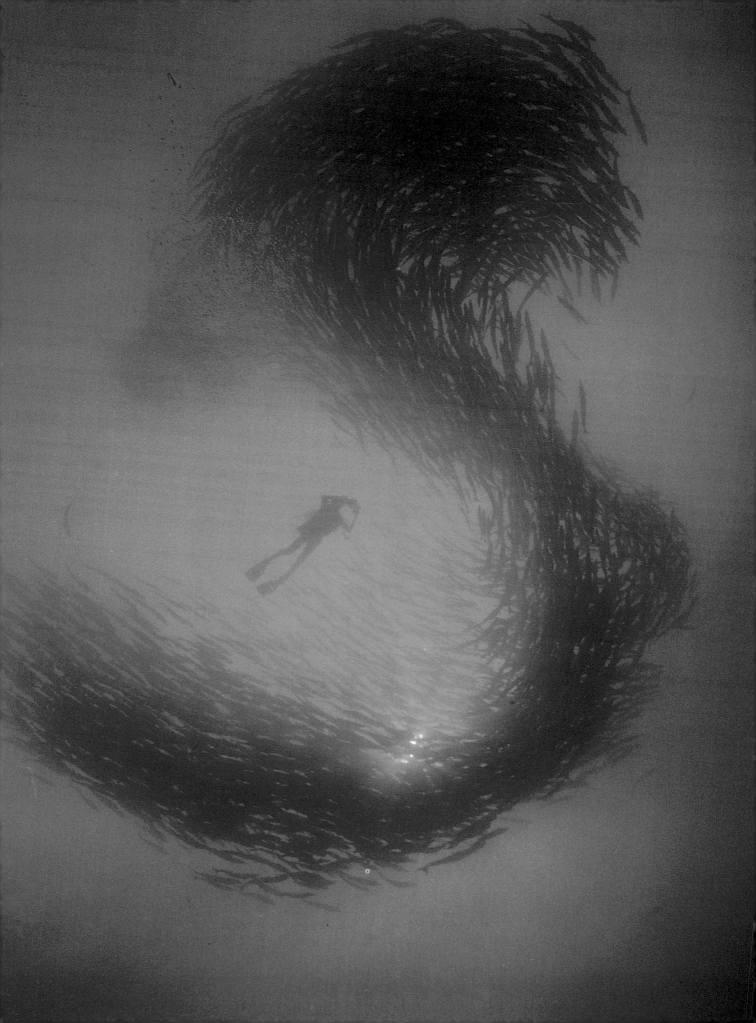

Underwater Photography

Underwater photography can be quite a challenge! First of all, diving equipment and skills are needed for anything below a few feet of water. Cameras for underwater use are generally expensive; then there are risks of water getting in, even a couple of drops of seawater can ruin electronic circuitry, and flashguns or strobes can be temperamental. Taking the photograph poses more problems, particularly in murky water, low light levels or when there is a current.

So why do it? The rewards for those who are bitten by the bug make it more than worthwhile. Many divers and snorkellers want holiday mementos of underwater views, diving buddies and encounters with fish, while others may require record shots of marine life and sites for identification and study.

For photographers such as myself the reward lies in trying to capture the supreme beauty and endless variety of animals, plants and scenery in an environment that is totally different from anything on land. The joy of being a wildlife photographer in the sea is that fish and other animals are more approachable than land animals in general and seem ready to accept a careful photographer as part of the environment. When swimming amongst a shoal of fish I can almost imagine that I am one of them!

EQUIPMENT

Various small cameras at the cheap end of the range can provide good "snapshots", particularly in clear shallow water, but for the serious photographer a 35 mm camera of some sort with a range

Some of the most exciting subjects may be seen in open water or near the surface. Several hundred barracudas school in a giant S-shape that dwarfs the photographer amongst them.

LOCATION : Sabah: Sipadan
CAMERA : Nikonos V with 15 mm lens; f8-11; Kodachrome 64

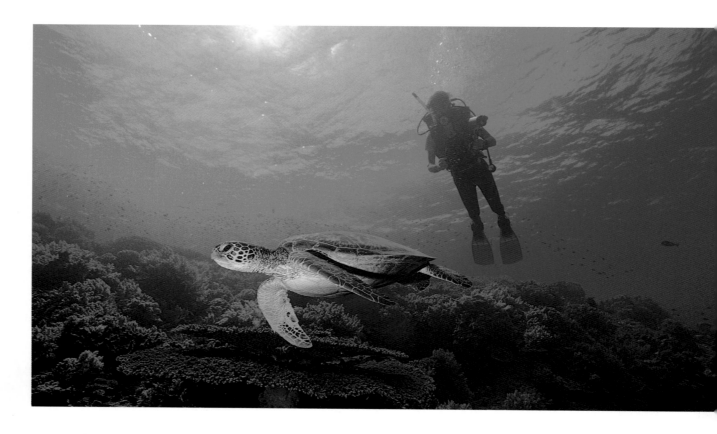

of lenses is essential. Different 35 mm systems have their pros and
cons. Nikonos cameras, made by Nikon, are waterproof and
purpose built for underwater use and no more bulky than a land
camera but they have the disadvantage of not being SLR
(single lens reflex) other than the expensive and large RS model.
As a result the photographer does not see the exact picture in the
viewfinder and must also estimate the distance to subject.
Most land SLR cameras can be housed in waterproof casings of
which there are a variety on the market; these are bulkier but
allow the photographer to focus (or use autofocus) and compose
the picture through the lens. The standard viewfinder is too small
for a diver wearing a face mask to use and is best replaced with a
larger actionfinder or sportsfinder in cameras that have a
removable pentaprism. Focusing can be difficult at low light levels
and it helps to have a modelling light. These are built into some
flashguns, or they can be improvised by attaching a small
torch or flashlight.

*Correct buoyancy control enables
the photographer to hang
effortlessly in mid water while
viewing the subject, a green turtle
Chelonia mydas.*

LOCATION : Sabah: Sipadan
CAMERA : Nikonos V with 15 mm lens;
f8; Fujichrome Velvia

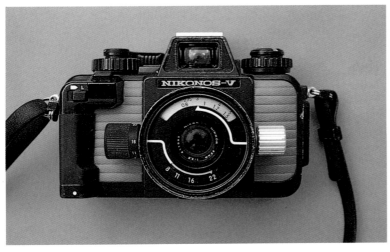

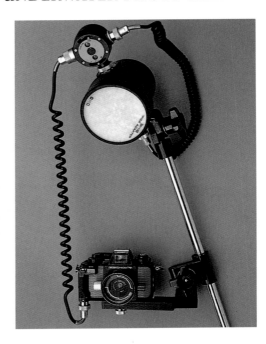

Above: Nikonos V camera with standard 35mm lens

Right: Nikonos V with 28mm lens plus Morris Aqua FI strobe with auto sensor, switchable to manual, auto ot TTL exposure control and slave function. The strobe has wide-angle diffuser fitted to soften and spread the light over a wider angle.

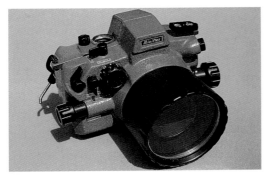

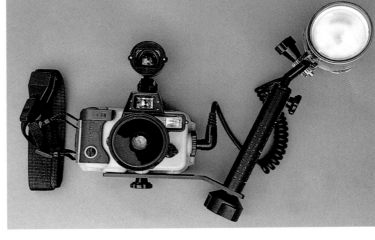

Above: Subal housing for Nikon F801 with flat port for Nikon 60mm AF macro lens

Right: Sea & Sea Motormarine II camera with supplementary 20mm wide-angle lens and optical viewfinder plus Sea & Sea YS50 strobe. The built-in strobe is disabled when an external strobe is attached.

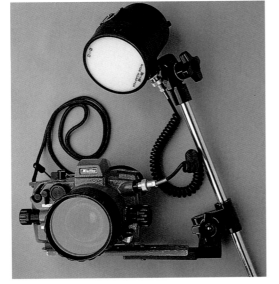

Right: Sea & Sea Motormarine II camera with fixed standard 35mm lens and built-in strobe and close-up lens.

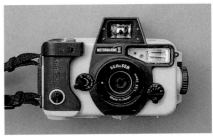

Left: Subal housing for Nikon F801 with flat port for Nikon 60mm AF macro lens plus Morris Aqua FI strobe without an optional auto sensor. The strobe has a wide-angle diffuser fitted to soften and spread the light over a wider angle.

Right: Sea & Sea YS50 strobe. The strobe head can be tilted to the correct angle for the distance of the subject from the lens.

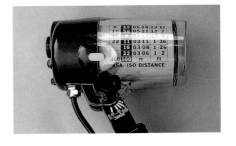

Photography: Brian Pitkin

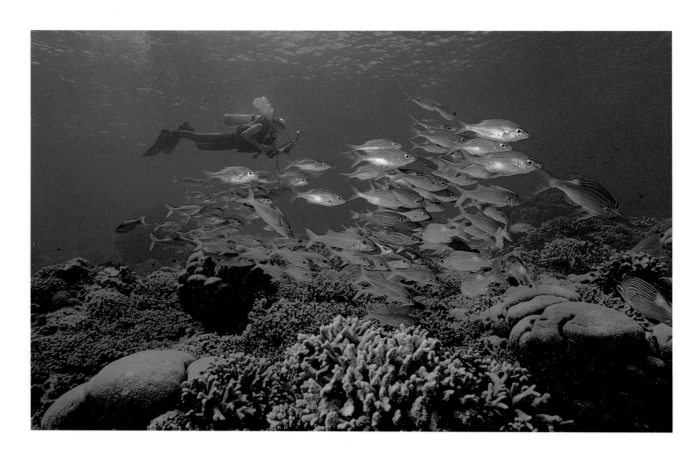

DIVING STYLE

Diving or snorkelling must be second nature so that the underwater photographer can concentrate on composing pictures. Good buoyancy control is essential to avoid stirring up sand or damaging fragile animals such as corals and also because lining up shots often involves hovering at various angles in mid water. Shallow sites are ideal for photography sessions, allowing divers to take time looking for interesting subjects and composing shots before the dive is over. Sandy areas, eel grass beds, and other places that seem dull at first glance are worth a closer look; many small animals may be hiding amongst plants or rubble. In general there is an abundance of marine life in the first 15 metres or so of water and plenty of light filters through. I sometimes spend one or two hours in one spot, totally absorbed in watching the fascinating inhabitants go about their daily lives. Photography is much more difficult when you are carried along in a current although there can be advantages; for instance, fast moving water can clear away sediment if you have inadvertently stirred any up. Currents bring food to many animals and current-swept sites may be rich in life; certain fishes gather in tight shoals and all line up

Swim slowly and smoothly when approaching a shoal of fishes, or they may scatter. It is usually best to swim just past the shoal before facing them and taking the photograph. Check the camera settings before you start the approach so that you are ready to react quickly.

LOCATION : Sabah: Sipadan
CAMERA : Nikonos V with 15 mm lens;
f8; Fujichrome Velvia

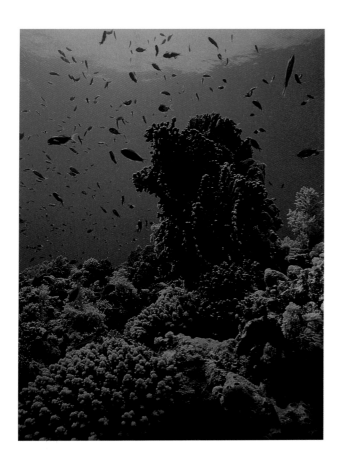

As you go deeper, water absorbs colour. Red shades disappear first and, at 40–50 feet / 12–15 metres, blue shades predominate in the available light.

LOCATION : Red Sea: Egypt
CAMERA : Nikonos with 15 mm lens; f8-11

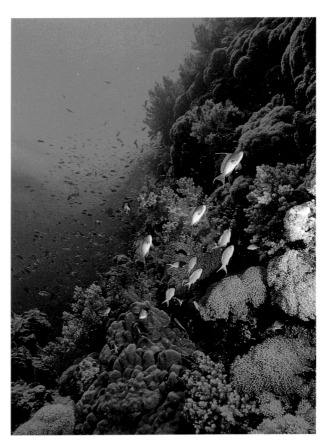

A similar scene lit by flash has plenty of foreground colour. This fades to blue in the distance, helping to create a three-dimensional effect. Alternatively, stay shallow and use a red-biased film (Ektachrome Underwater) if a colourful result is desired.

LOCATION : Red Sea: Egypt
CAMERA : Nikonos V with 15 mm lens; f8; Fujichrome Velvia

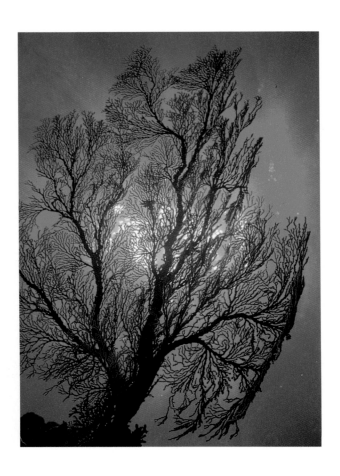

Natural light, without flash, can
be used to dramatic effect.
Silhouettes can be created by
positioning yourself so that the sun
is right behind the subject. The
lace-like structure of a sea-fan is
shown up by this treatment.

LOCATION : Indonesia:Sulawesi
CAMERA :Nikonos V with 28 mm lens;
f8-11; Fujichrome 100.

At depth red colours appear almost
black until lit by flash. With the
same lighting, the "black" rope
sponges in the background would
appear as red as the ones in the
foreground. Use a torch or
flashlight to get an idea of the
colours to expect in the photograph.

LOCATION : Cayman Islands.
CAMERA : Nikonos V with 15 mm lens;
f11; Fujichrome 100

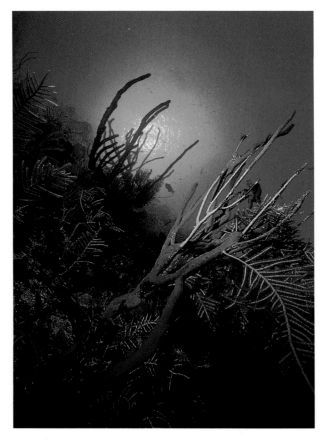

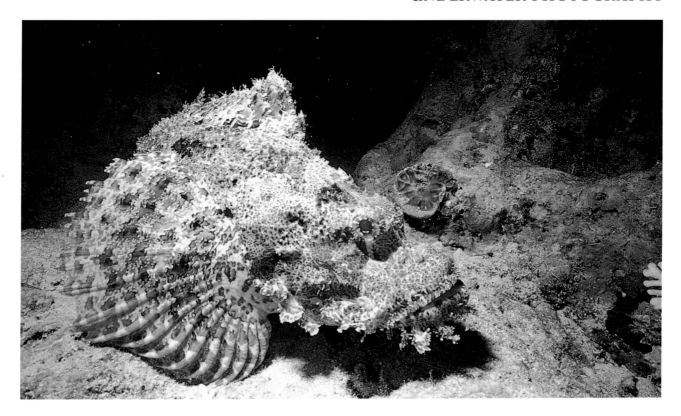

A low profile helps to make the subject stand out from its background, particularly important with camouflaged animals such as a scorpionfish.

LOCATION : Red Sea:Egypt
CAMERA : Nikonos III with 15 mm lens; f8-11; Kodachrome 64.

photogenically facing the same way, into the current.

Although it is relatively easy to approach fish and other animals in the sea it takes care and patience to get close enough to take good photographs of them. Chasing fish rarely has the desired effect and disappearing fishtails make disappointing views! It is best to stay in one spot and wait for fish to swim round again. Avoid sudden or jerky movement: marine animals look their best when they pose naturally but if they are disturbed they curl up or swim away. Knowing various species and how they behave can be a great help: some fish, particularly bottom-dwelling kinds, are sluggish and will stay put while others dart away; certain invertebrates withdraw into their tubes or shells but will emerge again if they are left alone for a few minutes. Many night active animals are sensitive to light and will react unfavourably up or hide from the beam of a bright torch; less powerful torches are preferable for photography at night and the light should not be shone directly at the animal for longer than necessary. A diver's bubbles may frighten fish away so it is a good idea not to breathe out at the critical moment; marine mammals such as seals and dolphins can sometimes be approached only by snorkelling and this can be a good means of photographing other animals near or at the surface.

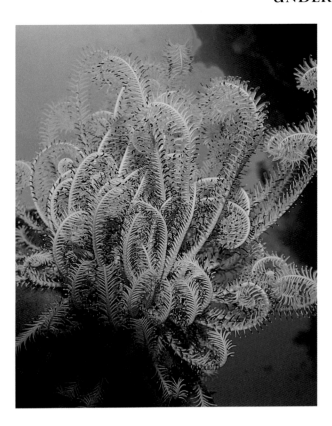

Try experimenting with different approaches. Another shot from the same roll shows a feather-star against a blue background of open water. Note that a wider aperture has been used than before. If the flashgun or strobe is on a manual setting, it must be held further away or set at a lower power to maintain correct exposure of the main subject.

LOCATION : Indonesia: Flores
CAMERA : Nikonos V with 28 mm lens plus close-up lens; f8-11; Fujichrome Velvia.

The underwater photographer should be considerate towards animals to avoid causing them undue stress, and a few tropical species such as venom-bearing scorpionfish and lionfish should be treated with caution. Marine animals, unless provoked, are rarely aggressive towards divers, and photographers can vouch for the fact that even sharks tend to be shy!

Familiarity with the site is often a tremendous help to the photographer who can get to know where individual animals are likely to be, and at what time of day and season of the year.

TECHNICAL PROBLEMS

A black background may help to show up the subject, particularly if it has an intricate outline such as the branching arms of a feather star. This can be using a small aperture setting, and by positioning yourself low in relation to the subject in order to isolate it from distracting background details.

LOCATION : Indonesia: Flores.
CAMERA : Nikonos V with 28 mm lens plus close-up lens; f16-22; Fujichrome Velvia.

Near the surface there is usually plenty of light and colours are unchanged but as you go deeper, even though it may still be reasonably light, colours gradually fade to shades of blue and black. Water absorbs colour, starting with the red end of the spectrum at about 20 feet, then yellows and greens until only blues remain. Using a flashgun will replace the bright colours that you would see at the surface or in the beam of a torch and a balanced combination of flash and natural light works well, particularly with standard to wide-angle views. Sunshine often

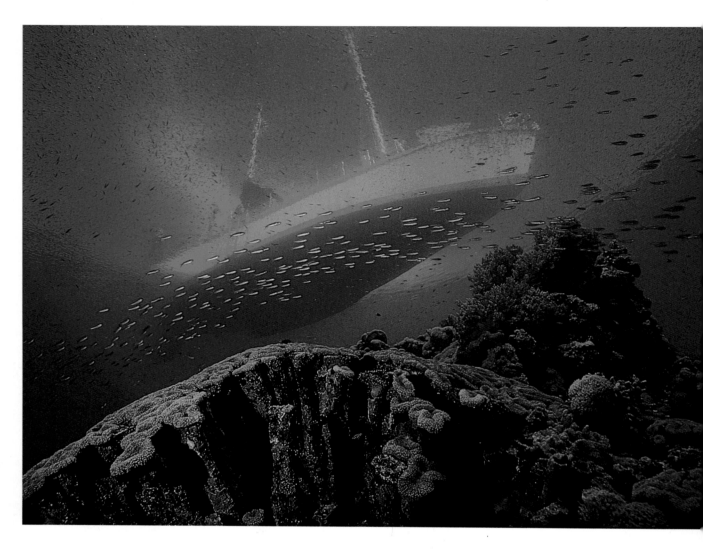

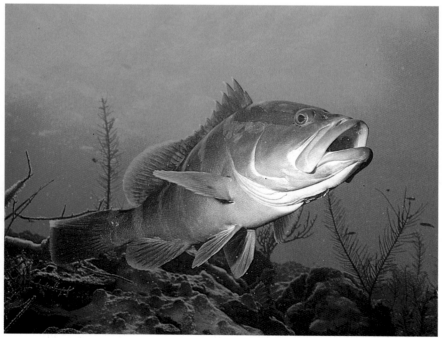

A powerful flashgun is not necessary for wide-angle photographs. The flashgun can be used to light just the foreground (fill-in flash), if enough sunlight is available to expose the background. Point the camera upwards to make full use of available light for the background.

LOCATION : South China Sea : Malaysia
CAMERA : Nikonos with 15 mm lens; f8;
Kodachrome 64

Viewing a Nassau grouper from a low profile sets it against a background of open water.

LOCATION : Cayman Islands.
CAMERA : Nikonos V with 28 mm lens;
f8-11; Kodachrome 64

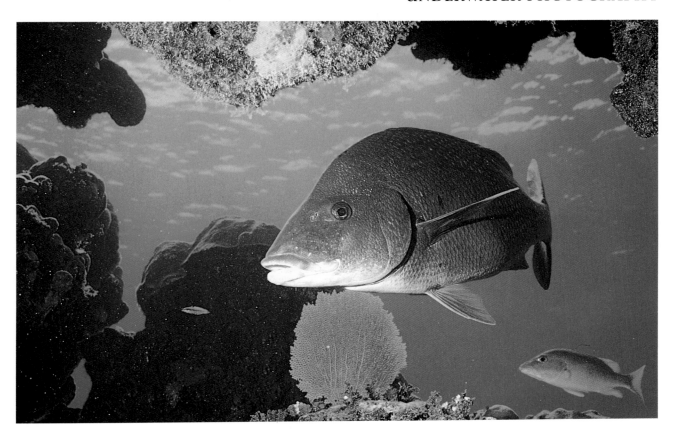

The setting or background is as important as the main subject in creating a pleasing image. A natural 'window frame' complements the fish hovering in the open space.

LOCATION : Cayman Islands.
CAMERA : Nikonos V with 28 mm lens; f8-11; Fujichrome 100

filters through the water with a beautiful diffuse light and I like to try to capture its subtle gradations in scenic shots, using flash just for foreground fill-in.

Getting down low behind the subject and pointing the camera upwards maximises the available light and helps to give a 'blue water' background. A low profile also gives a much more interesting view than pointing the camera at the seabed; it makes the subject stand out from a cluttered background.

Most subjects look more dramatic photographed at close range, either as the main focus of interest in an attractive setting or as a frame-filling portrait. Getting in close is particularly important underwater as a means of reducing the amount of water between lens and subject. Particles of sand and sediment often spoil clarity in the sea and even in clear tropical waters objects tend to look hazy if they are more than a few feet away. Wide-angle lenses/eg: 15 mm or 20 mm are ideal, allowing large subjects and views to be taken from a distance of two or three feet, giving bright crisp images. Such lenses do cause some distortion of perspective and curvature of straight lines but this is rarely obvious with underwater subjects. However, not all subjects can be approached so close and it is often necessary to use a 55 mm or 105 mm

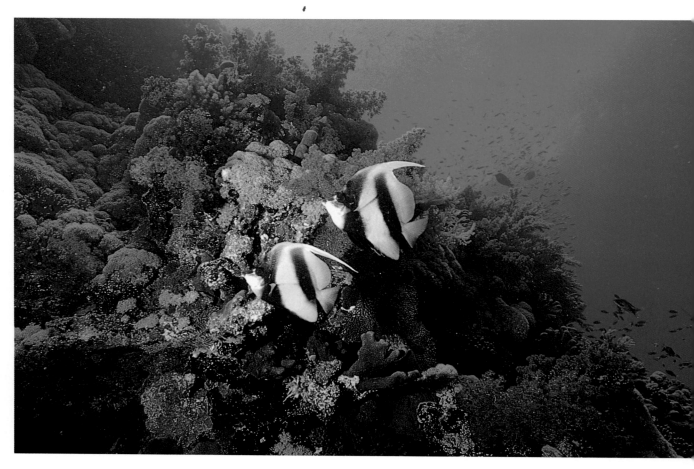

macro lens with a housed camera to photograph the more timid
smaller fishes.

Particles in the water lit by flash can cause backscatter, a
snowstorm-like effect, in the photograph. This is reduced by
positioning the flashgun away from the camera (usually above and
to one side). The flashgun can be mounted on a bracket or an
adjustable arm, or it can be hand held. In murky conditions it is
best to attempt only macro or close-up photographs, with a
working distance of inches rather than feet. Macro and close-up
lenses, and wide-angle lenses, are the most useful for dealing with
the range of subjects in underwater photography. The standard
lens, which is 35 mm for underwater use, is less useful on its own
since a moderately wide-angle lens will give better results with
most medium sized subjects.

Certain subjects such as silvery fishes and near-transparent
jellyfish present particular problems. Because the scales of many
fish act like mirrors, reflecting light back to the lens, a bright
light source such as a flashgun may overexpose the photograph
and cause flare. This can be overcome by reducing the exposure
by some means such as using a smaller aperture or holding the

*A pair of bannerfishes, Heniochus
acuminatus, are set against a
scenic coral reef. The edge of the
reef forms a strong diagonal that
makes a somewhat static scene
appear more dynamic.*

*LOCATION : Red Sea: Egypt
CAMERA : Nikonos V with 15 mm lens;
f8; Fujichrome Velvia*

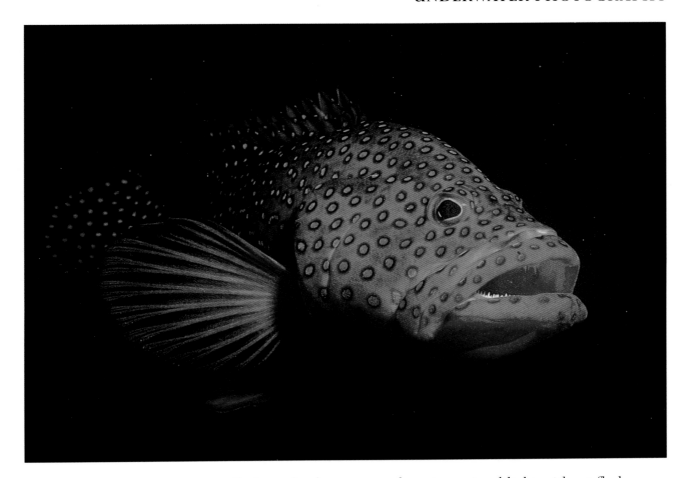

Getting in close to the subject emphasises colours and can produce dramatic crisply-detailed images. The coral grouper, Cephalopholis miniata, was about 10 in. / 25 cm away from the lens.

LOCATION : Red Sea: Egypt
CAMERA : Nikonos V with 28 mm lens plus close-up lens; f16-22; Kodachrome 64

flashgun further away, or by using natural light without flash. With jellyfish and other translucent subjects the reverse problem occurs; most of the light passes straight through them resulting in an under-exposed photograph. The solution here is to hold the flashgun right round to one side of the jellyfish, or even slightly behind it, which will light up the structures sufficiently.

Fast moving fishes can be tricky too; some fishes such as shoaling fusiliers stream by without pausing however patient you are. Flash operates at such high speed (about 1/1000th second) that it freezes the image but if there is also natural light in the picture the much slower shutter speed of 1/60th or 1/90th second will produce a slight double image, giving the fish a blurred outline. It is possible to get a sharp outline by panning (following the movement of the fish with the camera) although the background will be blurred.

It is better to find a couple of good subjects per dive and concentrate on them rather than going after many different things. Trying out different angles and compositions as well as bracketing exposures is worthwhile since you are unlikely to take the perfect photograph first go. Composition makes or breaks the picture and

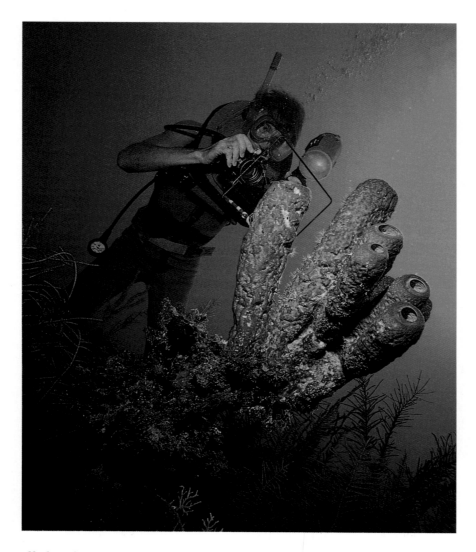

This photographer is using a Nikonos camera with a supplementary close-up lens and a framer. Static subjects, such as these yellow tube sponges, are particularly easy to photograph by this means. However, with patience and practice, a wide range of more active invertebrates, and even certain fishes, can be persuaded to pose in the frame.

LOCATION : Cayman Islands.
CAMERA : Nikonos V with 15 mm lens; f8-11; Kodachrome 64

all the elements in view must complement each other. It is easy to forget this when concentrating on the main subject but training yourself to look at the whole effect before pressing the shutter can save a lot of wasted film and effort. Seeing the main subject and other parts of the picture as abstract shapes helps, as well as looking out for pleasing contrasts in colour and texture: perhaps a red shrimp against a green coral or an intricately detailed coral outlined against a plain background of sea.

MAINTENANCE

Careful use and maintenance reduces the risks of flooding in cameras. Amphibious cameras, camera housings and flashguns should be soaked in freshwater immediately after being in the sea since corrosion can result from exposure to saltwater, and salt crystals can cause abrasion. Dry the camera, housing or flashgun

Details of subjects may make interesting photographs. Structures on the upper surface of a sunflower star, Pycnopodia helianthoides form a pleasing abstract pattern.

LOCATION : Canada: British Columbia
CAMERA : Nikonos V with 35 mm lens; extension tubes 1:2; f16-22; Kodachrome 64

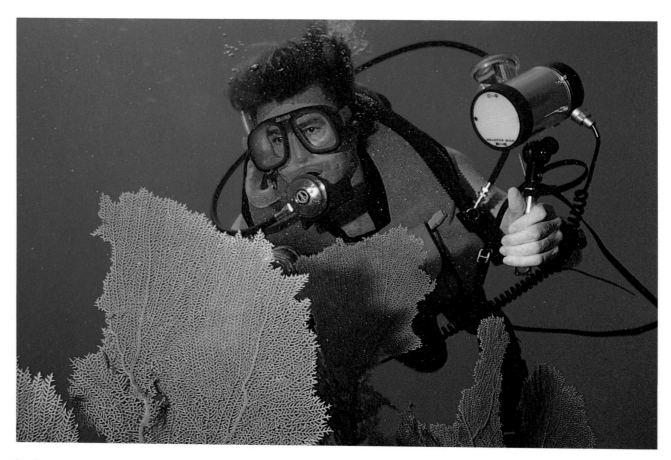

before opening and check that the O-ring seals are still clean and lightly coated with silicon grease before closing. O-rings need just enough grease to be supple and shiny but too much can cause leaks, as can a grain of sand or a hair stuck across the O-ring. Remove the batteries if you are not intending to use the camera for some time. If the camera and flashgun have not been used for a while, and especially before going on a trip, checking that everything is still in good working order can save disappointment.

MY PHOTOGRAPHIC EQUIPMENT

Details of the equipment and settings used for the photography in this book are given in the captions. In addition, most of the photographs were taken at 1/60 sec. and a Sunpak Marine 32 flashgun (strobe) was used.

A flashgun may be mounted on a bracket so that it is to one side and above the camera, or it may be hand-held. Holding the flashgun allows you to position it with ease and flexibility.

LOCATION : Cayman Islands.
CAMERA : Nikonos V with 28 mm lens; f8-11; Fujichrome 100

Silver scales of fishes reflect light back at the lens tending to overexpose a photograph lit by flash. The problem has been resolved with these bigeye trevallies by using sunlight as the dominant light source, with subdued fill-in flash. The flashgun was hand-held, well away from the subject and the photograph was exposed for available light.

LOCATION : Sabah: Sipadan
CAMERA : Nikonos V with 15 mm lens; f5.6-8; Fujichrome Velvia

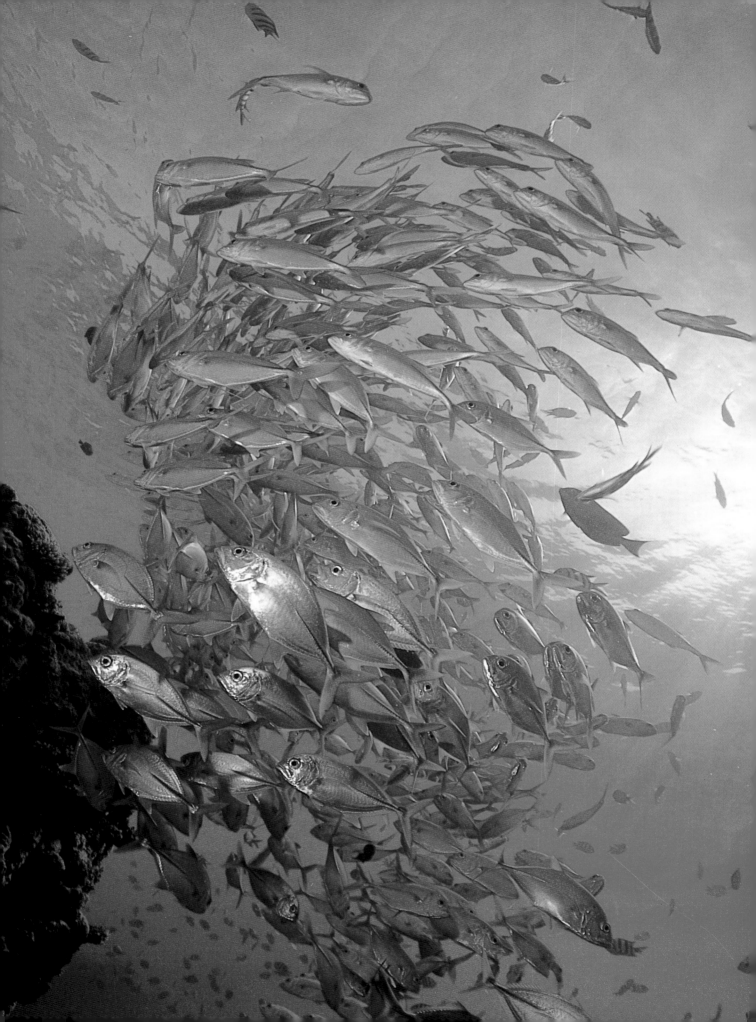

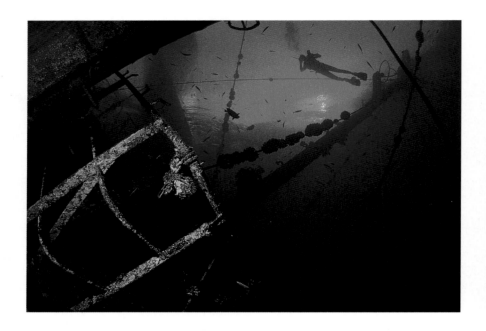

*The diver silhouetted in the distant
background gives perspective to a
dramatic shot of the wreck of the
'Giannis D'*

LOCATION : Red Sea: Egypt
CAMERA : Nikonos V with 15 mm
lens;1:2; f8-11; Kodachrome 64

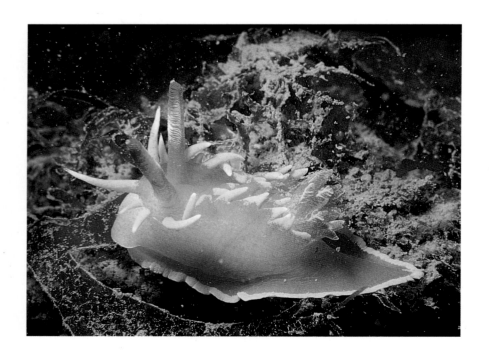

*Fine particles of sediment in the
water reduce visibility and create
problems for the photographer.
Conditions in British waters are
often unsuitable for wide-angle
photography, but fortunately there
are plenty of small subjects, ideal
for macro photography.
Nudibranchs such as Okenia
elegans, about 2 in / 5 cm in
length, are easily overlooked unless
you swim slowly, taking time to
scan rocks and ledges encrusted
with animals and plants.*

LOCATION : Great Britain: Wales
CAMERA : Nikonos III with 35 mm lens;
extension tubes 1:2; f16-22;
Kodachrome 64

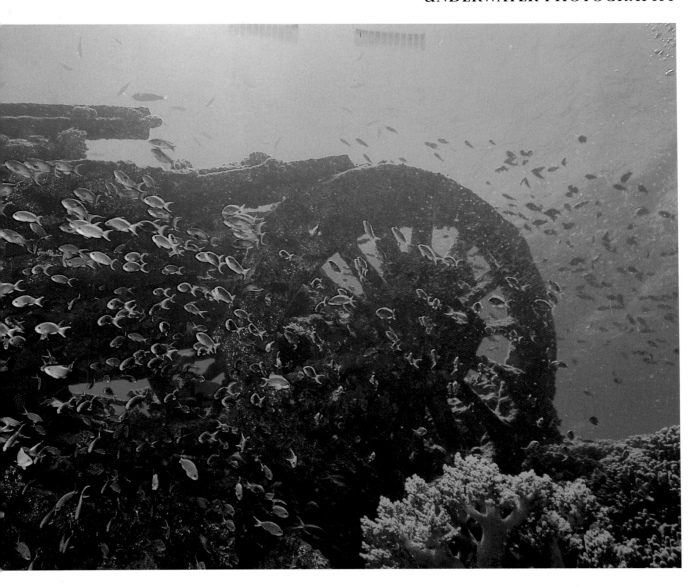

Orange sea perches set against a gun on the wreck at 'The Brothers Islands' makes an unusual juxtaposition.

LOCATION : Red Sea: Egypt
CAMERA : Nikonos V with 15 mm lens;f8; Fujichrome Velvia

Always take several photographs of each subject. The whole roll may not always be sufficient to exhaust the possibilities. A vertical format often appears more striking than a horizontal format, so it is worth making the effort to turn the camera on its side sometimes. *Below:* Another frame from the same roll of film shows the subject, a shoal of yellow-striped goatfishes *Mulloides vanicolensis*, in horizontal view.

LOCATION : Sabah: Sipadan
CAMERA : Nikonos V with 15 mm lens; f8-11; Kodachrome 64

Opposite: Wide-angle lenses magnify foreground objects disproportionally. This can be used to advantage to make small subjects appear more impressive. The damselfish, hovering above the soft coral, is only a few inches in length.

LOCATION : Red Sea: Egypt
CAMERA : Nikonos with 15 mm lens; f8; Fujichrome 50

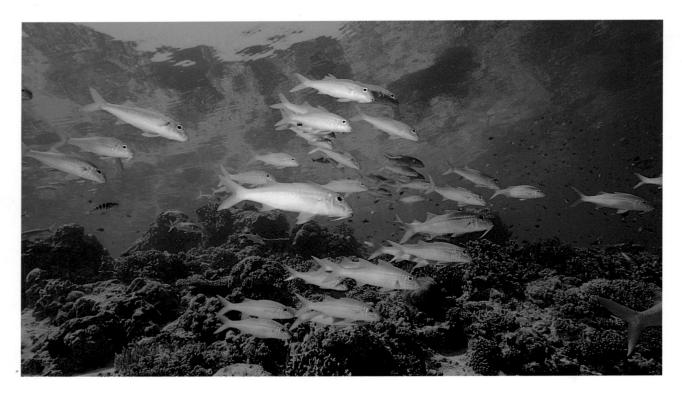

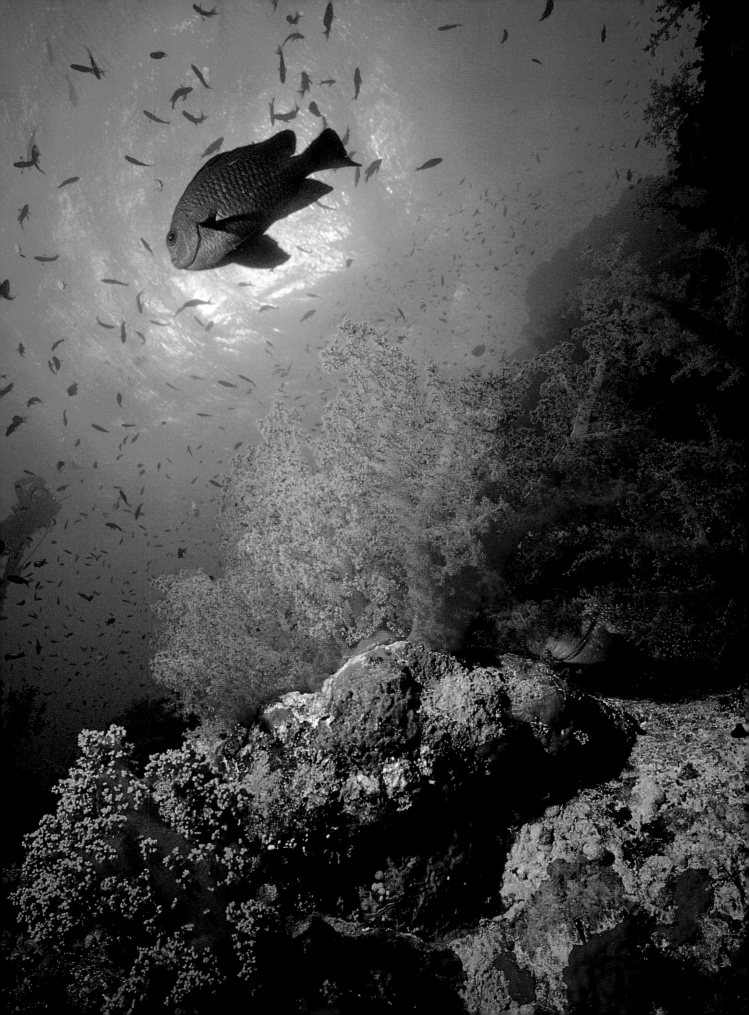

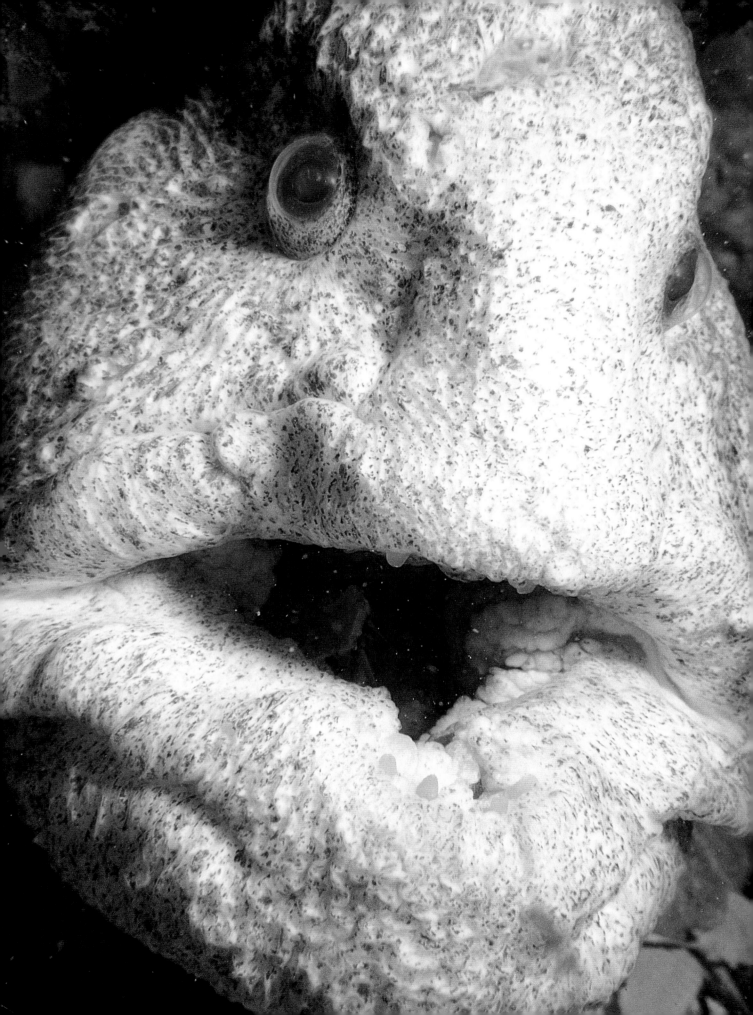

Predators

Most animals living in the sea are predators whose survival depends on hunting or trapping others for food. Amongst the smallest of these are tiny shrimps that catch and eat minute crustaceans and worms. Shrimps are devoured by small fishes who in their turn fall prey to other fishes while at the top of the underwater food chains are the most spectacular hunters, the largest of voracious fishes and sea mammals.

HUNTERS ON THE SEA BED

Less obvious aggressors are the static plant-like sea anemones and corals, but these too are predators, mainly carnivores feeding on small planktonic animals by filtering them out of the sea's currents. Anemones are also capable of catching fair sized fishes which they grasp with their tentacles, paralyse by means of stinging cells and then ingest through a central mouth. Many invertebrates, notably crustaceans such as the common lobster *Homarus gammarus* of the North-east Atlantic and the Mediterranean sea are more active hunters. The lobster's heavy muscular front claws are well adapted for cracking open the shellfish it eats: the claws are unequal, the large one is used for crushing while the smaller is suited for cutting. Large lobsters should be approached with caution as they can crush thumbs just as easily. Starfishes are slower moving but some are large and relentless predators that cut a swathe through the sedentary animals of the sea bed. The most notorious is the crown-of-thorns *Acanthaster planci*, capable of devastating coral reefs, but others include the North Atlantic sunstar *Crossaster papposus* which attacks other starfishes and their relatives. Although many invertebrates have a varied diet some are selective feeders including certain sea-slugs (nudibranchs) which seek out particular species of sponges or hydroids, or attack other molluscs and their eggs.

The wolf-eel, Anarrhichthys ocellatus, (up to about 6 ft/2m in length) is one of the few predators that are undeterred by the spines of sea-urchins, crushing them with its large canine and molar teeth.

LOCATION : Canada: British Columbia
CAMERA : Nikonos V with 35 mm lens plus close-up lens; f16-22; Kodachrome 64

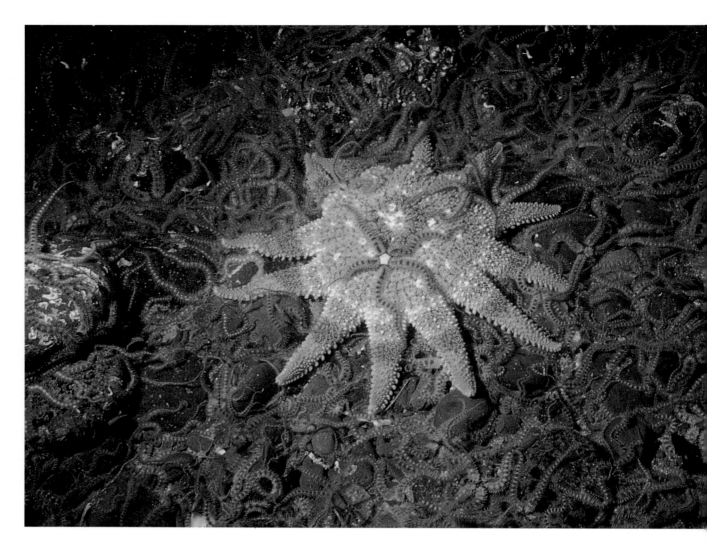

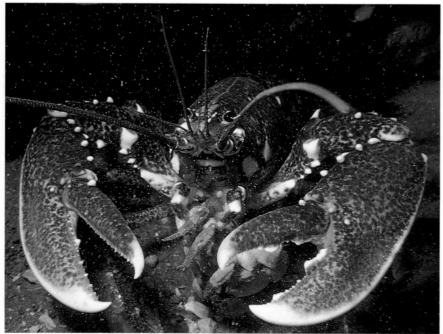

Starfishes crawl slowly over the sea
bed in search of prey. The sunstar
Crossaster papposus (up to about
1ft / 30 cm in diameter) feeds on
other starfishes and sometimes
also eats mussels.

LOCATION : Great Britain: Scotland
CAMERA : Nikonos II with 28 mm lens;
f11; Ektachrome 64

Powerful claws enable the lobster
Homarus gammarus (total length
up to 20 in. / 50 cm) to break open
the shells of bivalved molluscs.

LOCATION : Great Britain: England
CAMERA : Nikonos V with 35 mm lens
plus close-up lens; f16-22;
Kodachrome 64

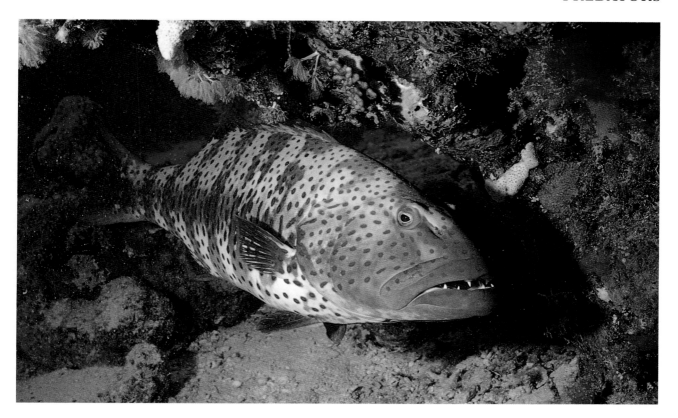

Groupers such as the roving grouper, Plectropomus maculatus, (up to 3 ft / 90 cm in length) lie in wait for passing fishes and are often seen resting in the shelter of large corals.

LOCATION : Red Sea: Egypt
CAMERA : Nikonos III with 28 mm lens; f11; Kodachrome 64

LARGE-MOUTHED GROUPERS

From bottom dwelling rays to open water shoals, tiny blennies to enormous sharks, most fishes are avid predators. Heavy bodied groupers belong to a large family, the Serranidae ranging from less than one foot to about 12 feet in length, the largest species weighing in at an impressive 600 to 700 lbs. They eat other fishes and crustaceans, and large groupers typically have a wide gape to enable them to engulf prey without having to move very far from their resting place. Many confusing common names are applied to various groupers such as giant cod and rock cod (in Australia) and coral trout (Indo-Pacific region) but they are distinct from the cod and trout families; some are also known as coney (Caribbean Sea), groper (Australia), rock hind and jewfish. Although some are docile, easily approached, and will even follow divers around like dogs, the sheer bulk of the largest groupers, particularly the jewfish *Epinephelus itajara* and groper *Epinephelus lanceolatus*, coupled with their determined nature when expecting food, commands respect and caution. Jewfishes have appetites to match their size, eating large spiny lobsters and hawksbill turtles among other formidable prey.

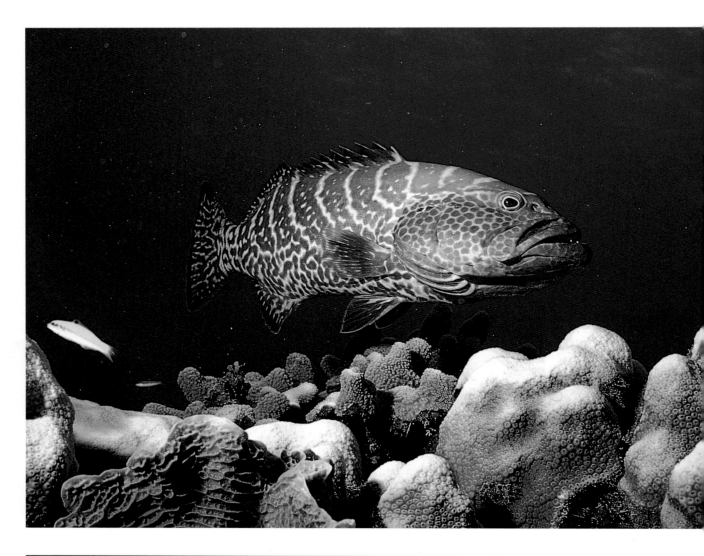

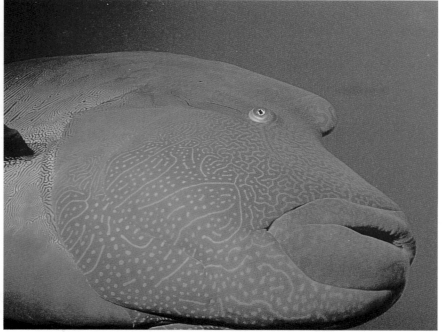

Many groupers are sturdily built and have a jutting lower jaw. The tiger grouper, Mycteroperca tigris (about 2 ft / 60 cm in length).

LOCATION : Cayman Islands.
CAMERA : Nikonos V with 28 mm lens;
f8-11; Kodachrome 64

The humphead wrasse, Cheilinus undulatus, (sometimes known as the Napoleon wrasse) patrols coral reef walls throughout the Indo-Pacific, feeding on various smaller fishes and a wide range of invertebrates. It is the largest species of wrasse, weighing up to 190 kg.

LOCATION : Red Sea: Egypt
CAMERA : Nikonos V with 28 mm lens;
f8-11; Kodachrome 64

WRASSES AND GRUNTS

Wrasses, in temperate and tropical seas, are often colourful and fairly small though the olive-green humphead or Napoleon wrasse *Cheilinus undulatus,* a gentle fish despite its bulk, may reach 9 feet/ 3 metres in length. Most eat crustaceans, molluscs and other invertebrates in the daytime, extending their jaws with canine-like teeth and thick fleshy lips to take food and crushing hard shells with their pharyngeal teeth on the bony supports of the gills.

Reef-dwelling grunts, so-named because they can make sounds amplified by their swim bladder when grinding their pharyngeal teeth, are related to the abundant and diverse snappers. Both groups are widespread in the tropics and catch other fishes and invertebrates principally at night. Unlike grunts typical snappers have prominent canine teeth.

STREAMLINED FOR ATTACK

Oceanic predators include fast swimming tuna or tunny and mackerel, moving in silver shoals to take smaller shoaling fishes such as herring, sprat and sardines. Jacks also rely on swimming power to chase and herd fish shoals, sometimes driving them towards the surface and causing panic as they close in to pick off their prey.

DANGEROUS WHEN PROVOKED

Although few fishes are aggressive towards people under normal circumstances moray eels, stingrays, barracudas and sharks are popularly feared and can be dangerous. Moray eels, even the largest at more than six feet long, usually retreat into their crevices when approached but they will snap at fingers without hesitation and can inflict severe jagged wounds which often become infected. Their grip is strong and difficult to dislodge. Morays look fierce because they constantly open and shut their mouths as if biting but this is merely to maintain a respiratory current drawing water in through the mouth and out over the gills. This happens automatically in actively swimming fishes but, though morays weave in and out of tunnels in the reef where they live and hunt, particularly at night, they spend much time lying in wait in these holes from which they ambush passing fishes and

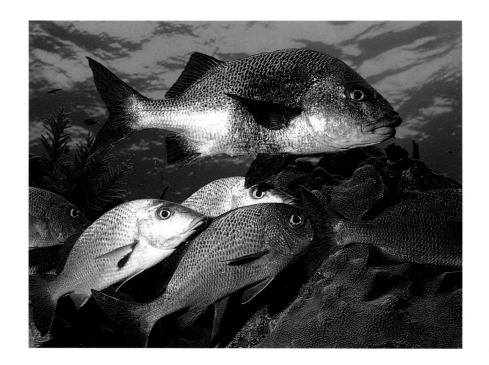

The black margate, Anisotremus surinamensis, (up to 2 ft / 60 cm in length) is one of the largest Caribbean grunts. It swims alone or in small groups, preying on crustaceans, fish and long-spined sea-urchins.

LOCATION : Cayman Islands.
CAMERA : Nikonos V with 28 mm lens; f8-11; Kodachrome 64

octopuses. All morays have long muscular snake-like bodies without paired fins and while most have long sharp fangs some such as the zebra eel *Echidna zebra* have short blunt teeth and tend to eat crabs and molluscs rather than fishes. Morays are widespread in tropical oceans and in the Mediterranean Sea. Conger eels have a similar lifestyle to morays but inhabit cooler areas in general, such as the coasts of northern Europe, though they are also found in Mediterranean waters. At a weight of up to 140lb and with stout crushing teeth for a powerful bite they are not fishes to provoke. Like morays, congers hide in holes with only their head sticking out. However, congers particularly favour shipwrecks to make their home in. Another group of bottom-dwelling fishes, the wolffishes such as the north-western Pacific wolf-eel, also have strong jaws and heavy teeth.

Stingrays are named on account of the venomous spine used for defence; they hunt and catch food by other means. The normal method is to stir up sand using their snout and flapping wing-like fins, uncovering molluscs and crustaceans which are then crushed by the stingray's flattened teeth. As stingrays move around their territory, mainly in tropical lagoons and shallow reefs, although two species occur in the Mediterranean Sea and around Britain, their flattened disc or kite shaped bodies leave tracks in the form of slight craters where they have dug for food or merely rested. When not feeding they lie motionless on the sea bed for hours. Barracudas, also mainly found in tropical seas, have elongated

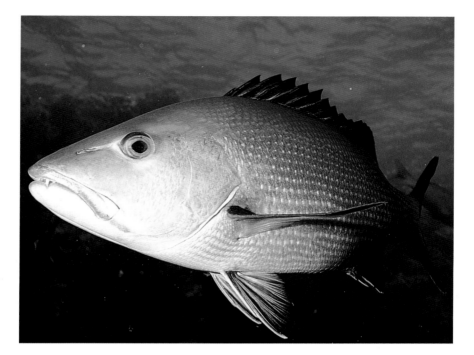

Snappers, Lutjanus, are voracious carnivores noted for their large canine teeth. Various species are seen in most tropical seas, where they feed mainly at night on fishes and crustaceans. The larger species may reach 2 ft / 60 cm or more in length.

LOCATION : Red Sea: Egypt
CAMERA : Nikonos II with 28 mm lens; f11; Fujichrome 50

streamlined bodies and massive jaws and teeth suited for their habit of sidling up and then making a fast dash and grabbing smaller fishes, after nearby. They take large prey for their size and the great barracuda *Sphyraena barracuda* feeds on sea basses, puffers, grunts and even strong-swimming jacks among others. In the West Indies it occasionally attacks people but only by mistaking them for fishes; this can happen in murky water, particularly if the barracuda is attracted to a bright metallic object such as a diver's watch which catches the light in the same way as silvery fish scales. In clear water barracudas are safe to swim with and often come to sites where boats regularly moor; they may follow swimmers around, but only out of curiosity.

FEEDING FRENZY

Sharks are the most dreaded of all marine predators, fast-moving and fearless. The majority are unlikely to attack people and are given a bad press unfairly on account of the few species that are known to be dangerous. These include hammerhead and mako sharks, the tiger shark *Galeocerdo cuvier* and, most aggressive and unpredictable of all, the great white shark *Carcharodon carcharias* which eats turtles and sea lions as well as large fishes. The largest white sharks, up to about 20 feet/ 6 metres in length, would be capable of swallowing a man whole and can make ragged wounds with their large triangular teeth. Most shark attacks take place in

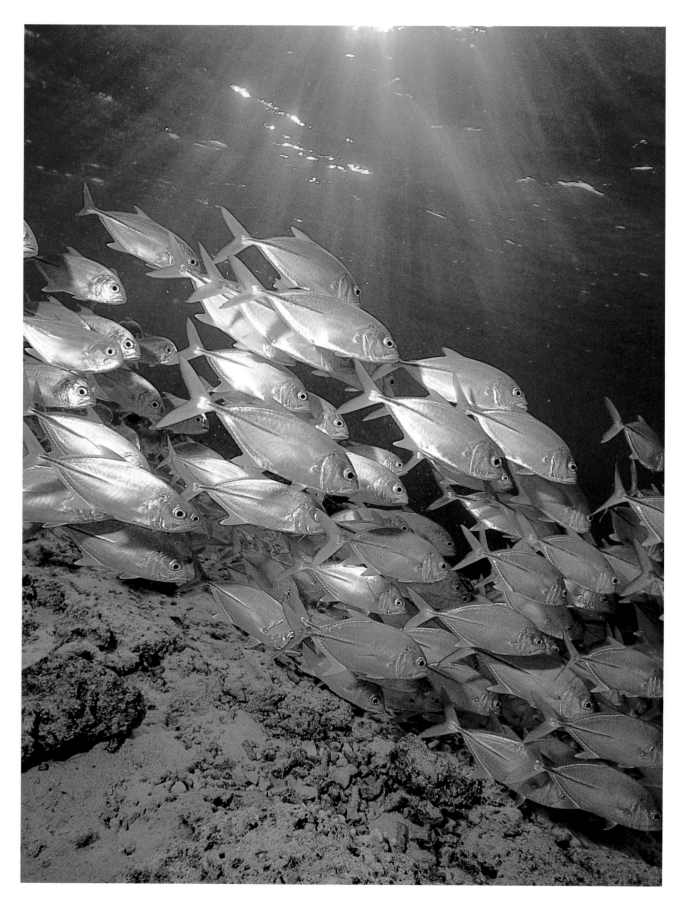

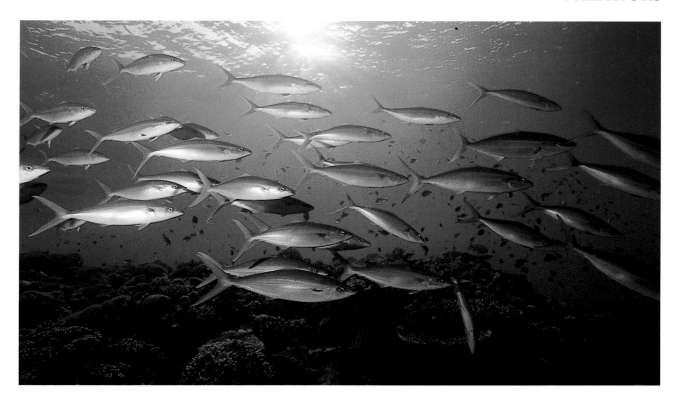

Rainbow runners, Elagatis bipinnulata, (up to about 3 ft / 1m in length) are slender carangids (jacks) that school in open water or near the edge of tropical reefs. They are sometimes seen in the company of other, larger, predators, such as sharks and tuna.

LOCATION : Sabah: Sipadan
CAMERA : Nikonos V with 15 mm lens; f8-11; Kodachrome 64

Jacks or trevallies are open water predators but some species hunt along the reef edge or may be seen near the lower slopes of steep walls. Bigeye trevallies, Caranx sexfasciatus, (up to nearly 3 ft / about 85 cm in length) gather in schools of up to several hundreds of fishes.

LOCATION : Sabah: Sipadan
CAMERA : Nikonos V with 15 mm lens; f8; Fujichrome Velvia

warm tropical waters; they are attracted to food by scent and by vibrations in the water and can detect even a tiny amount of blood. Presence of blood in the water can induce a feeding frenzy when sharks become so excited they will bite at anything. They may also attack intruders to their territory and display aggression by pointing their pectoral fins at a downwards angle, arching the back and swimming with a zig-zag motion. Many sharks feed on fishes, often picking off wounded or slower ones but basking and whale sharks, harmless giants with tiny teeth, strain plankton from the water. Rays are the preferred food of hammerheads and are also hunted by tiger sharks, which have a catholic diet. One of the sharks most often seen by divers is the whitetip reef shark *Triaenodon obesus* which is widespread in the Indo-Pacific.

TURTLES

Most reptiles and mammals are terrestrial but some have adapted to living and hunting in the sea. Turtles, other than the vegetarian green turtle *Chelonia mydas*, are omnivores. The diet of the hawksbill *Eretmochelys imbricata* includes crustaceans, molluscs and the Portuguese man-of-war *Physalia*, a jellyfish-like hydroid that other animals usually avoid. Apparently the turtle closes its eyes

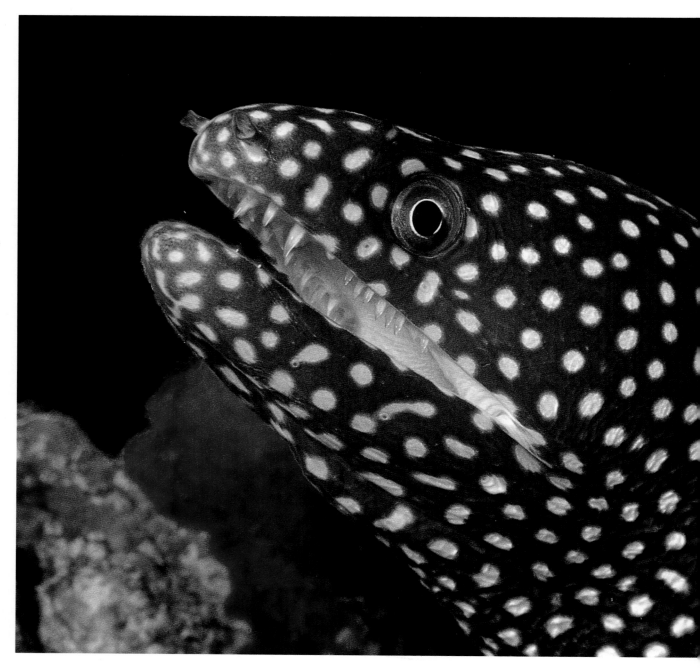

Despite their fierce appearance,
morays rarely bite unless provoked.
Most species are muscular and have
needle-sharp teeth that readily
tear the flesh of struggling prey.
The speckled moray, Gymnothorax
meleagris, is one of the smaller
species, about 20 in./ 50 cm
in length.

LOCATION : South China Sea:
Philippine Islands.
CAMERA : Nikonos with 35 mm lens;
extension tubes 1:2; f22; Fujichrome 100

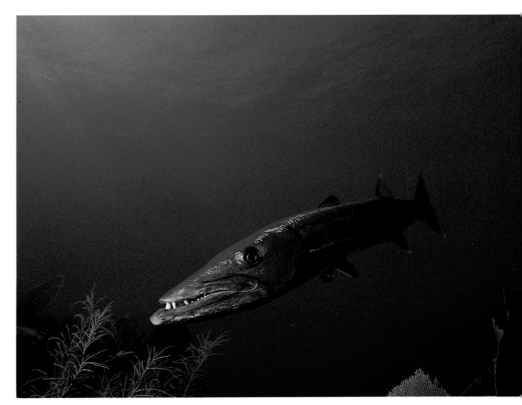

The great barracuda, Sphyraena barracuda (up to about 6 ft / 2 m in length). Long jaws with enormous canine and shearing teeth give the barracuda a menacing gaze and enable it to make a clean straight bite.

LOCATION : Cayman Islands.
CAMERA : Nikonos III with 15 mm lens;
f11; Fujichrome 100

to avoid the stinging tentacles. Turtles have suffered from commercial exploitation for food and ornament, often by particularly callous practices, to the point where most species are endangered.

VENOMOUS SEA SNAKES

Sea snakes are mostly found in the Indo-Pacific area, where even though they are air breathing reptiles, some are capable of diving to depths of 600 feet / 180 metres to catch their prey of eels and other fishes. Such sea snakes live in coastal waters and include species that go ashore to mate and lay their eggs. Others never leave the water as they have lost the ability to crawl on land and

instead feed at the surface in open water, drifting, sometimes in large packs, and mate at sea giving birth to live young. Sea snakes have been known to kill people with venom up to ten times more toxic than that of a cobra but they bite less readily than land snakes and often inject only a small amount of venom.

SEALS AND WHALES

Sea lions and seals move awkwardly on land but are agile in their pursuit of fishes underwater. Sea lion pups learn to catch food from the age of five months and adults eat up to 12 or 15 lbs of fishes and squid per day, sometimes stunning large octopuses by whacking them against the surface of the water. Seals feed on mussels, crabs and sea-birds in addition to fishes and squid.

All cetaceans (whales and porpoises) are carnivores but many of the largest whales such as humpback, blue and right whales, have no teeth and instead of catching large prey strain vast quantities of plankton in the form of krill and other small crustaceans from the water. Toothed whales, including sperm whales, porpoises and dolphins, are active hunters using sonar to find fishes or squid by echolocation. The most voracious of these are killer whales with a remarkable combination of size (up to 30 feet/ 9 metres long), speed, power and high intelligence. Unlike most marine predators, which hunt as individuals, killer whales may work in packs of up to 40; they cooperate in attacks on large whales, some of the pack holding down the prey by the flippers while others tear off chunks of flesh with their conical interlocking teeth. Seals are their favourite food, but porpoises and penguins are among other animals they will attack.

Predation is the normal way of life in the sea; fishes and other animals have developed many different strategies for hunting and killing prey and this is reflected in the immense variety of their appearance and behaviour. Of course even avid carnivores spend much of their time at rest or engaged in other activities such as reproduction, but the need to eat and to avoid being eaten are the prime day-to-day concerns of all marine life.

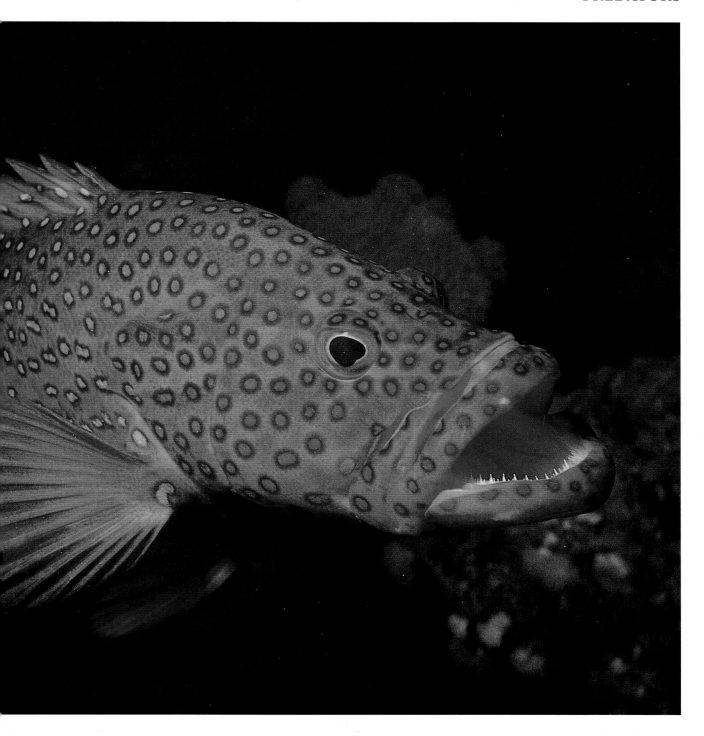

The coral grouper or coral trout,
Cephalopholis miniata, is commonly
seen amongst corals on Indo-Pacific
reefs from the Red Sea to Australia,
where it preys on fishes
and crustaceans.

LOCATION : Red Sea: Egypt
CAMERA : Nikonos V with 28 mm lens plus
close-up lens; f16-22; Kodachrome 64

Whitetip reef sharks, Triaenodon obesus, (up to about 5.5 ft / 170 cm in length) cruise over the reef in search of a variety of fishes, crustaceans and octopuses. Remoras often attach themselves to the shark's flanks to feed on parasites.

LOCATION : Sabah: Sipadan
CAMERA : Nikonos V with 15 mm lens; f8-11; Kodachrome 64

The "beak" of the omnivorous hawksbill turtle, Eretmochelys imbricata, is one of the features that distinguish it from the similar-looking, vegetarian green turtle. The hawksbill uses its beak to scrape sponges and other encrusting invertebrates from the reef face, and to prise out molluscs and crack them open.

LOCATION : Sabah: Sipadan
CAMERA : Nikonos V with 15 mm lens; f8-11; Kodachrome 64

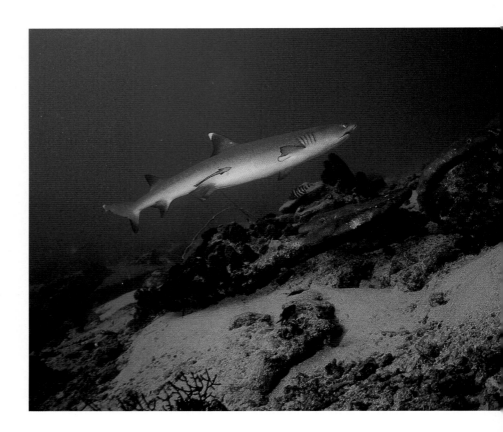

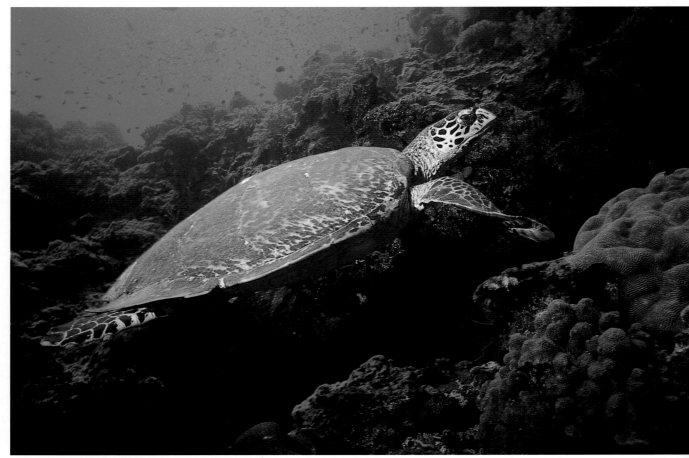

Streamlined for speed, the Galapagos sea lion, Zalophus californianus wollebacki, dives to catch fish. Bulls weighing up 250 kg sometimes fight, injuring each other.
LOCATION : Galapagos Islands.
CAMERA : Nikonos III with 28 mm lens; f8-11; Kodachrome 64

Stingrays use their pectoral fins to stir up the sand when searching for crustaceans and molluscs.
LOCATION : Red Sea: Egypt
CAMERA : Nikonos with 15 mm lens; f8-11; Kodachrome 64

Overleaf: Some species of barracudas, Sphyraena, swim in large schools. This is a school of more than 500 fishes, each about 3 ft / 1m in length.
LOCATION : Sabah: Sipadan
CAMERA : Nikonos V with 15 mm lens; f8; Fujichrome Velvia

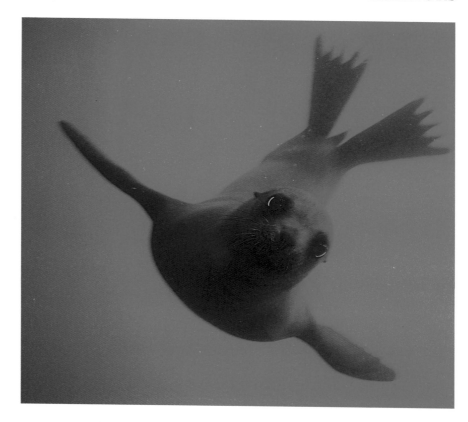

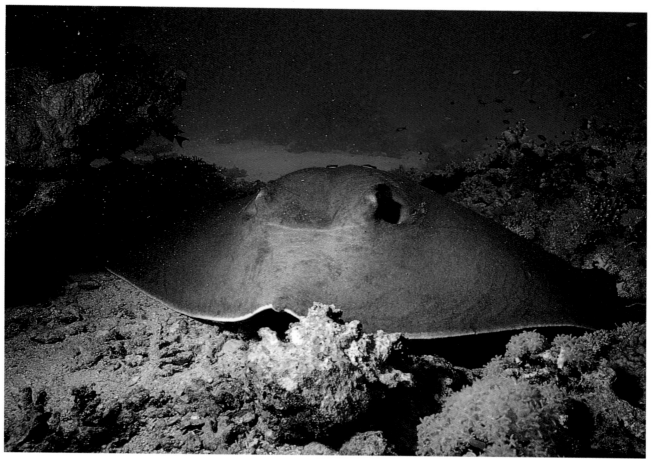

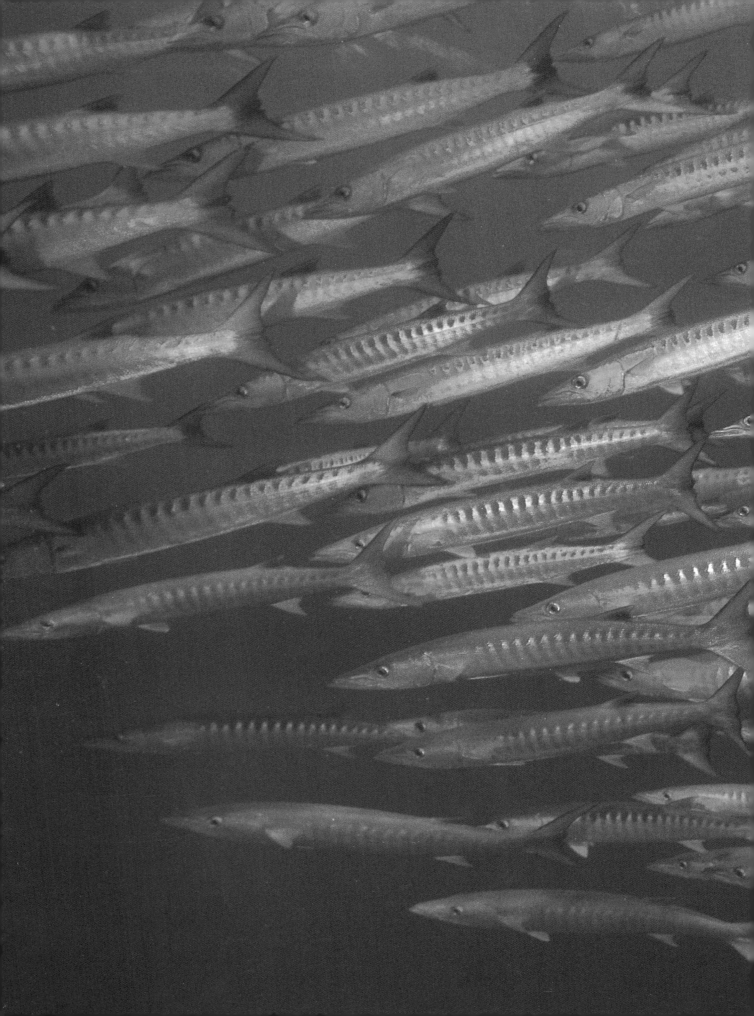

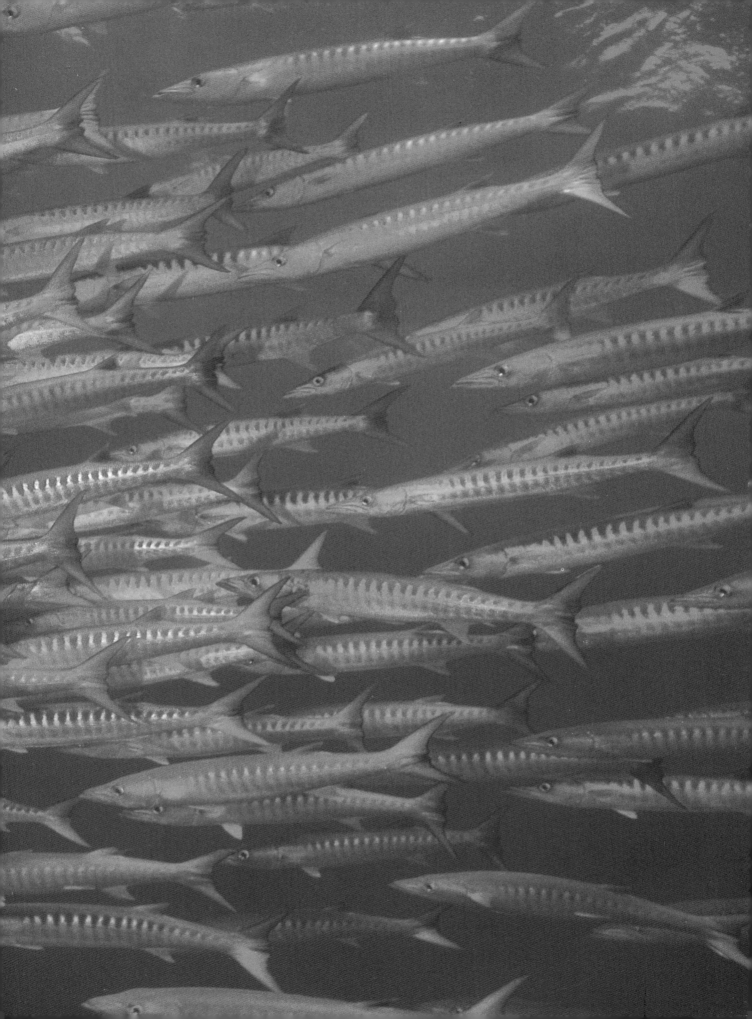

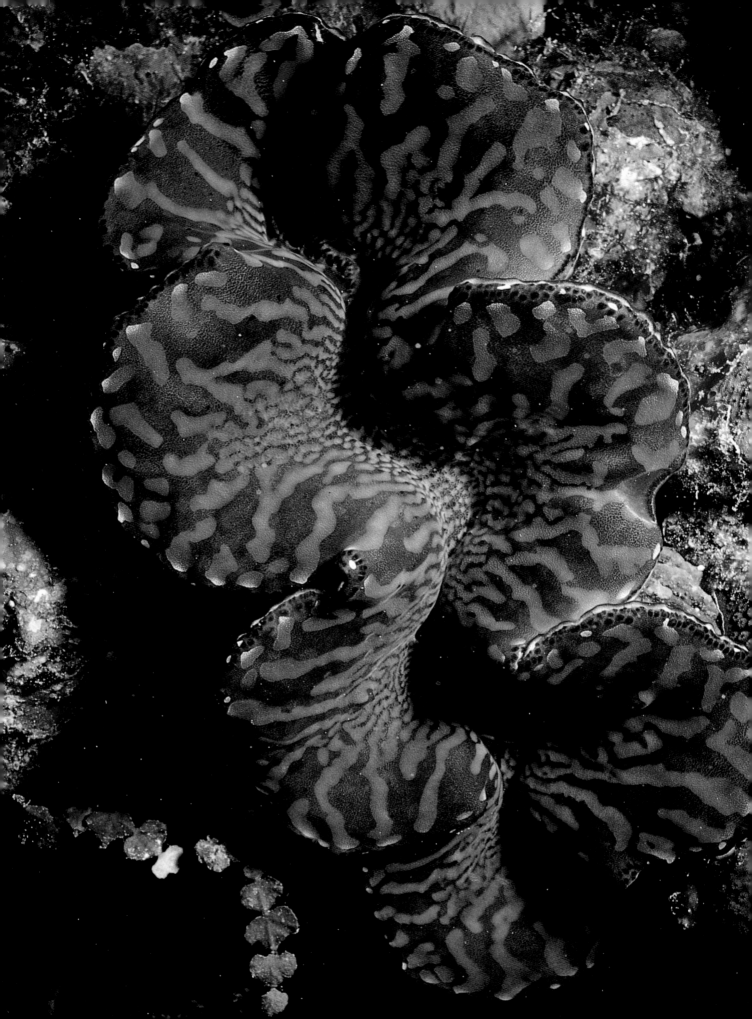

Defence

Most sea animals run the risk of being eaten by predators and some have developed a fascinating variety of ways to protect themselves, ranging from hard shells to venom-loaded spines. Such armoury is cumbersome and restrictive but allows small or slow moving creatures to venture into the open in search of food without becoming the next meal of a larger fish. Many others use camouflage to avoid being seen at all or simply hide in holes in the reef or burrow in the sand. Unfortunately even the most ingenious defences have their weak points and sooner or later many animals fall victim to the various predators adapted to deal with them.

RETRACTING TENTACLES

True corals have a stony skeleton, often with rough or razor-sharp projections, into which the soft tissues of the living animal, the anemone-like polyps, can withdraw. Sea anemones have no skeleton but many can retract their tentacles into the body thus saving them from being nibbled and from the greater dangers of damage by strong currents, wave action, or when exposed at low tide since many live in shallow turbulent sites.

SHELLS AND TUBES

The calcareous shell is the most obvious feature of many molluscs since most of the soft parts are tucked inside it. Whenever the animal is threatened, protruding parts such as the mantle, a sheet of skin which secretes the shell, can be rapidly withdrawn too. Bivalves and many gastropods have shells in a strikingly diverse array of shapes and sizes. In gastropods including terrestrial snails the shell is normally spirally coiled and accompanied by an operculum, a plate which can seal the opening when the animal is

The clam Tridacna retracts its blue patterned mantle, a sheet of soft tissue, and closes the two heavy valves of its shell (up to 3 ft/ 1m in length) against attackers.

LOCATION : South China Sea: Malaysia
CAMERA : Nikonos V with 28 mm lens plus close-up lens; f16-22; Kodachrome 64

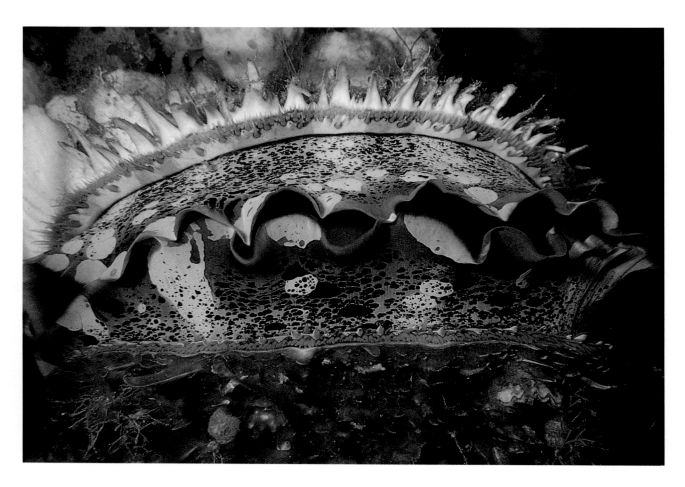

inside the shell. Gastropods frequently creep across the sea bed or over seaweed, grazing or scavenging. Bivalved molluscs, as the name suggests, have a pair of shell valves hinged by an elastic ligament allowing them to open and close. Such shells are not easy to carry around thus the majority of bivalves, including clams and thorny oysters, are sedentary, some even burrowing in sediment or rock for added protection. They use a pair of siphons to draw water bearing oxygen and small fragments of food in, over the gills and out again. Mollusc shells deter many would-be predators but others, particularly some of the larger fish, have heavy teeth capable of crushing shells. Ironically the lasting beauty of their shells endangers many molluscs that are prized by conchologists and souvenir hunters.

Tube worms and fan-worms, unlike ragworms and other active members of the polychaete class, live in a tube attached to the sea bed or to seaweed. One or two whorls of delicate feathery tentacles project from the top of the tube to respire and to filter food particles from the water but the worm's body remains hidden in the tube and will withdraw the tentacles almost

The shells of thorny oysters,
Spondylus, (up to 8 in. / 20 cm
in length) snap shut at the
approach of possible predators.
The rugged, spiny outer layer of the
shell gives additional protection.

LOCATION : Sabah: Sipadan
CAMERA : Nikonos V with 35 mm lens
plus close-up lens; f16-22;
Kodachrome 64

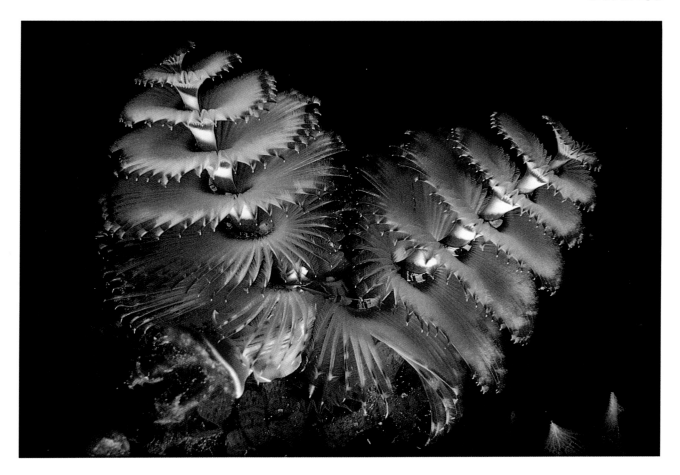

Two conspicuous whorls of tentacles (gills) extend from a calcified tube embedded in coral but the Christmas tree worm, Spirobranchus giganteus, (1.5 in. / 4 cm in height) can retract its gills in an instant at the slightest disturbance. The tube is then closed by a lid, the two-pronged operculum.

LOCATION : Cayman Islands.
CAMERA : Nikonos III with 35 mm lens;
extension tubes 1:2; f16-22;
Kodachrome 64

instantaneously at the slightest hint of danger. The calcareous tubes of serpulid and spirorbid tube worms, such as the widespread tropical Christmas tree worm *Spirobranchus giganteus* are plugged by an intricately shaped operculum once the tentacles are retracted. Fan-worms also make tubes to live in but these are membranous constructions, plastered with mud, and have no operculum.

ENCLOSED IN A CARAPACE

Shells and tubes protect the soft body inside but some delicate parts have to be exposed if the animal is to feed or move about. Lobsters and crabs, like other arthropods, solve this problem by having all-over armour plating jointed for ease of movement. This external skeleton is a thick layer of cuticle made of horny chitin and is calcified in crustaceans to give rigidity with less brittleness than a mollusc's shell of the same thickness. At the joints of the appendages and body segments the cuticle is membranous and flexible. Crabs and lobsters are crustaceans with

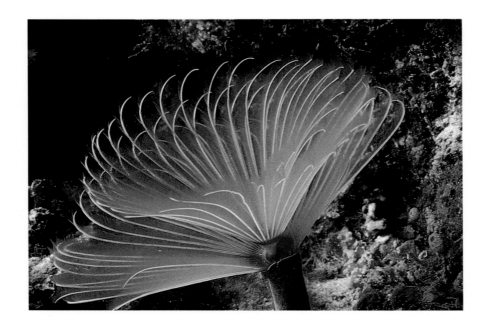

A plume of finely branched tentacles (about 3 in. / 8 cm across) is the only visible part of a fan-worm (Sabellidae). The greyish, mud-coated tube that the worm secretes and dwells in is flexible.

LOCATION : South China Sea: Philippine Islands.
CAMERA : Pentax LX with 50 mm lens; Hugyfot housing; Kodachrome 64

a particularly hard crust; their thorax is covered over top and sides by a solid shield, the carapace. The disadvantage of a rigid external skeleton is that it cannot increase in size and must instead be moulted from time to time so that the crab or lobster can grow, a process which leaves the animal vulnerable until its new outer layer has expanded and hardened. Male crabs mate with females that have just moulted and are still soft or just hardened; the male selects and grasps his chosen mate before she has moulted and guards her from the attentions of other males. Pairs of certain species, such as the velvet swimming crab *Liocarcinus puber*, in the North-east Atlantic, may be seen scuttling across the sea bed, locked together in readiness.

Many crabs and lobsters have powerful claws which they use for defence as well as for predation. Even so they are inclined to flee from attackers rather than stand their ground for long, preferring to wedge themselves in a crevice. Instead of doing this, box crabs tuck their legs into grooves in their carapace making a compact box-like shape that is difficult to prise open. Hermit crabs carry their retreat with them, using a discarded gastropod shell as a secondhand mobile home. The hermit's abdomen is soft skinned and twisted to fit the spirally coiled shell and as the crab grows it must periodically seek out a larger shell and move into it. Hermit crabs withdraw into their shells when they encounter danger and jam their front leg claws across the opening.

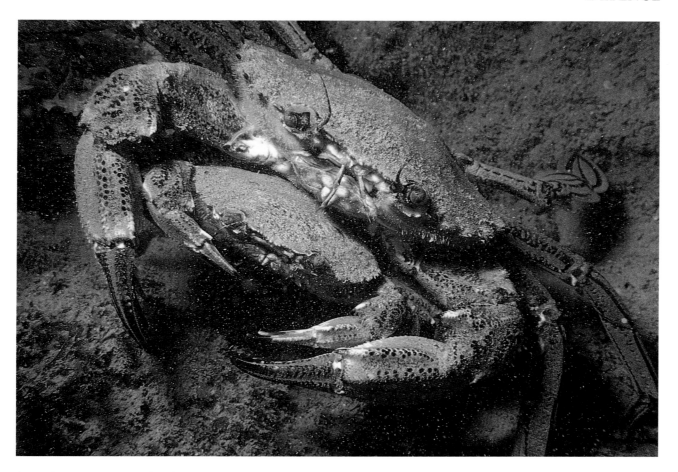

SPINES AND VENOM

Sea-urchins have a rigid covering, the shell-like test, but this is thin walled and brittle and additional protection is needed to deter predators from crushing it. Slate pencil urchins on Indo-Pacific reefs have long sturdy movable spines and use these to wedge themselves in crevices throughout the day for added security; other sea-urchins are covered in thinner sharp spines, too prickly for most predators to tackle. A few sea-urchins in warm waters have gone a step further by arming the spines with venom, secreted in *Diadema* urchins by the spine's coating. The brittle spines break off in the skin of attackers, including unwary bathers who tread on these common inhabitants of tropical shallows. Rarer relatives are the highly venomous nocturnal *Asthenosoma* urchins, whose spine tips are beaded with sacs full of poison.

Spines are such an effective defence that they have been developed independently by many widely differing groups of animals and by plants too. Spiny lobster and some spider crab carapaces, various mollusc shells, starfishes and many bottom-

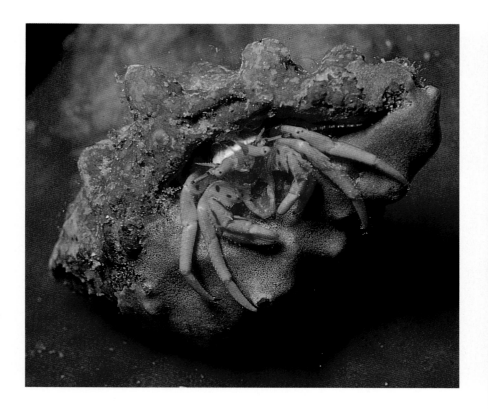

A hermit crab views its
surroundings cautiously, prepared
to retreat into its shell. The shell
that this tiny animal is living in is
1 in. / 25 mm in length and is
partly encrusted with pinkish
coralline algae.

LOCATION : Indonesia: Flores
CAMERA : Nikonos V with 35 mm lens;
extension tubes 1:1; f16;
Fujichrome Velvia

dwelling fish are spined. Slow swimming porcupinefishes of
tropical reefs have very sharp movable spines all over the body.
Normally these lie flat and streamlined against the body but when
the fish is threatened it takes in water and inflates to a globular
shape; this action erects the spines as well as giving the fish a
larger, more intimidating appearance. Puffers *Arothron* can also
inflate themselves to a much larger size, though without the added
benefit of prominent spines, and can use this as a means of
wedging their bodies into a safe crevice when attacked.
Venom provides a last line of defence as the predator closes in for
the kill. Lionfishes *Pterois* and *Dendrochirus* hover placidly in
sheltered corners of coral reefs, their divided fin rays spread in a
graceful fan, but when provoked they point the row of long dorsal

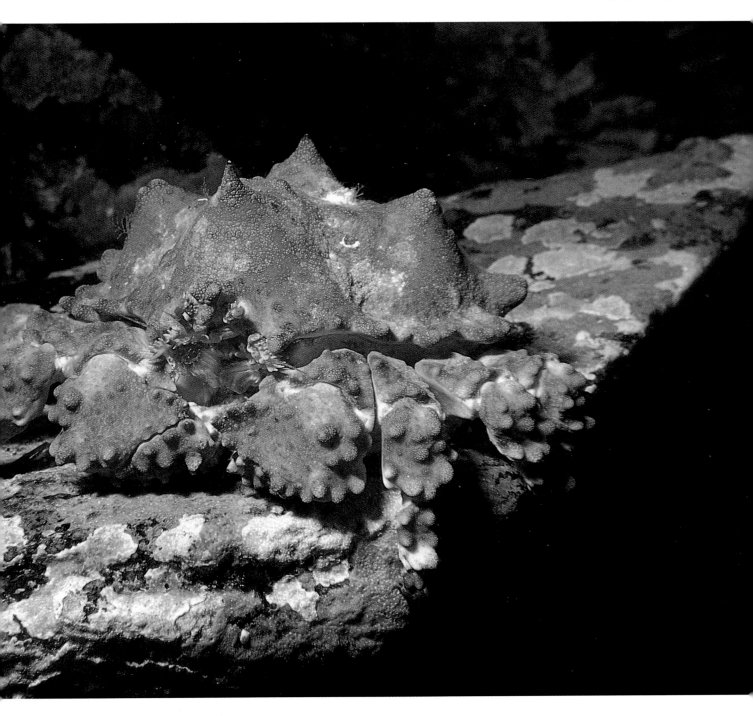

*The Puget Sound king crab,
Lopholithodes mandtii, (up to about 8
in. / 20 cm across) is more closely related
to hermit crabs than to true crabs.
The heavy rugged carapace has four large
cone-shaped humps and the legs are
covered in tubercles.*

*LOCATION : Canada: British Columbia
CAMERA : Nikonos V with 35 mm lens plus
close-up lens; f16-22; Kodachrome 64*

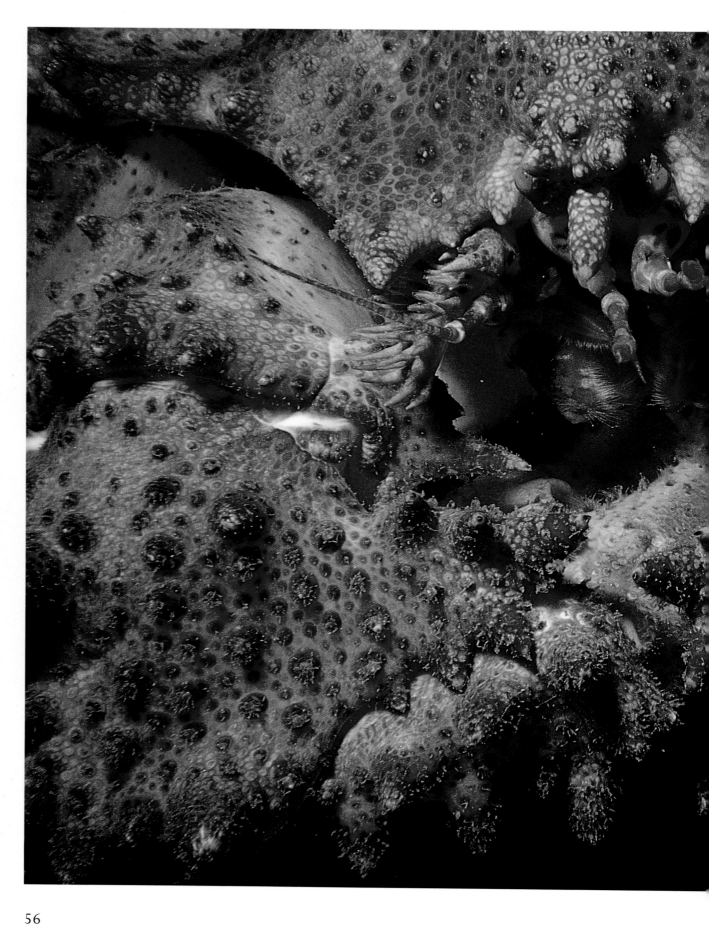

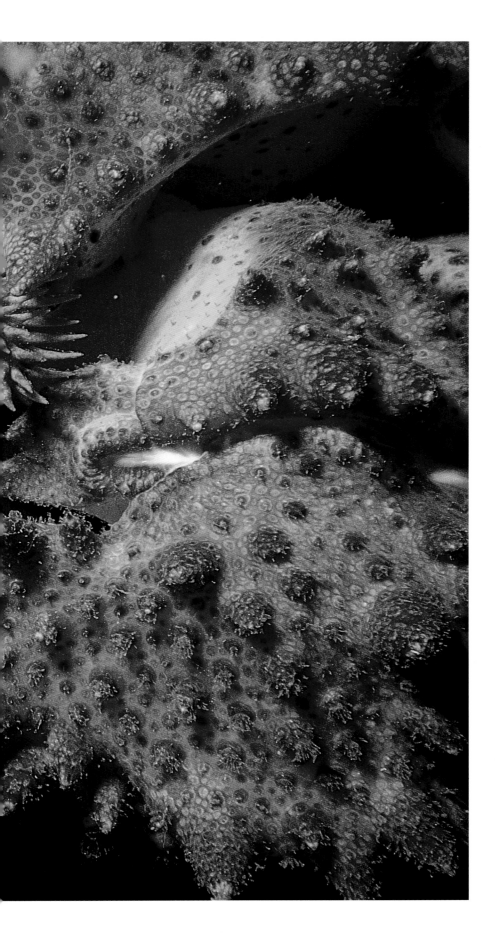

With its legs folded against the carapace, the Puget Sound king crab presents a compact solid outline that is impervious to most predatory animals.

LOCATION : Canada: British Columbia
CAMERA : Nikonos V with 35 mm lens plus close-up lens; f16-22; Kodachrome 64

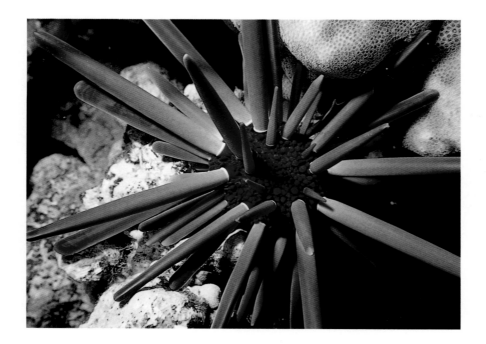

*Heavy spines prevent the slate
pencil urchin, Heterocentrotus
mammillatus, (up to 10 in. / 25 cm
in diameter) from being dislodged
from the narrow crevice where it
hides by day. At night it emerges
onto the reef to feed on algae.*

LOCATION : Red Sea: Egypt
CAMERA : Nikonos V with 35 mm lens
plus close-up lens; f16; Fujichrome 50

rays towards an attacker as a warning. As in many other
scorpaenid fishes, these fin rays are long spines which channel
venom from basal glands ready to inject a dose causing
excruciating pain.

TOXINS AND STINGS

Trunkfishes or boxfishes are encased in bony plates to a rigid
rectangular or triangular shape and for additional defence several
species of these Indo-Pacific and Caribbean reef fishes secrete a
toxic substance. This toxin is capable of killing other fish in a
confined space such as an aquarium. Soapfishes, shy relatives of
the grouper family and widespread in the tropics, produce a toxin
in the slimy, soapy mucus covering their skin and are often
brightly marked to advertise this bitter tasting deterrent.
Many invertebrates as well as fishes are similarly distasteful and
predators learn to recognise and avoid them.

The nematocysts (stinging cells) of sea anemones, corals,
jellyfish and hydroids are primarily used in capturing food but also
serve defensive purposes in some. The stings of a few species are
particularly powerful; brushing against the hydroid, fire coral
Millepora or various fern-like stinging hydroids, can leave a
burning rash on delicate skin. Most small animals prefer to avoid
contact with stinging cells but aeolid nudibranchs (a group of sea-
slugs) not only feed on nematocyst-bearing coelenterates with

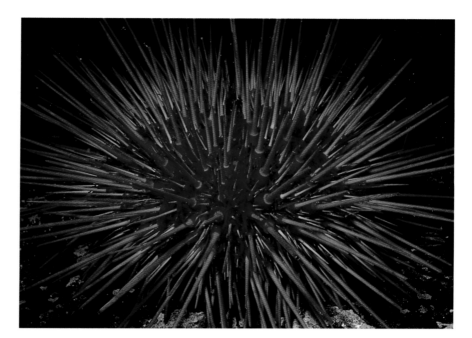

The long spines (3 in. / 8 cm) of the red sea-urchin, Strongylocentrotus franciscanus, deter most animals from attacking it but it is preyed on by wolf eels. The diameter of the test or shell of this sea-urchin is up to 8 in. / 20 cm.

LOCATION : Canada: British Columbia
CAMERA : Nikonos V with 35 mm lens plus close-up lens; f16-22; Kodachrome 64

impunity but take over the stinging cells of their prey for their own defence. These cells are passed undigested from the nudibranch's gut to internal sacs at the tips of its cerata (long dorsal lobes) where they are stored ready for use. When a fish tries to attack an aeolid nudibranch it is confronted by a cloud of nematocysts fired from the erect cerata. The sea-slug *Glaucus* preys on and utilises the potent nematocysts of the Portuguese man-of-war drifting at the sea's surface, and painful stings have been reported by bathers in Australia.

The fire-worm *Hermodice carunculata* fringed with white tufts of fine hair-like setae appears as inviting to the touch as a plushly trimmed cushion but these bristles are needle sharp, ready to pierce and break off in an attacker. Lacking in spines or venom, sea-cucumbers use a different defensive strategy. Certain tropical species, and the north-east Atlantic and Mediterranean cotton spinner *Holothuria forskali*, respond to interference by extruding specialised tubules as long sticky threads from the anus. Some other species without such tubules eject their gut instead, which can be regenerated and so may serve as an expendable titbit to placate a predator while the sea-cucumber makes its escape.

SAFETY IN NUMBERS

Many fishes are inadequately armed against attack and rely on evasive tactics such as speed in swimming; flying fish even leap

*The poisonous sea-urchin
Asthenosoma varium (up to 6 in. /
15 cm in diameter) inhabits Indo-
Pacific reefs, where it hides by day
but is active at night. It is
reputedly the most venomous sea-
urchin that occurs in the Red Sea.
White bead- like sacs near the tips
of the spines contain venom which
is injected when the spines pierce
skin.*

*LOCATION : Red Sea: Egypt
CAMERA : Pentax LX with 50 mm lens;
Hugyfot housing; f16; Kodachrome 64*

right out of the water to escape from the jaws of a predator! Small
fishes are vulnerable swimming alone, an easy target for larger,
more powerful fishes to home in on, especially in open water.
By crowding together in a dense shoal they are all safer;
individuals are more difficult to pick out of the mass and
predators may even momentarily mistake the dark shadow of the
shoal for that of a single huge fish. Weak and sick members of the
shoal are most at risk since they are the stragglers on the
outskirts. Silversides and sand-smelts of lagoons and other
temperate or tropical inshore waters are whitebait-sized adepts at
schooling. Sweepers *Parapriacanthus* on tropical reefs herd together
in shimmering curtains of silvery bodies, moving in unison then
changing direction at the same instant as if linked by an invisible
thread. Whatever their personal defences the majority of marine
animals rely on their habitat to provide safe retreats. Coral reefs
and rocky shores or sea beds are full of crevices and overhangs in
which to take cover though for many fish it is sufficient to dart in
against the wall to escape notice while a shark cruises by.
Shipwrecks too act as artificial reefs and soon become colonised
by a variety of life. All these havens are richly populated compared
with the open seas which are devoid of refuges.

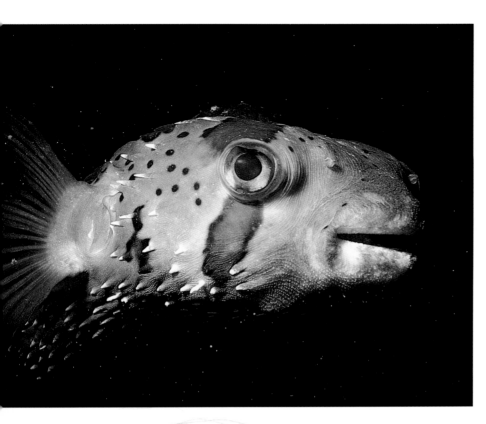

Porcupinefishes, Diodon, (up to about 2 ft / 60 cm in length) have sharp movable spines all over the body. These lie flat against the body except when the fish inflates itself.

LOCATION : Galapagos Is.
CAMERA : Nikonos with 28 mm lens plus close-up lens; f16-22; Kodachrome 64

With spines erect, the porcupinefish or balloonfish, Diodon holacanthus, (usually about 1 ft / 30 cm or less in length) is likely to be swiftly rejected by attackers.

LOCATION : Cayman Is.
CAMERA : Nikonos with 35 mm lens; extension tubes 1:2; f16-22; Kodachrome 25

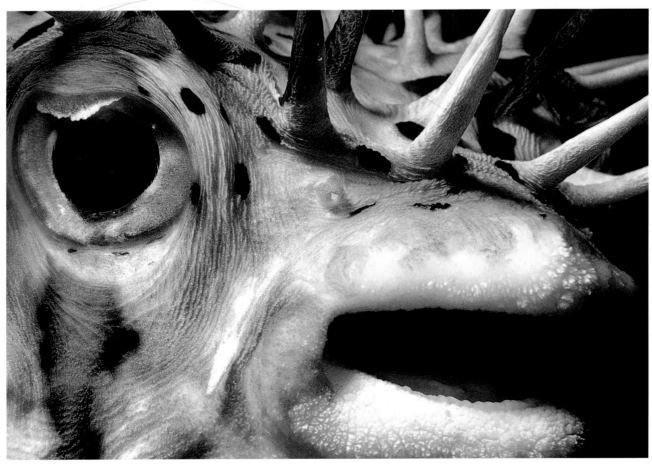

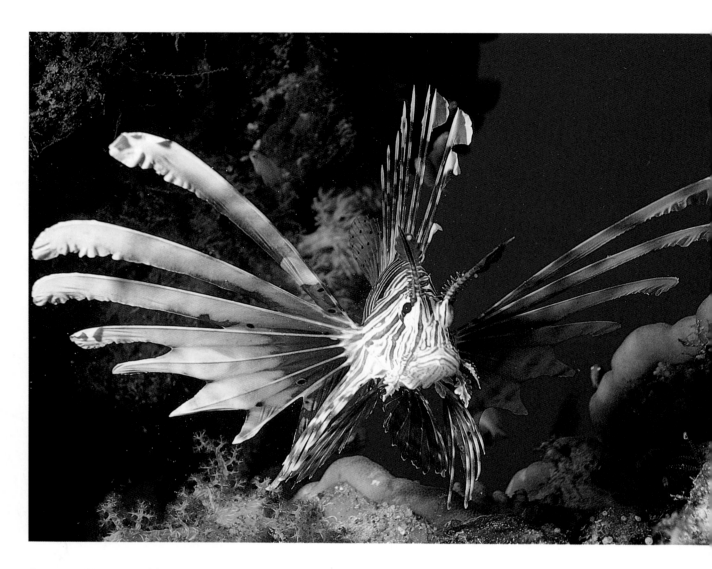

An eye-catching array of fins
signals the lionfish hovering
fearlessly on the open reef; its
protection is the dorsal row of fin
spines which are venom-bearing.
The common lionfish Pterois
volitans is about 1 ft / 30 cm
in length).

LOCATION : Red Sea: Egypt
CAMERA : Pentax LX with 50 mm lens;
Hugyfot housing; f8; Kodachrome 64

Zebra lionfish, Dendrochirus
zebra, (about 6 in. / 15cm in
length)

LOCATION : Indonesia: Flores
CAMERA : Nikonos III with 35mm lens;
extension tubes 1:2; f16;
Fujichrome velvia

Spotfin lionfish, Pterois antennata,
(up to about 8 in. / 20 cm in
length).

LOCATION : Indonesia: Flores
CAMERA : Nikonos V with 35mm lens;
extension tubes 1:2; f16;
Fujichrome velvia

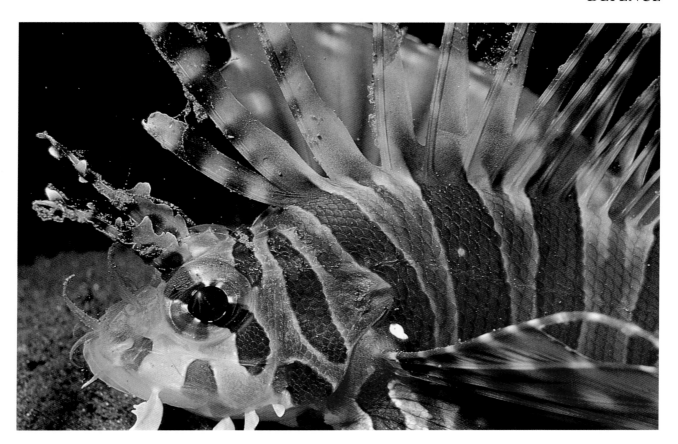

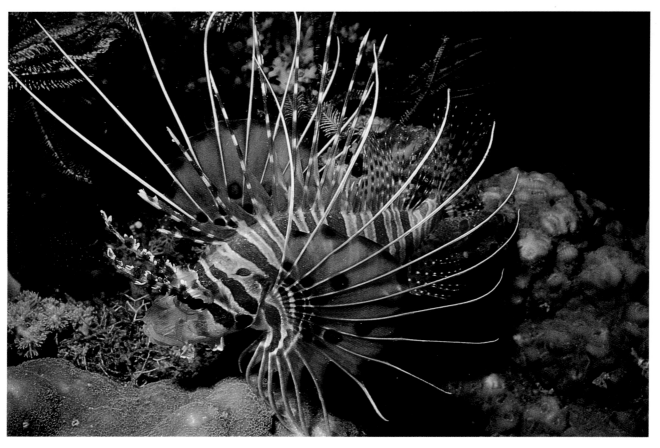

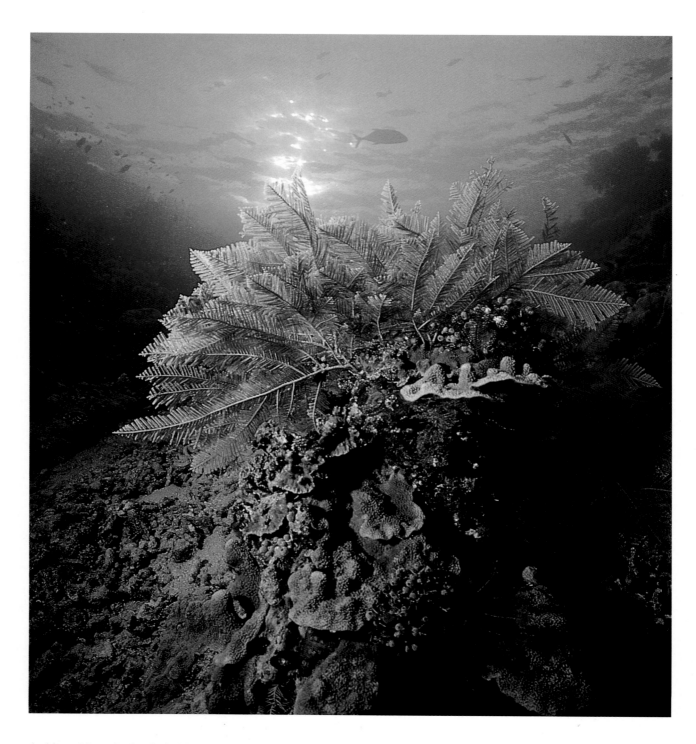

Avoid touching stinging hydroids
such as Aglaeophenia cupressina.
These fern-like animals, up to 3ft /
1m in height, appear harmless but
can deliver a painful, lingering
sting.

LOCATION : Indonesia: Sulawesi
CAMERA : Nikonos V with 28mm lens;
f8–11; Kodachrome 64

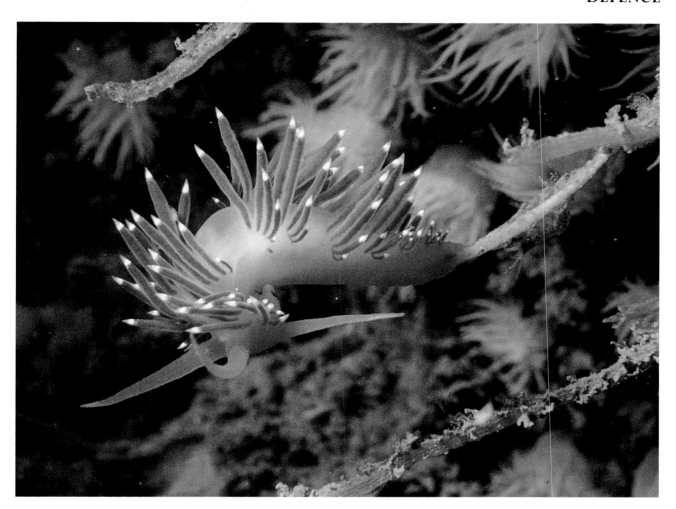

Tufts of cerata cover the back of aeolidacean nudibranchs, armed with stinging cells derived from the prey of these sea-slugs. Coryphella browni (up to 2 in. / 5 cm in length).

*LOCATION : Great Britain: England
CAMERA : Nikonos II with 35 mm lens; extension tubes 1:2; f22; Ektachrome 64*

A row of red gills down each side of the fire-worm Hermodice carunculata is a signal to warn other animals away. There is no danger from the gills but the accompanying silky white tufts of sharp bristles detach easily when touched, and lodge in the skin with a burning sensation.

*LOCATION : Cayman Islands.
CAMERA : Pentax LX with 50 mm lens; Hugyfot housing; f8-11; Kodachrome 64*

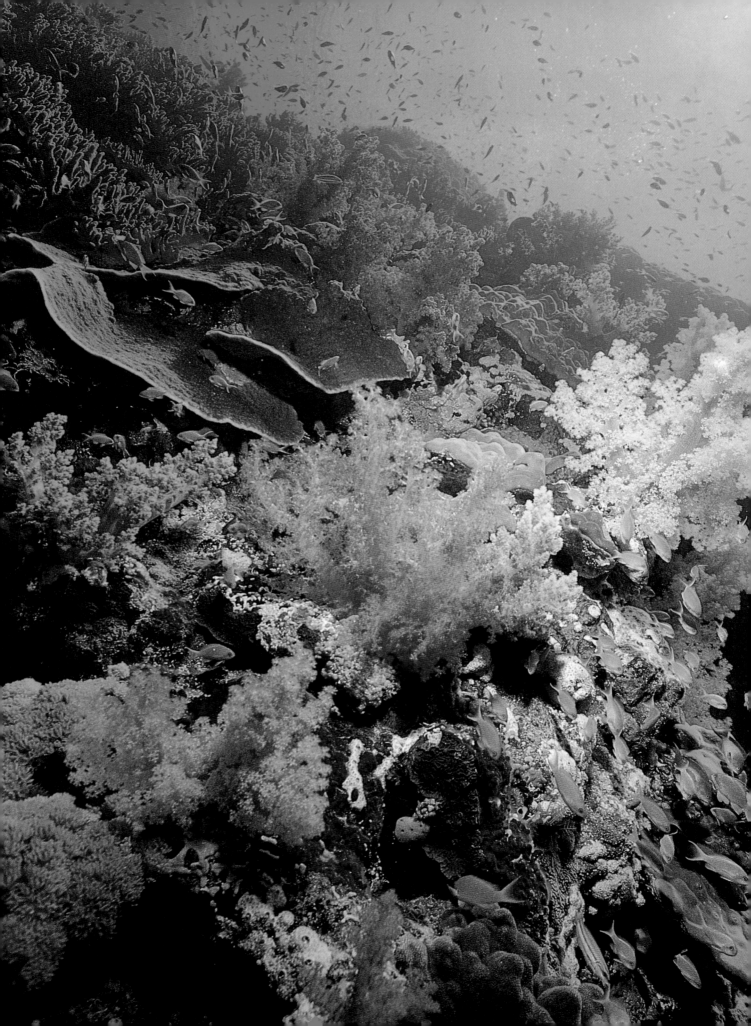

Corals & Reefs

Coral reefs are supreme among all the beautiful environments of the sea in the diversity and intricacy of their growth forms. Several types of reefs exist, mainly in the tropics since their development requires a water temperature of at least 18°C. Fringing reefs, typical of the Caribbean, Red Sea, East Africa and many Indo-Pacific islands, run close to the shoreline. Barrier reefs are formed much further away from the shore; the largest is the Great Barrier Reef, stretching for 2000 km and up to 100 km off the coast of Australia. Atolls, forming a horseshoe or ring round a lagoon, occur mainly in the Indo-Pacific.

The reef builders are stony corals whose colonies are made up of small animals, the polyps, each of which secretes an external calcareous cup. The combined efforts of the colony form the skeleton which gives the coral colony its particular shape, often a massive structure bearing no resemblance to the soft delicate polyps. The polyps, which have numerous tentacles, are anemone-like in appearance and stony corals are classed with sea anemones in the coelenterates.

ZONES OF THE REEF

A reef consists of a number of zones of differing coral communities determined by factors such as light availability, slope of the reef and wave action. These zones are complex and variable even on the same type of reef though the following are among those seen on many reefs. Lower reef slopes below about 20 metres may be covered by thin plate-like growths of various coral species that can tolerate reduced light levels, while upper slopes are filled with a great diversity of coral species and growth forms. The reef edge or front at the top of a slope may be subjected to wave action in shallow water and corals here tend to be sturdy or capable of surviving a battering. Lagoons, sheltered from waves by

Colourful soft corals, Dendronephthya, (up to about 3 ft / 1m in height, occasionally larger) grow in profusion on some Indo-Pacific reefs.

LOCATION : Red Sea: Egypt
CAMERA : Nikonos V with 15 mm lens; f5.6-8; Fujichrome Velvia

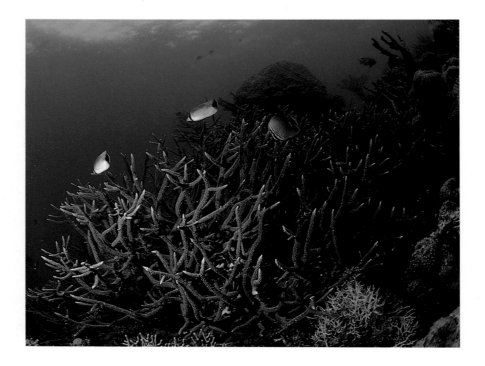

the reef crest, are tranquil in contrast. Sand and sediment can cloud the water but corals that tolerate this may develop more finely branched and delicate structures in deeper areas of lagoons than on any other part of the reef.

VARIETY OF GROWTH FORMS

Certain corals are restricted to particular zones while others may vary their growth form according to site. Elkhorn coral *Acropora palmata*, the dominant builder of shallow Caribbean reefs, is characteristic of wave-swept shallow sites where it grows in dense stands. This coral is able to exploit different conditions within its zone; it has thick heavy branches in its usual growth form but in conditions of extreme surf it may survive only in an encrusting state. *Acropora* corals are a group of more than 300 species that often dominate shallow gentle slopes of the upper reef with colonies forming highly branched 'trees', 'bushes', and 'tables', or 'plates', columns and massive clumps. Many species are of the 'staghorn' type that often form dense thickets of slender branches. On shallow sites *Acropora* corals are vulnerable to storm damage but they recover rapidly with new growth arising from toppled colonies and branches. Caribbean pillar coral *Dendrogyra cylindricus* is capable of similar regrowth. Below the elkhorn zone in the Caribbean, star corals *Montastrea* are particularly abundant

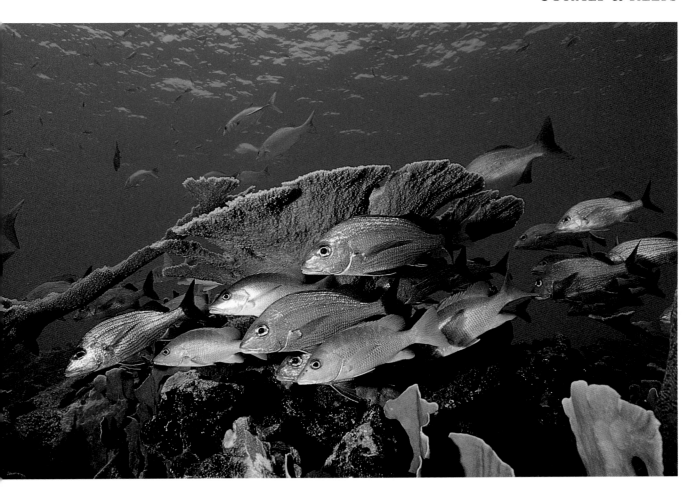

Elkhorn coral, Acropora palmata, growing in large stands up to 10 ft / 3 m in height, is the most important builder of shallow reefs in the Caribbean. Although its massive antler-like branches can withstand wave action they are vulnerable to storm damage but colonies regrow rapidly and compete with neighbouring corals by overshadowing them. The broad branches provide shelter for shoals of fishes such as the grunts and snappers seen here.

LOCATION : Cayman Islands.
CAMERA : Nikonos III with 15 mm lens; f11; Fujichrome 100

and form large mounds, or plates at depth, though they grow much more slowly than elkhorn coral. Domed colonies of brain corals with their maze of winding ridges are a distinctive feature of many reefs throughout the tropics. Brain coral is a name is given to various species of corals of superficially similar appearance in *Diploria*, *Platygyra*, *Leptoria*, *Goniastrea*, and *Lobophyllia*. Boulder or pore corals *Porites* grow in rounded clumps up to 8 metres across or as branching colonies and are common on shallow parts of the reef. The corallites, which are cups of the individual polyps in the colony, are small, giving the coral a smooth appearance from a distance. In contrast to the massive growths of many corals some species of Caribbean lettuce corals *Agaricia* and their Indo-Pacific relatives *Pachyseris* form thin plates on sheltered slopes, or leafy structures as delicate as bone china. Indo-Pacific *Goniopora* species range from encrusting plates to clusters of columns and have very long polyps which are usually extended day and night. The polyps of many *Galaxea* corals are also extended during the day and are exceptionally beautiful in their

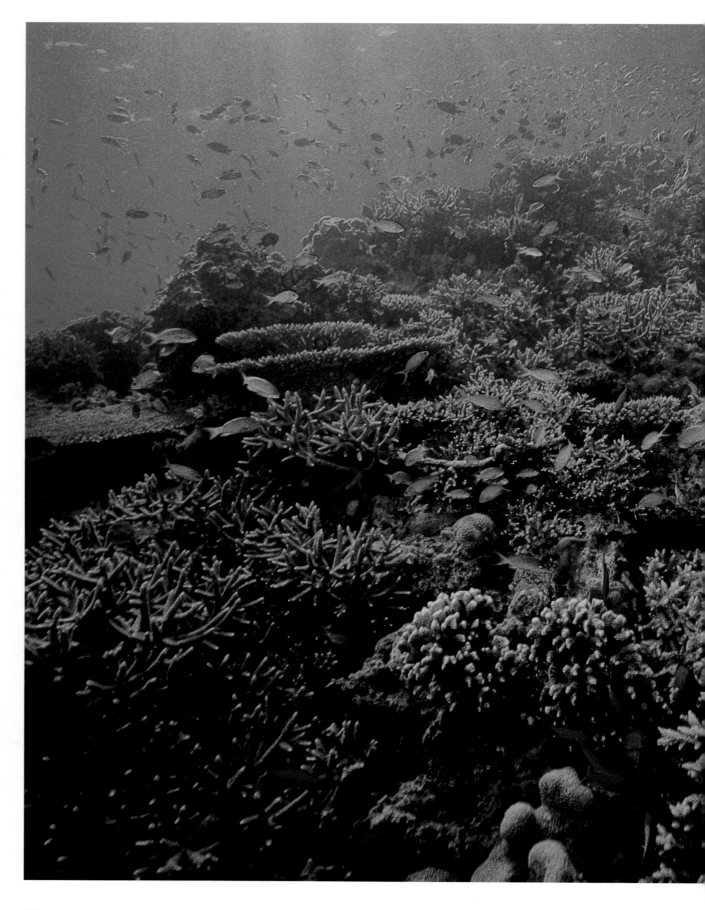

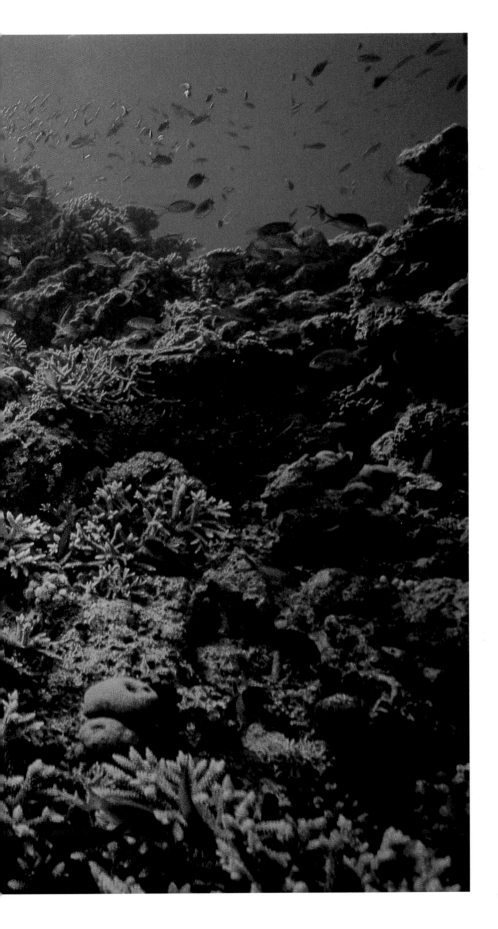

A shallow reef top fringing the tiny island of Sipadan, off Sabah, is covered in a variety of growth forms of coral, mainly of Acropora species.

CAMERA : Nikonos V with 15 mm lens; f8; Fujichrome Velvia

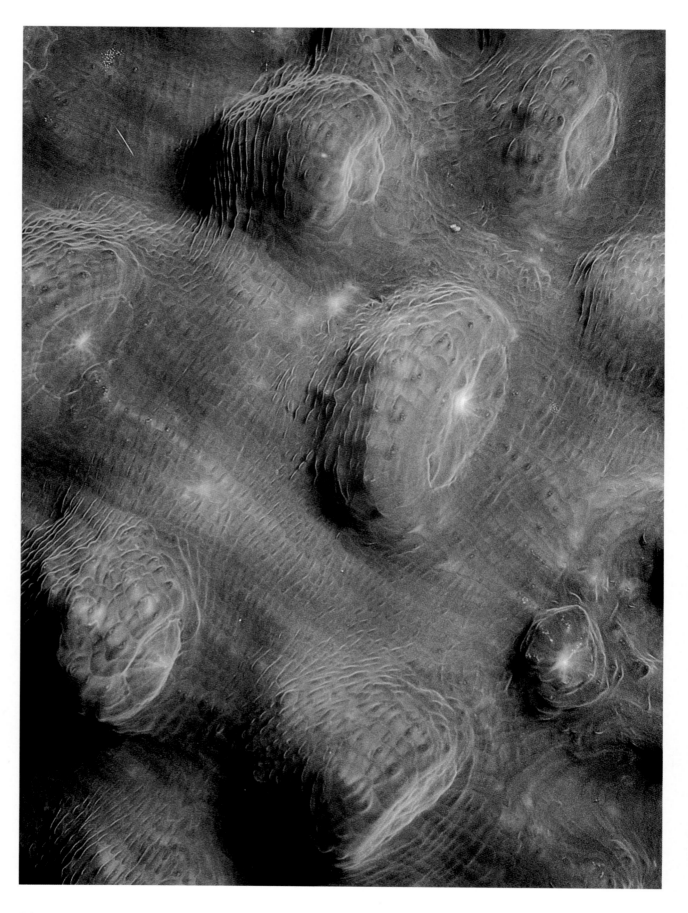

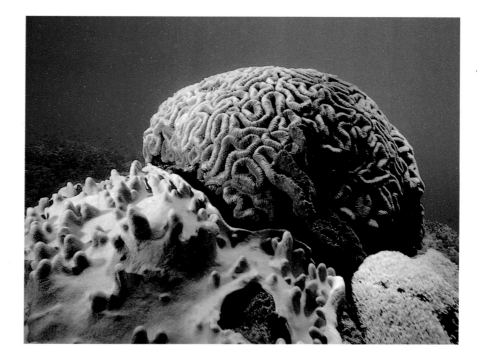

Dome-shaped masses of brain coral, named for the convoluted structure, may grow to 10 ft / 3 m in diameter. Lobophyllia hemprichii is a brain coral common on Indo-Pacific reefs.

LOCATION : Indonesia: Sulawesi
CAMERA : Nikonos III with 15 mm lens;
Kodachrome 64

The corallites of Mycedium have a distinctive nose-shape. Colonies of Mycedium elephantotus are widespread in the Indo-Pacific.

LOCATION : Sabah: Sipadan
CAMERA : Nikonos V with 35 mm lens;
extension tubes 1:2; f16-22;
Kodachrome 64

structure and translucent colours. Since corals are long-lived and sedentary (some massive *Porites* colonies may have been growing for nearly 1000 years), mature reefs become crowded forcing corals to compete for space. *Acropora* corals are particularly successful and can dominate the reef by a combination of rapid growth and the ability to overshadow their neighbours. Many other corals are directly aggressive. As they come into contact some such as *Galaxea*, which is widespread in the Indo-Pacific and sometimes forms enormous colonies, extrude digestive filaments to destroy the edges of their neighbours' soft tissues, while others use specialised sweeper tentacles to damage competitors.

Many corals feed by night on minute planktonic animals which they catch by means of the ring of tentacles, armed with stinging cells, at the tip of each polyp. Others, particularly deep water species, ingest organic debris by trapping particles in their mucous secretions.

Reef-building stony corals need sunlight and are limited to depths where light can penetrate but, where the water is sufficiently clear, certain species flourish at well below 50 m. Their polyps contain single-celled algae zooxanthellae that require light for photosynthesis to carry out their important role in skeleton formation. The branching, convoluted or tiered growth forms of corals enable them to make the most of the available light that reaches the reef. During the day the tentacles of bubble coral,

Lettuce corals, *Agaricia*, form
fragile plates up to about 1 ft /
30 cm across. The small star-like
patterns, in the valleys between the
ridges, mark the location of the
numerous polyps that make
up the colony.
LOCATION : Cayman Islands.
CAMERA : Nikonos V with 35 mm lens;
extension tubes 1:2; f16-22;
Kodachrome 25

The flower-like structure of the
coral Galaxea fascicularis belies its
aggressive nature. Galaxea corals
can attack neighbouring corals by
extruding filaments which digest
their tissues. Colonies may grow
to 1 ft / 30 cm in diameter.
LOCATION : Maldive Islands.
CAMERA : Nikonos V with 35 mm lens;
extension tubes 1:1; f16-22;
Fujichrome 100

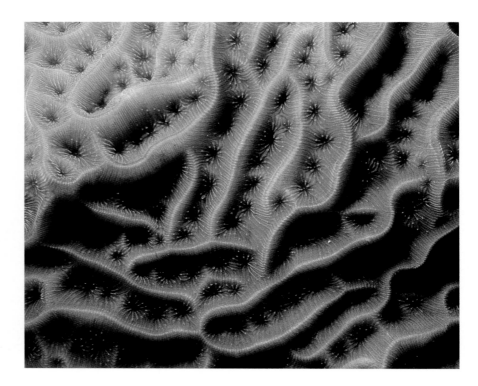

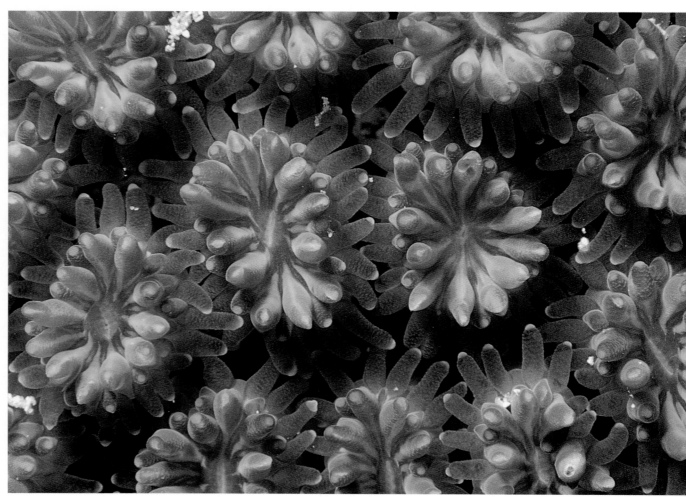

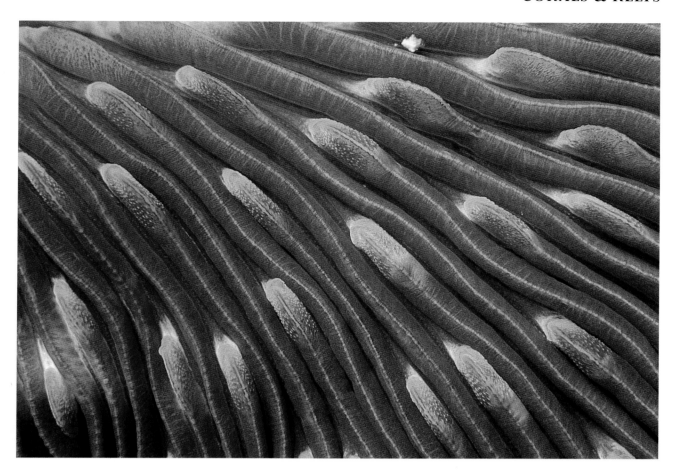

The radiating-ribbed structure of solitary mushroom corals Fungia resembles the gills on the underside of a mushroom. These corals are free-living, resting on patches of coral rubble on the slopes of the reef. Fungia scutaria, oval in shape, may grow to about 7 in. / 18 cm in length.

LOCATION : Indonesia: Flores
CAMERA : Nikonos V with 35 mm lens; extension tubes 1:1; f16; Fujichrome Velvia

Favia species are among the most abundant shallow-water corals and may form massive growths, up to 3 ft / 1 m in diameter. Details of the individual corallites that make up the colony are seen here.

LOCATION : Indonesia: Flores
CAMERA : Nikonos V with 35 mm lens; extension tubes 1:1; f16; Fujichrome Velvia

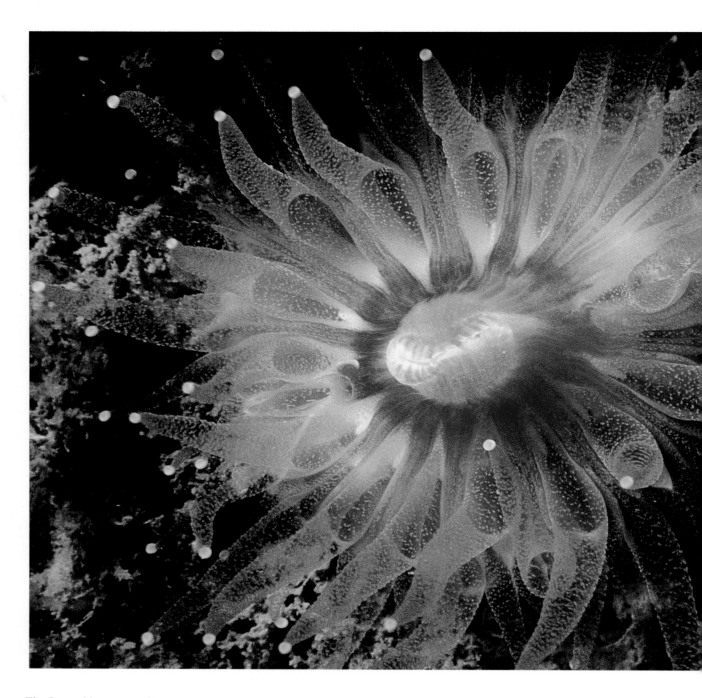

The Devonshire cup coral,
Caryophyllia smithi, is one of the
few true (stony) corals seen in
temperate waters. Individuals are
about 1 in. / 3 cm in length.

LOCATION : Great Britain: Wales
CAMERA : Nikonos II with 35 mm lens;
extension tubes 1:2; f22; Kodachrome 64

Plerogyra, have balloon-like expansions which contract at night when the tentacles are used for feeding. It has been thought that the balloons might protect the coral but recent studies suggest that their function is to increase the area for photosynthesis, a theory supported by the fact that the swellings are larger at depth, where there is reduced light.

Much colony growth takes place by asexual budding of polyps but corals reproduce sexually in addition. The Great Barrier Reef hosts an impressive annual event, the mass spawning of corals when pink and yellow egg and sperm bundles are released all over the reef. This takes place after sunset and is timed to coincide with low neap tides. Synchronous reproductive behaviour increases the chances of fertilisation and predators quickly become satiated by the quantities released.

Although most corals form colonies some solitary corals also exist, such as mushroom corals *Fungia* common on Indo-Pacific reefs. A few coral species grow in temperate and cold water, not as reef-builders but as isolated individuals or in clusters. These include the Devonshire cup coral *Caryophyllia smithi* of the North-east Atlantic and certain orange or yellow Mediterranean dendrophylliid corals.

OTHER REEF BUILDING ANIMALS

Several animals other than true corals secrete a calcified skeleton and contribute as reef builders. Fire corals *Millepora* are hydroids that form large brittle, branching or plate-like growths covered with fine hair-like tentacles whose stinging cells are capable of producing a painful rash on bare skin. Organ pipe coral *Tubipora musica* is a member of the octocorals, the class to which soft corals and gorgonians belong, and can form massive colonies consisting of numerous upright tubes arranged in parallel rows. The deep red skeleton is largely masked by pale polyps which extend from the tubes but it retains its colour after the colony has died, unlike true corals whose skeletons bleach to white after death.

SOFT CORALS AND GORGONIANS

Like stony corals, soft corals and gorgonians are colonies of anemone-like polyps. Soft corals form fleshy colonies which lack a rigid skeleton but are strengthened by small calcareous spicules,

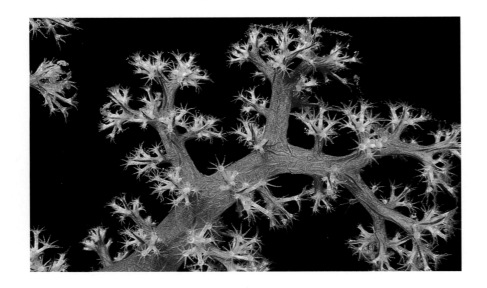

while gorgonians are usually reinforced by a central horny rod. This makes them more flexible than stony corals and allows the development of extremely finely branched forms. Most species of soft corals and gorgonians grow on coral reefs, although they do not help to build reefs. Colourful colonies of *Dendronephthya* soft corals are an impressive feature of Red Sea reefs and occur elsewhere in the Indo-Pacific but the less conspicuous pale greyish clumps of other soft corals such as *Sarcophyton trocheliophorum* may be common also. Gorgonians, though cosmopolitan, are most abundant on Caribbean reef tops. They include a range of forms from sea-fans, which have a mesh of fine branches aligned in one plane to strain their food of tiny organisms from the current, to irregular bushy growths and plume-like sea-whips. A number of soft corals and gorgonians occur in cooler waters, including precious coral *Corallium rubrum*, a gorgonian made rare by commercial exploitation in the Mediterranean and seas off Japan. The soft coral dead man's fingers, *Alcyonium digitatum*, covers rock faces abundantly in the North Atlantic, and a similar species, the sea strawberry *Gersemia rubiformis* occurs from northern California to the Bering Sea.

REEFS AT RISK

Since most corals are slow-growing, reefs are at risk from many hazards, both natural and man-made. Storms can flatten large stands of shallow-growing coral. Corals are sensitive to temperature changes and the warm current El Nino has on occasion, caused catastrophic damage to reef-building corals in tropical parts of the eastern Pacific Ocean. Corals have been exploited for ornament and used as building materials. Reefs in certain parts of the Philippines and Malaysia have been damaged by illegal fishing practices of dynamiting or by the use of cyanide. Apart from these direct threats reefs suffer from the results of other activities, such as dredging and deforestation that can flush sediments over corals and choke them, and from industrial pollution. The current popularity of diving causes wear and tear to reefs and unchecked tourism can result in serious deterioration as has occurred in Florida. On other reefs more concerned tourist developments combined with various conservation measures such as the use of fixed anchorage points are maintaining a better balance, allowing the reefs to stay in good shape.

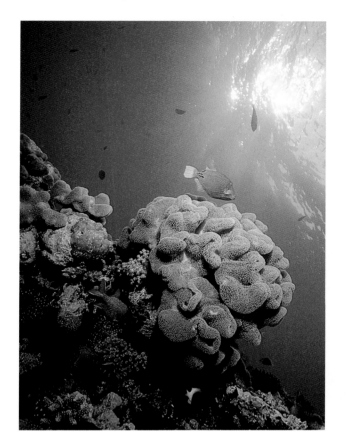

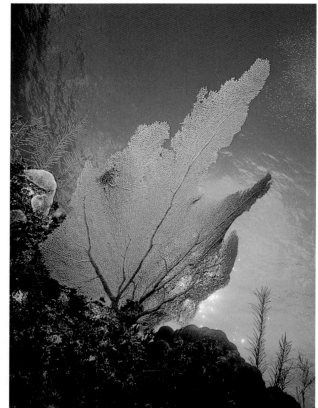

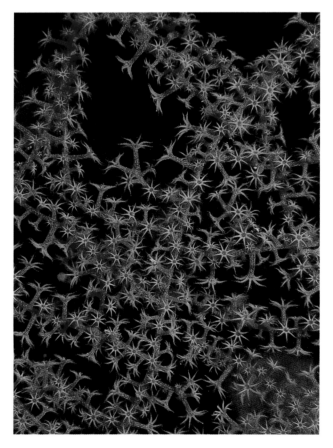

Above left : Leather corals, Sarcophyton trocheliophorum,
(up to 3 ft / 1 m across) are sturdy, drab-coloured soft corals.
Small pale polyps cover the convoluted upper surface.

LOCATION : Maldive Islands.
CAMERA : Nikonos V with 15 mm lens; f8-11; Fujichrome 100

Above right : Purple sea-fans, Gorgonia ventalina, are
abundant on shallow and moderately deep reefs in the
Caribbean. The closely fused network of tiny branches is
supported by a few thicker stems, up to about 6 ft / 2 m
in height.

LOCATION : Cayman Islands.
CAMERA : Nikonos III with 15 mm lens; f11; Kodachrome 64

Right : Viewed at close range, details of the structure of a
gorgonian sea-fan are clearly visible. Tiny polyps, each with
eight tentacles, cover the fine mesh of branches of this
unidentified species.

LOCATION : Indonesia: Flores
CAMERA : Nikonos V with 35 mm lens; extension tubes 1:2; f16;
Fujichrome Velvia

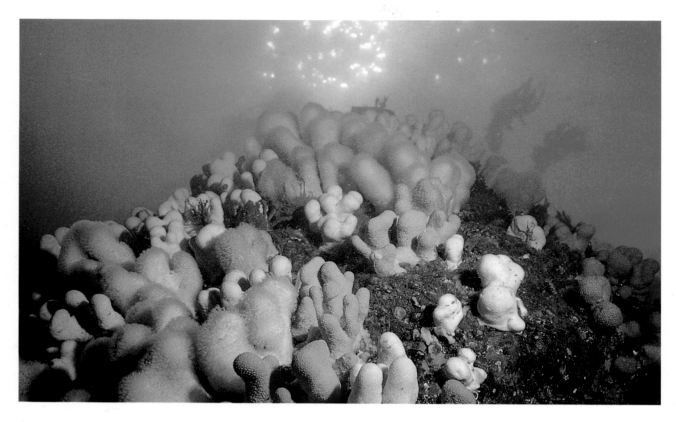

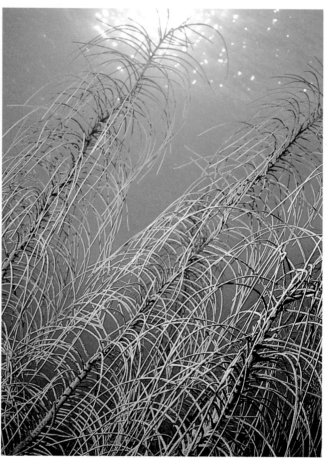

Carpets of the white or orange soft coral dead man's fingers, Alcyonium digitatum, are seen on many rock faces in the North Atlantic.

LOCATION : Great Britain: Scotland
CAMERA : Nikonos II with Vizmaster wide-angle supplementary lens; f8; Kodachrome 64

Sea plumes, Pseudopterogorgia, grow abundantly on shallow Caribbean reefs. The feather-like branches of these gorgonians may grow to a height of about 6 ft / 2 m.

LOCATION : Cayman Islands.
CAMERA : Nikonos V with 28 mm lens; f8-11; Kodachrome 64

Many different growth forms of gorgonians are seen on shallow Caribbean reefs but their colours are more subdued than those of some of their Indo-Pacific counterparts.

LOCATION : Cuba
CAMERA : Nikonos V with 28 mm lens plus close-up lens; f11; Agfachrome 100

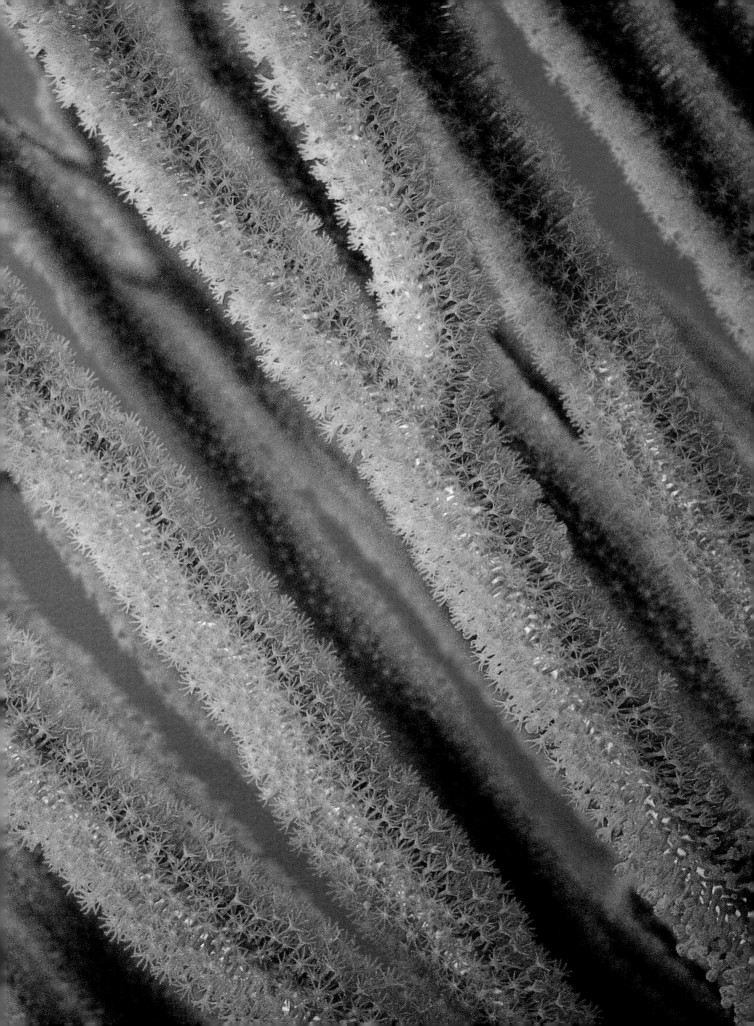

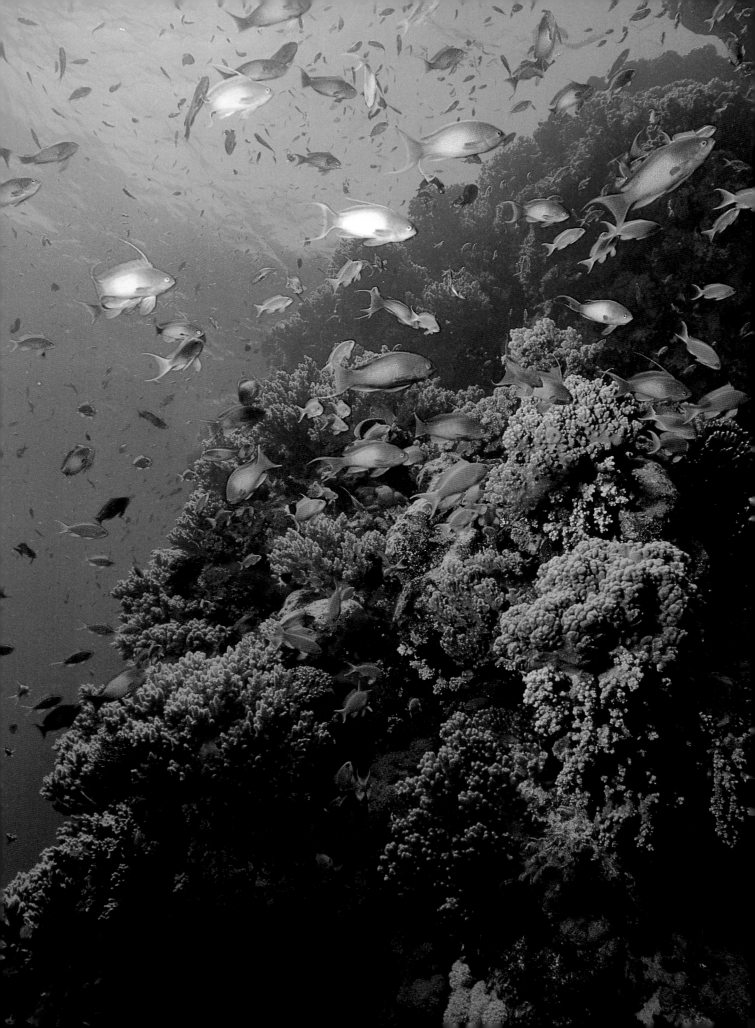

Reef Dwellers

Tropical reefs have been likened to rainforests because of their rich diversity not just in terms of corals or trees but in the wealth of animal life that they support. Coral reefs are complex systems in which a wide range of animals live together, competing for niches and depending on the reef and on each other for shelter and food whether they are permanently attached to the reef, crawl over it or swim about it. Materials are constantly recycled within the reef as they pass from one animal to another through food chains and other relationships in the community network. Reef dwellers include sponges, sea anemones, worms, crustaceans, molluscs, echinoderms and fishes, some specially adapted to feed on coral and many others adapted to a range of ingenious lifestyles in these extraordinary environments.

TOXINS

A high proportion of coral reef invertebrates and fishes are toxic, including venomous species, deadly to humans, such as the Indo-Pacific stonefish and the cone shell *Conus geographus*, which kills fishes. Many corals and sponges contain toxic substances which are picked up directly by the animals that feed on them and these toxins accumulate as they are passed through the food chain. Toxins play a role in defence, predation and in competition for space in a society rich in resources but inclined towards overcrowding.

AT HOME ON THE REEF

Since space is at a premium the majority of animals tend to guard their territory rather than risk losing it by straying too far. Sessile and sedentary animals are abundant, many colonising reef walls and dead coral skeletons, and others specialising in overgrowing

Orange sea-perches, Pseudanthias squamipinnis, (about 3 in./ 8 cm in length) are basslets that often gather in large numbers around the tops of steep slopes and walls on the reef.

LOCATION : Red Sea: Egypt
CAMERA : Nikonos V with 15 mm lens; f8; Fujichrome Velvia

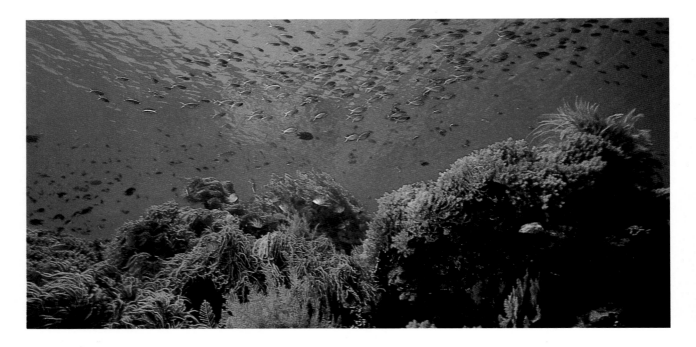

and sometimes attacking living corals. Sponges often come into competition with corals but can grow unchecked in shaded areas where reduced light restricts coral growth. Walls and cave entrances may be covered by thin encrusting sheets of sponges but there is a wide range of other growth forms including hard or rubbery tube and rope sponges, which protrude in clusters from reef walls, and barrel sponges that can be massive enough for a large grouper to shelter inside. More usual occupants of sponges are small nocturnal crustaceans and echinoderms that hide during the day.

The skeletons of large clumps of stony coral can be studded with numerous small invertebrates such as calcareous tube worms and living *Porites* corals are particularly favoured sites. The tubes of the Christmas tree worm *Spirobranchus giganteus*, common on Indo-Pacific and Caribbean reefs, and the Caribbean red fan-worm *Pomatostegus stellatus* are hidden from view, largely embedded in coral. The colourful crown of gills is the only part of the worm that protrudes from the tube and it retracts instantaneously when disturbed. Tube worms do not burrow; the coral grows around the tube instead. Date mussels *Lithophaga* actively burrow in coral boulders and also in branching corals, weakening the structure. More active animals use corals as a home base from which they can forage and return to the security of their chosen spot, often amongst the branches of a staghorn coral or in one of the millions of holes and crevices in the reef. Shoaling reef fishes shelter in the

Tiny basslets Pseudanthias (about 2-4 in. / 6-10 cm in length) may swarm over the corals on shallow reef tops in the Indo-Pacific.

LOCATION : Indonesia:Sulawesi
CAMERA : Nikonos V with 15 mm lens; f8-11; Fujichrome 100

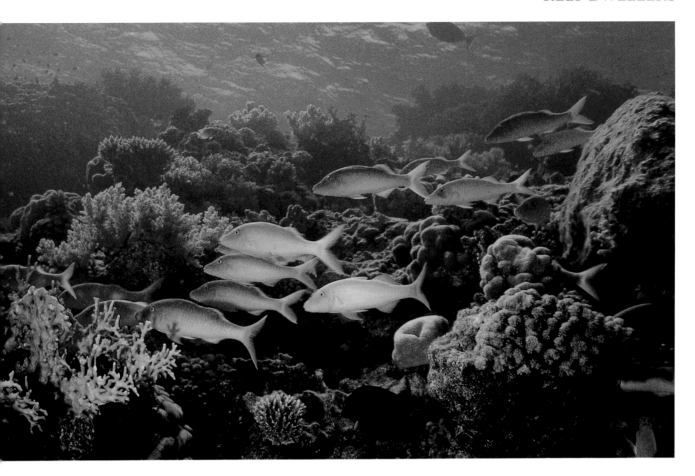

Goatfishes such as the yellowsaddle goatfish, Parupeneus cyclostomus, (up to 20 in. / 50 cm in length) sometimes swim singly but are often seen in shoals on shallow coral reefs or sandy lagoons. They use their chin barbels to detect prey in the sand.

LOCATION : Red Sea: Egypt
CAMERA : Nikonos V with 28 mm lens; f8-11; Fujichrome 100

lee of coral heads, walls and large corals such as the Caribbean elkhorn *Acropora palmata*. Certain groupers and other large fishes such as sweetlips *Plectorhynchus* commonly rest beneath spreading table corals, and at night, branching corals harbour an assortment of sleeping fishes. Cleaning stations, are highly developed on tropical reefs. These are sites where certain shrimps and small specialised fishes set themselves up as cleaners, maintaining the health of fishes which gather at the station and wait to be groomed.

CORAL ATTACKERS AND GRAZERS

A variety of reef dwelling invertebrates and fish attack coral. Boring sponges burrow into the skeleton and can kill the whole colony and the fire-worm *Hermodice carunculata* strips the living coral tissues. Coral feeders in the Indo-Pacific include the puffer *Arothron meleagris*, and the pin-cushion star *Culcita novaeguineae*, which eats juvenile growths of staghorn and certain other stony corals but without serious effect.

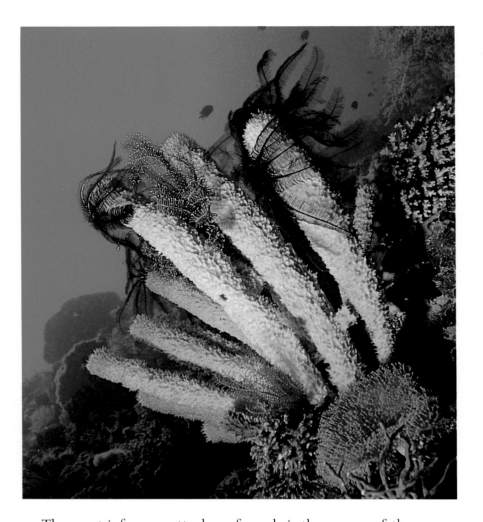

A group of yellow tube sponges, growing on an Indo-Pacific reef slope, provides a prominent surface for several feather stars to perch on.

LOCATION : Indonesia:Flores
CAMERA : Nikonos V with 15 mm lens; f5.6-8; Fujichrome Velvia

The most infamous attacker of corals is the crown-of-thorns starfish *Acanthaster planci*. The crown-of thorns is normally rare but has caused disasters when it occurs in plague proportions, destroying large stretches of reef, which take several decades to recover. Severe environmental disturbances such as the occasional El Niño event can kill certain corals, upsetting the balance of species and allowing the crown-of-thorns access to the fast growing corals that it likes to feed on. The crown-of-thorns eats the living polyps leaving the skeleton intact. The starfish's spiny covering and venom means that it has few enemies though the harlequin shrimp *Hymenocerus picta*, a puffer, and a mollusc, the trumpet triton *Charonia tritonis*, are among those adapted to feed on it. The dominant predator differs from one region to another but between them they keep the crown-of-thorns under control in normal circumstances except in the eastern Pacific.

Parrotfishes are named after their strong beak of fused teeth which they use to extract algae by scraping the coating off dead corals and grinding living corals. The noise they make in

A sponge growing on the coral reef is home to a tiny reef goby less than 1 in. / 25mm in length. Various similar small gobies live on sea whips, soft corals and stony corals.

LOCATION : Papau New Guinea : West New Britain
CAMERA : Nikonos V with 35 mm lens; extension tubes 1:1; f16; Fujichrome Velvia

crunching pieces of coral rock is often heard by divers before they have sighted the fish. Indo-Pacific bumphead parrotfishes *Bolbometapon muricatum* travel over shallow reef tops in shoals, rasping and breaking the coral and defecating trails of sand. Buffalo fishes, as they are sometimes known, grow to a length of three feet or more, and the bulky forms moving noisily by, wreathed in the clouds of sand that they produce, often resemble a stampeding herd.

Other grazing herbivores include some surgeonfishes, damselfishes, blennies and invertebrates such as certain cowries and sea-urchins. The teeth of comb-tooth blennies are adapted for scraping algae from rocks and dead corals. The heavy grazing activity of fishes during the day and of sea-urchins at night is important in cleaning the reef of excessive algae so that fresh surfaces exist for invertebrate larvae to colonise.

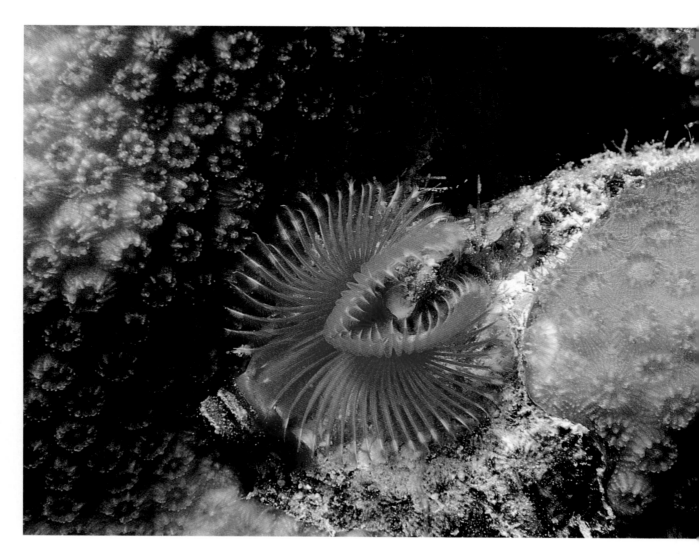

The U-shaped crown of gills of the red fan-worm, *Pomatostegus stellatus*, obscures its calcified tube which is largely embedded in a colony of stony coral. Growth of the tube keeps pace with the coral.

LOCATION : Cayman Islands.
CAMERA : Nikonos III with 35 mm lens; extension tubes 1:2; f16-22; Kodachrome 64

The pin-cushion star, *Culcita novaeguinae*, (diameter up to about 10 in. / 25 cm) is a predator of staghorn and other corals. Adults of this starfish have extremely short arms.

LOCATION : South China Sea: Malaysia
CAMERA : Nikonos with 28 mm lens plus close-up lens; f16-22; Kodachrome 64

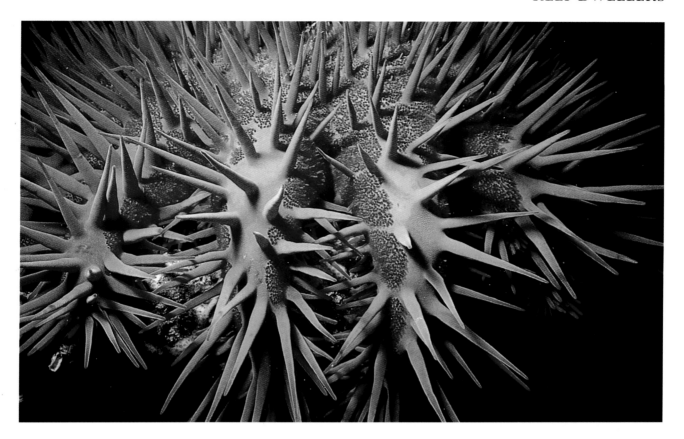

The crown-of-thorns starfish,
Acanthaster planci, (up to 2 ft /
60 cm in diameter) is infamous for
attacking coral reefs by feeding on
the coral polyps. The upper surface
of the starfish is covered with thick
sharp spines up to two inches long,
each coated with a mild toxin
for added protection.

LOCATION : Red Sea: Egypt
CAMERA : Nikonos III with 28 mm lens
plus close-up lens; f16-22;
Kodachrome 64

SOFT CORAL AND SEA-FAN PREDATORS

Other animals live and feed on the soft corals and gorgonians that abound on many reefs. Cowrie-like molluscs such as the flamingo tongue mollusc *Cyphoma gibbosum* and its rarer relative the fingerprint mollusc *Cyphoma signatum*, leave a trail of exposed coral skeleton as they slowly scrape away the surface tissues of Caribbean sea-fans. The shells of both animals are plain cream but are enveloped, when the animal is active, by the brightly patterned mantle. Indo-Pacific molluscs *Phenacovolva* cover their shells with a beautiful red mantle which matches the gorgonian corals they feed on. Soft corals, particularly the grey fleshy lobes of *Sarcophyton*, are commonly preyed on by egg cowries *Ovula*, large white-shelled molluscs with a contrasting, mainly black mantle.

REEF FISHES

Among the multicoloured clouds of fishes that swim above the coral gardens butterflyfishes are particularly eye-catching and are ideally suited to their environment. Their highly compressed

*A strong beak of fused teeth
enables the parrotfish Scarus to
bite and grind the surface of stony
corals, from which it extracts algae.
Scrape marks are sometimes seen
on corals where the fishes have
been feeding. Most parrotfishes
are about 10-20 in. / 25-50 cm
in length.*

LOCATION : Red Sea: Egypt
CAMERA : Nikonos V with 28 mm lens
plus close-up lens; f16-22;
Kodachrome 64

*The highly compressed bodies of
butterflyfishes such as Chaetodon
semilarvatus (up to about 9 in. /
23 cm in length) are well suited for
swimming in and out between the
upright branches of stony corals.
Some species feed on coral polyps
which they pick out delicately with
their small mouths.*

LOCATION : Red Sea: Egypt
CAMERA : Nikonos V with 28 mm lens;
f8-11; Fujichrome 100

bodies enable them to weave in and out between the upright
branches of stony corals with agility and ease. Many species feed
on the tiny worms and crustaceans that hide between coral
branches and some eat coral polyps which they pick out
individually with their small mouth at the end of a long pointed
snout. Angelfishes are shaped like larger versions of butterfly
fishes and graze over reefs eating sponges or algae.
Reef-dwelling fishes include many wrasses, triggerfishes,
squirrelfishes, trunkfishes, groupers and goatfishes amongst
others. Indo-West Pacific reefs are particularly rich in fish life,
more so than those of the Atlantic Ocean. Pair bonding is
common in coral reef fishes and couples tend to set up home in a
particular territory which they defend aggressively. Small
damselfishes such as turquoise pullers *Chromis* and black-and-
white banded humbugs *Dascyllus* hover in shoals or mixed groups
above stands of staghorn and table corals (*Acropora*) on Indo-Pacific
reefs and dive for shelter amongst the stony branches when
predators approach. Each table coral has its own group of tiny
territorial fish swarming over it. Basslets or sea-perches behave
similarly, adopting a section of the reef edge or a coral head. Little

*Indo-Pacific sweetlips, members
of the same family as Caribbean
grunts, use the reef as a place of
shelter during the day.
Oriental sweetlips, Plectorhynchus
orientalis, (up to about 18 in. /
45 cm in length) may be seen
swimming around table corals or
hiding under these spreading
colonies.*

LOCATION : Maldive Is.
CAMERA : Nikonos V with 15 mm lens;
f8; Fujichrome Velvia

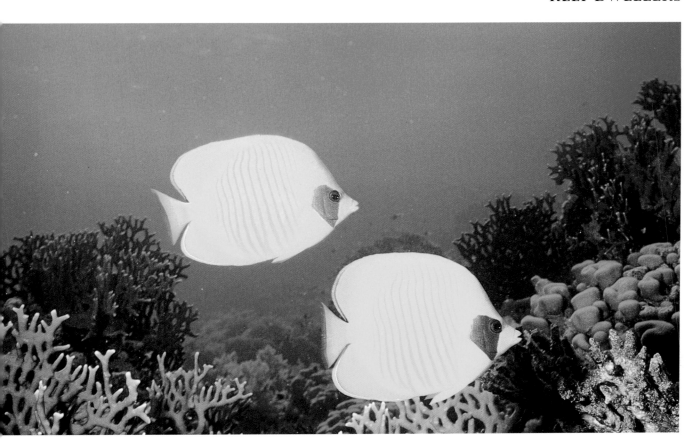

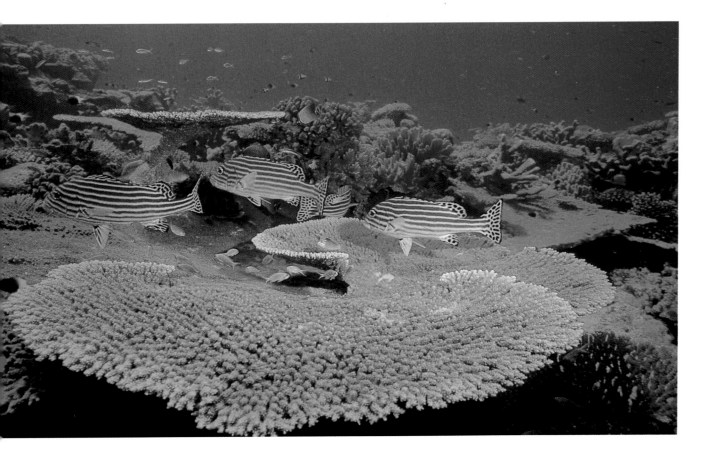

reef gobies, often only one or two inches long, perch on various stony corals and also on sea-whips and soft corals while other fishes such as morays make use of the labyrinths in the reef face. Small holes and abandoned worm tubes in walls, and in corals with boulder-like growth form such as *Porites*, are occupied by tiny blennies like the midas blenny *Ecsenius midas* that perch with their head protruding from the hole, venture out, or retreat deep inside when scared. Shoals of grunts and various snappers hang in the lee of corals. Pelagic fishes are less closely bound to the reef but several groups such as sharks, barracudas, jacks and silversides include members that patrol the reef edge.

CORAL CRABS AND SHRIMPS

A wide range of crabs can be seen on coral reefs, particularly at night since many hide during the day. Large brightly coloured coral crabs Xanthidae, such as *Carpilius* and the poisonous splendid

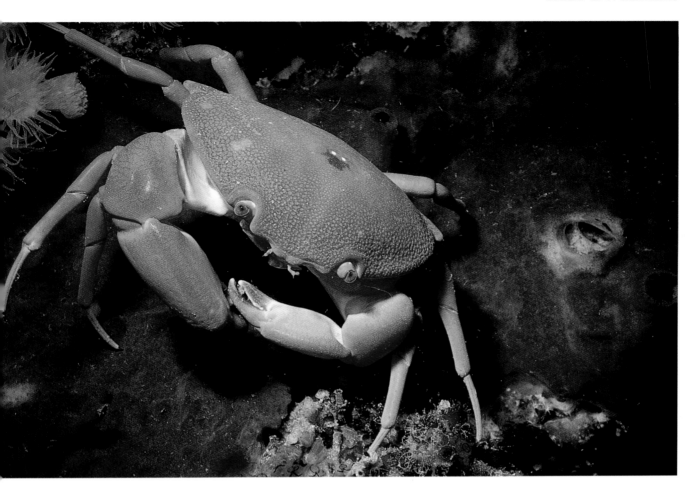

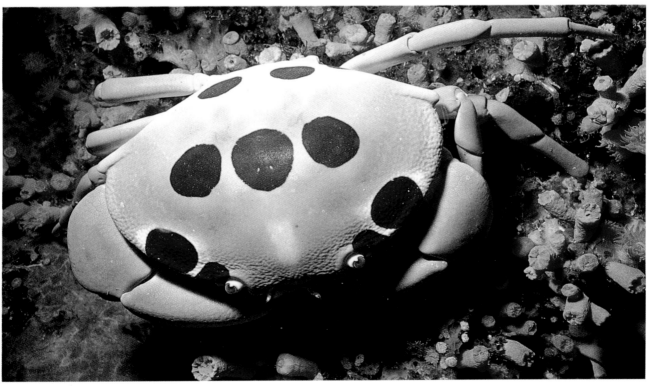

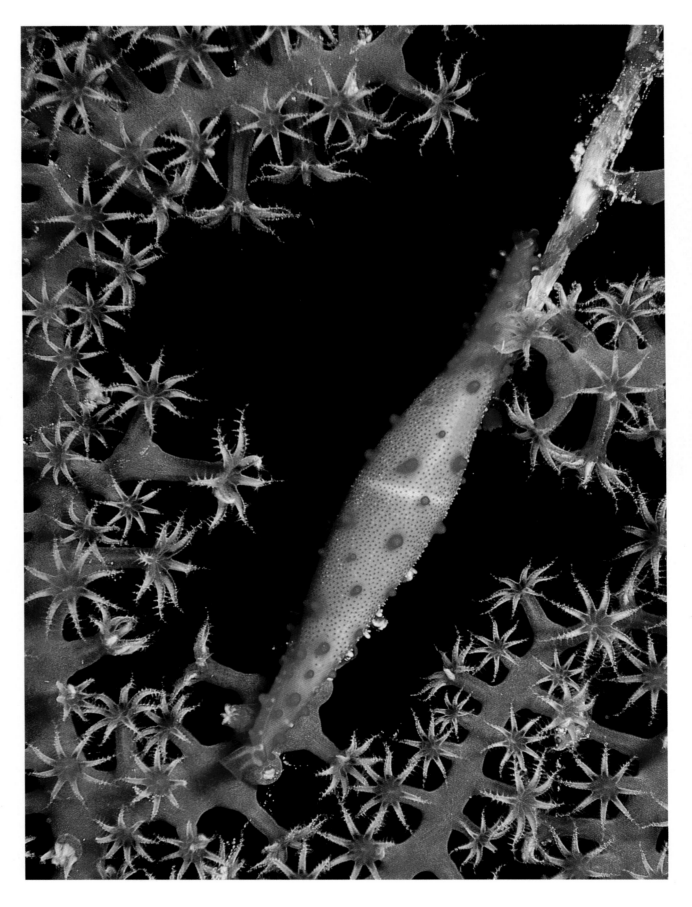

The flamingo tongue, Cyphoma gibbosum, is a small mollusc, up to 1 in. / 3 cm long, living and feeding on Caribbean gorgonians, leaving a trail of exposed coral skeleton as it eats away the surface. The shell is plain cream; the distinctive pattern of spots is on the mantle, a membrane spread over the outside of the shell but rapidly withdrawn into the shell if the animal is disturbed.

LOCATION : Cayman Islands.
CAMERA : Nikonos III with 35 mm lens; extension tubes 1:2; f16-22; Kodachrome 64

A perfect colour match for its host, the ovulid mollusc Phenacovolva rosea (up to 1.5 in. / 4 cm in length) and some of its relatives feed on gorgonian sea-fans in the Indo-Pacific.

LOCATION : Sabah: Sipadan
CAMERA : Nikonos V with 35 mm lens; extension tubes 1:2; f16-22; Kodachrome 64

reef crab *Etisus splendidus*, may be conspicuous in the Indo-Pacific. *Xanthid* coral crabs occur also in the Caribbean but tend to be more timid than certain spider crabs on those reefs. The king crab *Mithrax spinosissimus*, a huge spider crab, is an impressive sight on Caribbean reefs, although it is not so common where it has been hunted for food. Small members of the coral crab and spider crab families are less obvious and, like shrimps, many are commensals living on certain kinds of stony corals, soft corals or gorgonian sea-fans where they may match their host's colours; decorator crabs even attach bits of the coral, that they live on, to themselves for added camouflage. A rich reef may have well over one hundred species of shrimps. Many live in close contact with corals or with other reef-dwelling animals such as sea anemones and echinoderms, and they are often associated with a particular host. *Periclimenes* shrimps include numerous small species, often transparent with white lines and blotches or coloured similarly to their host, that specialise in such associations (see Chapter 9).

Large sea anemones, often with colourful column or tentacles, are hosts to fishes in addition to shrimps. Clownfishes and anemonefishes are associated with Indo-Pacific anemones and small blennies can be found in the beautiful Caribbean giant anemone *Condylactis gigantea*.

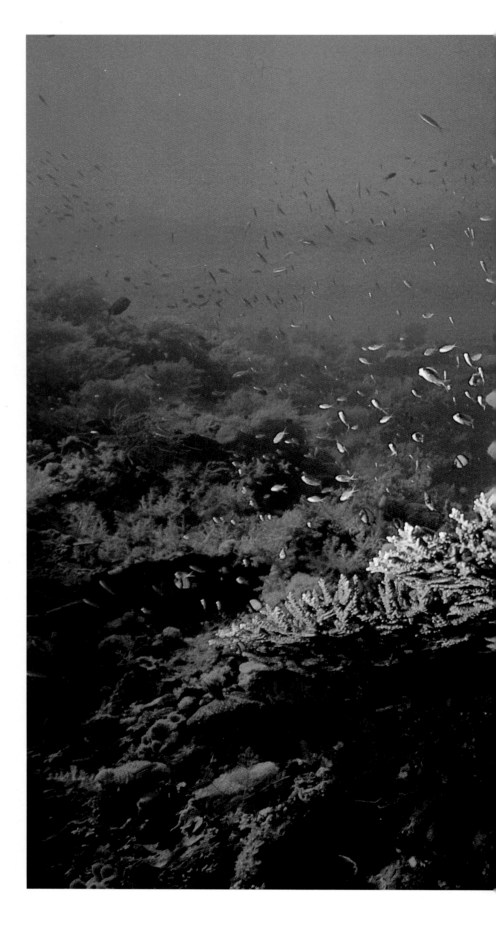

The small fishes seen hovering
above the large table coral here are
damselfishes (head-band humbugs,
Dascyllus reticulatus, and
turquoise coloured pullers,
Chromis), and basslets,
Pseudanthias. They may appear
unconcerned but they are
constantly wary and, when
approached too closely, dart into
the coral's network of branches.

LOCATION : Indonesia: Flores
CAMERA : Nikonos V with 15 mm lens;
f8; Fujichrome Velvia

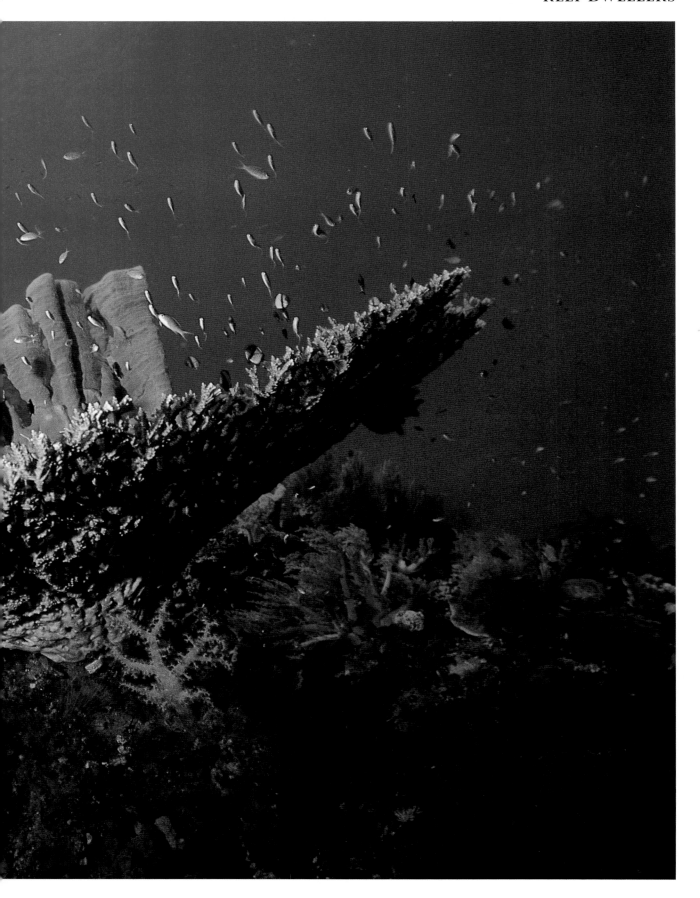

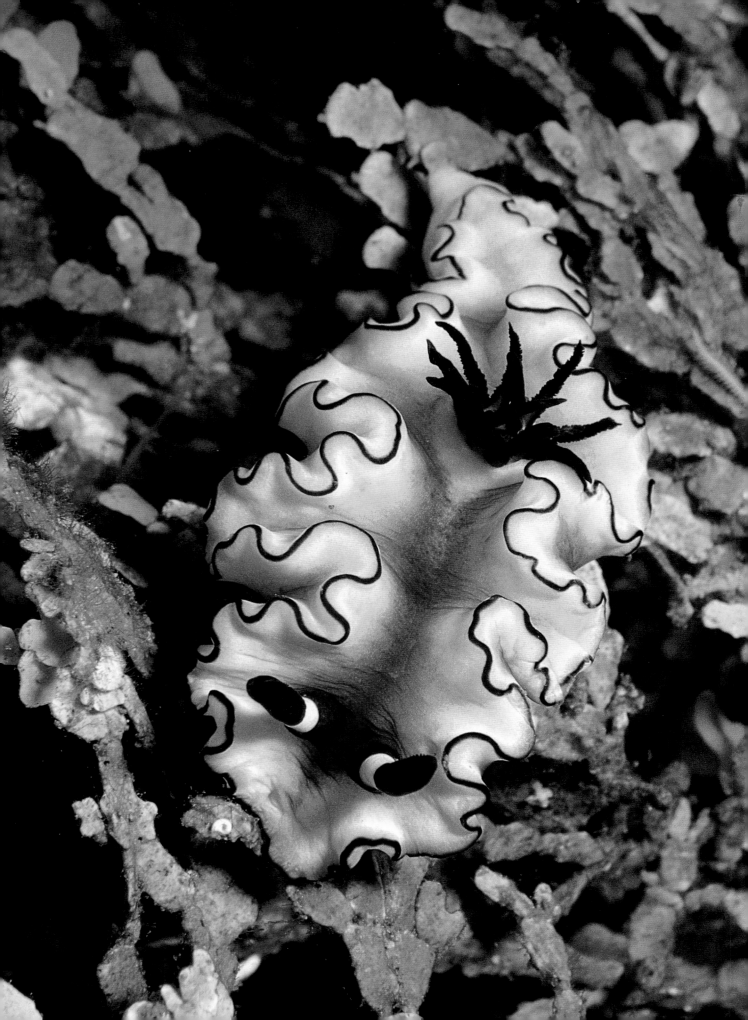

Crawling & Swimming

Swimming might seem to be the ideal means of moving about in the sea yet many invertebrates prefer to keep their feet on the ground rather than take a chance against currents and wave action. Several major groups, sponges, sea anemones, corals, tube-dwelling worms and most sea-squirts, lead a largely sedentary existence anchored to the sea bed but other animals lead more active lives using a wide range of modified limbs and other structures for locomotion.

PADDLING

Active worms such as ragworms and cosmotropical fire-worms have a row of short fleshy appendages (parapods) ending in bristles down each side of their bodies, one pair of appendages per segment. The worm undulates its body and uses the parapods as paddles whether walking or swimming, though it spends much of its time at rest.

WALKING AND JUMPING

Crabs, lobsters and shrimps have well-adapted jointed walking limbs enabling them to scamper over rock or sand and are known as decapods, having five pairs of thoracic walking legs. A crab's broad shape lends itself to the familiar sideways motion; other decapods walk forwards or sideways and certain spiny lobsters make mass migrations marching head to tail. Many have a much faster means of movement when danger threatens: in crawfish and other spiny lobsters, and shrimps also, the strongly muscled abdomen ending in a broad tail fan can be flexed sharply to propel the animal rapidly backwards. A springing shrimp can disappear

The sea-slug Casella atromarginata is creeping slowly over algae on a reef in Flores, Indonesia.

CAMERA : Nikonos V with 35 mm lens; extension tubes 1:2; f16-22; Fujichrome Velvia

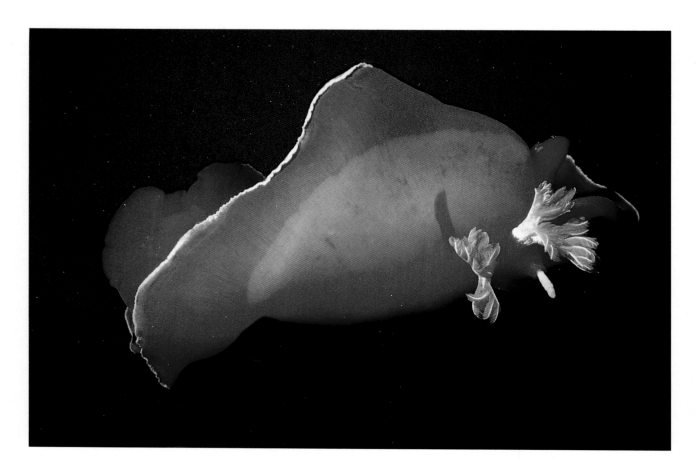

from view in this manner and end up some distance away.
Some groups of small crustaceans can swim using their thoracic or
abdominal limbs and the latter are well developed swimming
structures in shrimps and prawns but swimming is rare amongst
their more heavily built relatives. In a few crabs, the swimming
crabs, the last pair of legs are flattened to form paddles but even
so they are poor swimmers.

CREEPING

Whelks, cowries, sea-slugs, and other gastropod molluscs creep
across the sea bed by movements of the large muscular foot in
similar fashion to their land counterparts, snails and slugs. A few
sea-slugs and others with reduced shells are capable also of
swimming by various means to escape from predators or for other
purposes. On Indo-Pacific reefs the sea-slug *Hexabranchus*, aptly
named the Spanish dancer, contorts its body and swirls its mantle
in flamenco style. Another sea-slug, the hooded nudibranch off
the Pacific coast of North America, swims by twisting its head and
tail first to one side then to the other. A few western European

*Sea-slugs usually crawl over the sea
bed but the large Spanish dancer,
Hexabranchus sanguineus,
(up to 6 in./ 15 cm in length)
swims on occasions.
The brightly-coloured sea-slug is
seen here twisting its body and
mantle in swimming action.*

*LOCATION : Red Sea: Egypt
CAMERA : Nikonos II with 28 mm lens
plus close-up lens; f22; Kodachrome 64*

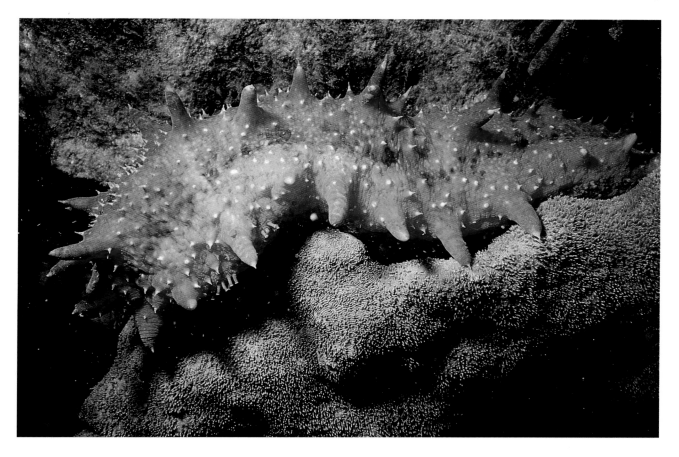

Most sea-cucumbers, such as this large individual (about 18 in. / 45 cm in length), have locomotory tube feet on their lower surface. In addition, waves of muscular contractions of the body may aid movement in certain sea-cucumbers, giving them the appearance of a giant caterpillar.

LOCATION : Galapagos Is.
CAMERA : Nikonos with 28 mm lens plus close-up lens; f16-22; Kodachrome 64

species of sea-hares swim smoothly by flapping the parapodial lobes which are broadly expanded edges of the foot.

Bivalved molluscs are generally sedentary and many burrow or attach themselves to solid objects but a few can swim for short distances despite the encumbrance of their shells. File shells flap their mantle fringe of long tentacles while the queen scallop leaps from the sea bed and swims energetically away from predators by opening and closing its shell valves, looking like an animated set of false teeth.

ACTIVE SQUIDS

The most active molluscs, octopuses, squids and cuttlefishes, are highly complex and intelligent hunters capable of rapid movement. Squids are the fastest in general and are streamlined for swimming, often shoaling in open water. The normal swimming mode is backwards; the squid's mantle forms a pair of fins which undulate for slow movement and the tentacles are used as a rudder. When speed is important the squid forces a stream of water out of a funnel in its body and is jet-propelled forwards to

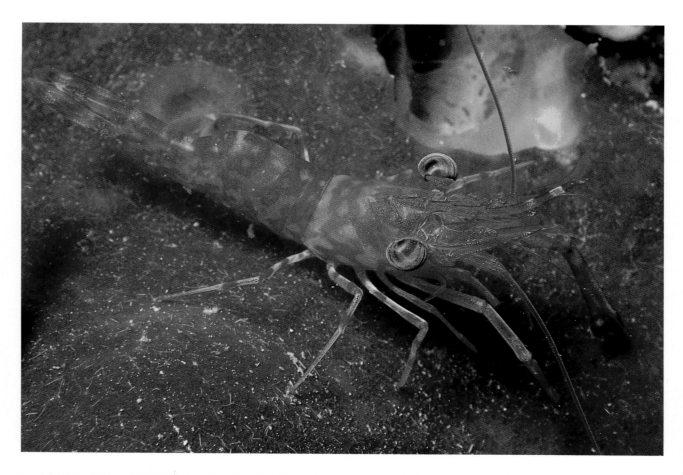

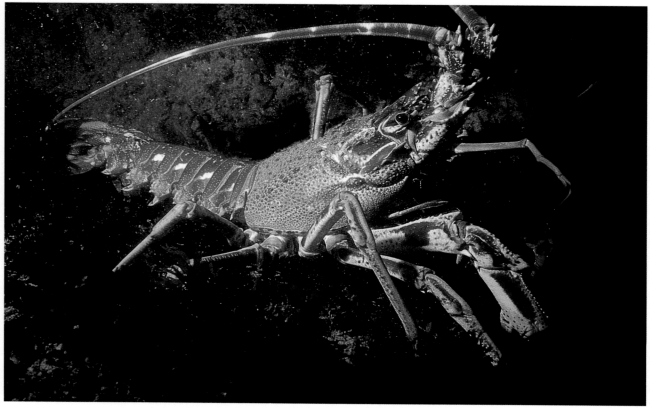

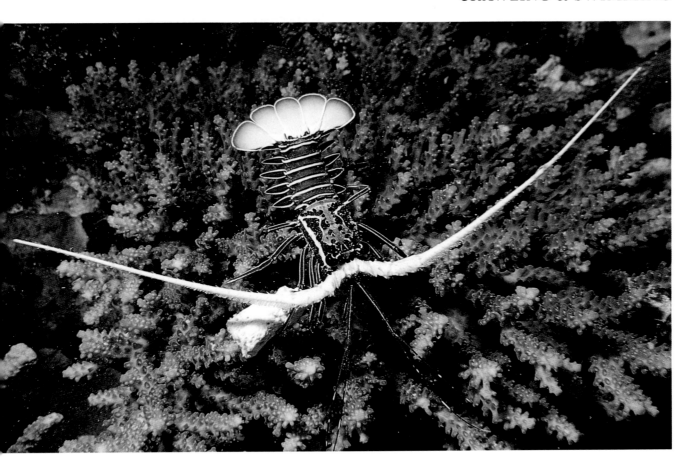

catch prey or backwards to escape from danger depending on which way the tip of the funnel is directed. Cuttlefishes tend to swim more slowly than squids, and octopuses usually crawl over the sea bed, but both can also move by jet propulsion. A few cephalopods are giants and squids of over 50 feet/ 15 metres in length have occasionally been recorded. Although they are rarely dangerous, the tentacles of a large octopus have remarkably strong suction power.

TUBE FEET

Starfishes and other echinoderms move by means of a unique mechanism, the water vascular system in which hundreds of delicate tube feet are moved by means of hydraulic pressure. Water is taken in through the sieve plate on the upper surface and channelled to the hollow elastic tube feet which are alternately expanded and contracted causing the animal to move, though very slowly and laboriously. Tube feet often end in suckers to grip the hard rock or reef surfaces where starfishes and their relatives

commonly live. In starfishes the tube feet are arranged in rows in
a groove on the underside of each arm but tube feet are not
confined to the lower surface in all echinoderms and are used for
feeding as well as for locomotion by many. Brittle-stars look like
very slender starfishes but are much more active and crawl by
wriggling their five narrow arms; densely writhing communities
exist on some temperate sea beds.

Tube feet are not always used for walking and some
echinoderms use other means of movement. Feather-stars or
crinoids trap food with their tube feet and crawl using their arms.
Many tropical species hide away during the day and pick their way
slowly across the reef at dusk. Feather-stars start life on a stalk
but break off to swim by waving their many flexible feather-like
arms until reaching a suitable place in which to settle as adults.
Some such as the common British and North Atlantic feather-star
Antedon bifida retain the ability to swim throughout adult life,
although it does this rarely, preferring to cling to the rock surface
by its cirri, a cluster of small jointed appendages.

*Undulations of the mantle, which
extends as a fin along each side of
the body, enable the cuttlefish
Sepia officinalis (up to 1 ft /
30 cm in length) to swim.*

*LOCATION : Great Britain: England
CAMERA : Nikonos II with 28 mm lens
plus close-up lens; f16-22;
Fujichrome 50*

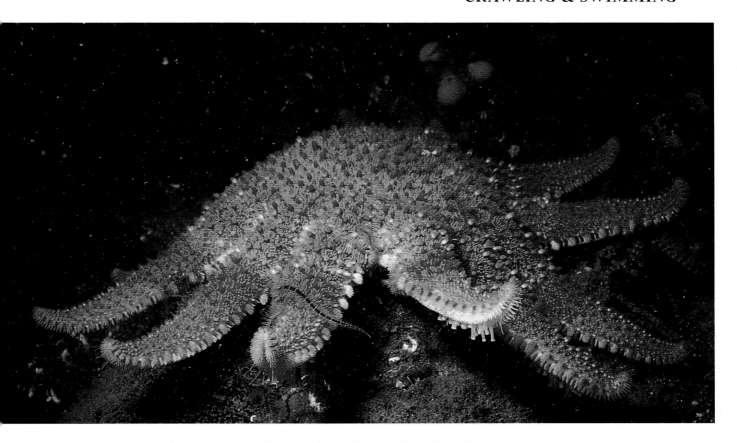

Starfishes move by means of tube
feet on the underside of their arms.
The sunstar Crossaster papposus
(up to about 1 ft / 30 cm in
diameter) has 8-13 arms
instead of the 5 arms typical
of most starfishes.

LOCATION : Great Britain: Scotland
CAMERA : Nikonos III with 28 mm lens
plus close-up lens; f16-22;
Kodachrome 64

STREAMLINED FOR SPEED

The majority of fishes are streamlined for fast swimming, prime exponents including tuna, some of which can probably exceed 40 miles per hour, and mackerel; both groups make seasonal migrations of up to hundreds of miles. Scombrid fishes (tuna and mackerel) have a pointed head and well developed, powerful tail-fin among other adaptations for speed and stamina and most have a body temperature higher than that of the ambient water. Body shape and behaviour determine the swimming style. Jacks and mackerel and similar fishes are propelled mainly by the tail and steer with the fins. Many fishes swim in shoals; for small species this is often a defensive measure but for larger fishes such as barracuda and jacks the behaviour is more likely to be for social reasons and (in the case of jacks) for predation. Schooling may also have hydrodynamic advantages. Whatever the reason, gatherings of several hundred large fishes can be seen streaming or circling at a favoured site day after day.

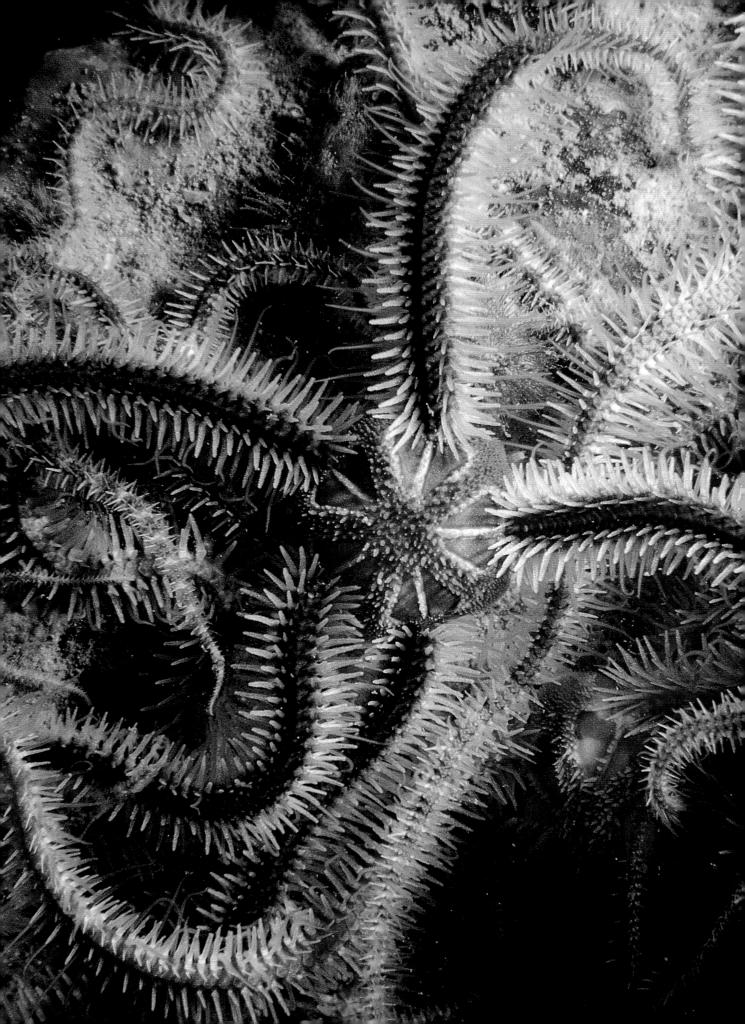

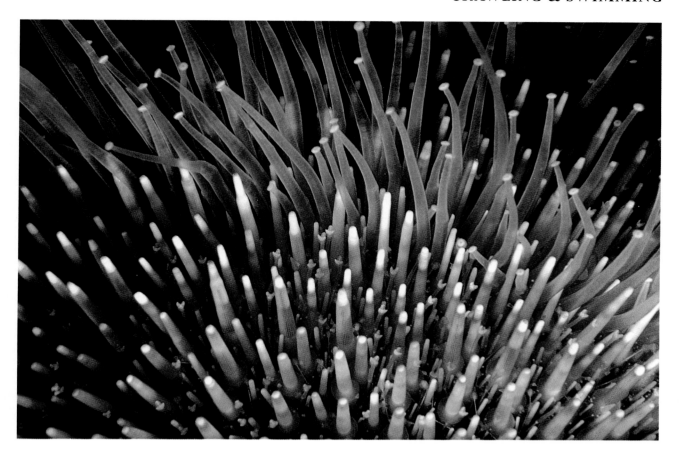

Numerous long slender tube feet protrude amongst the spines of the edible sea-urchin, Echinus esculentus, (up to about 8 in. / 20 cm in diameter). Sea-urchins have movable spines that assist the tube feet in the animal's locomotion.

*LOCATION : Great Britain: England
CAMERA : Nikonos II with 35 mm lens; extension tubes 1:2; f22; Ektachrome 64*

Brittle-stars are more active than other echinoderms. Some species are gregarious; the common European brittle-star Ophiothrix fragilis (length of arms usually 2-3 in. / 5-8 cm) may gather in large numbers, covering sizable areas of the sea bed.

*LOCATION : Great Britain: Wales
CAMERA : Nikonos III with 35 mm lens; extension tubes 1:2; f16-22; Kodachrome 64*

SLOW SWIMMERS

Slow-swimming fishes, particularly those with rigidly encased bodies such as trunkfishes and boxfishes, propel themselves mainly by beating the pectoral fins and sculling with the dorsal and anal fins, using the tail predominantly for steering although it can be used to give bursts of faster movement. The armoured plates reduce mobility by preventing bending of the body. Trumpetfishes of tropical waters also swim by dorsal and anal fin movements with little use of the body or tail unless they need to move fast. Seahorses and some pipefishes have lost the tail fin altogether and seahorses use their tails for clinging onto weed stems instead of for swimming.

UNDULATING AND GLIDING

Various long bodied fishes such as eels and sharks generally swim by waggling the body from side to side in a wave-like motion. Sharks are propelled largely by the tail action and many fast active swimmers can make a dash towards their prey by sole use of the

tail with the body held rigid instead of undulating. Although rough to the touch, the alignment of tiny denticles or grooved tooth-like scales covering the shark's skin helps to increase speed by reducing water resistance.

Flatfishes and rays, though unrelated, share a flattened shape which serves a dual purpose, blending with the sea bed where they rest for much of the time and enabling them to glide through the water when they swim.

Flatfishes swim by rippling their fins in a wave-like motion and stingrays swim in similar style by undulating their pectoral fins for normal slow movement but flap these wing-like fins when fast movement is required. The largest rays move gracefully and powerfully solely by flapping their large fins. Eagle rays, with a wingspan of three or four feet/ one metre, can leap right out of the water and manta rays, up to 20 feet/ six metres or more across, can leap partly out. Eagle rays have been observed giving birth in this unusual manner, releasing the young into the air one by one!

Smaller fishes are often seen to leap clear of the water when

The trumpetfish Aulostomus maculatus (usually about 1.5-2.5 ft/46-76 cm in length) hovers around branching gorgonian corals on the reef top. It normally drifts or swims slowly, with the body rigid, using its dorsal and anal fins.

LOCATION : Cuba
CAMERA : Nikonos III with 28 mm lens; f8-11; Kodachrome 64

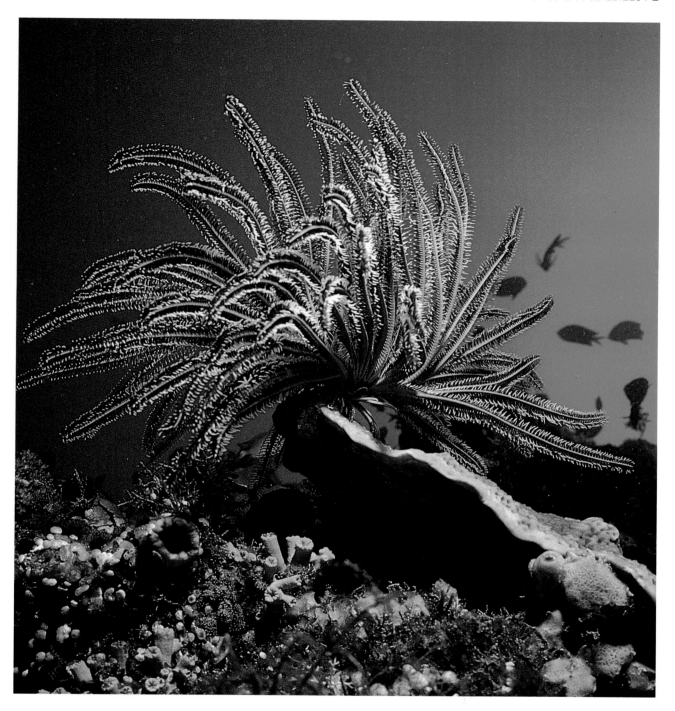

*Feather-stars (often about 6 in. /
15 cm in height) are inactive for
much of the time but when they
wish to take up a new position on
the reef they pull themselves along,
mainly by their numerous arms.*

*LOCATION : Indonesia:Sulawesi
CAMERA : Nikonos with 28 mm lens;
f8-11; Kodachrome 64*

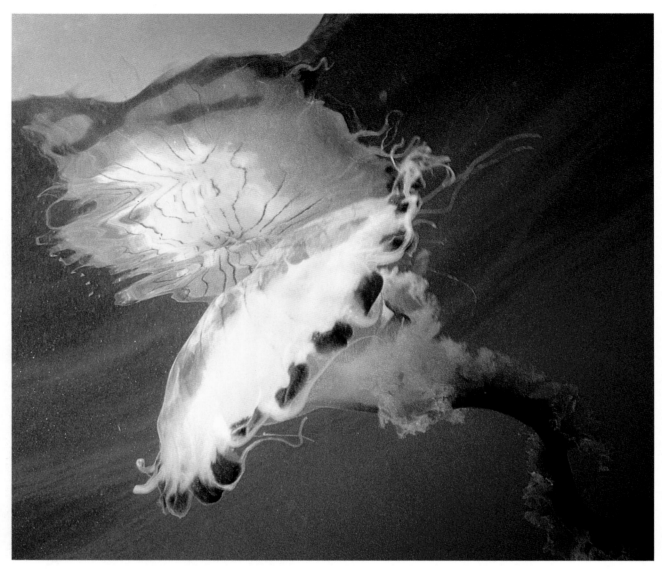

chased by predators and the sea may appear to 'boil' when a shoal is under attack at the surface. Flying fishes fool predators by covering a good distance above the water before dropping back into the sea. They propel themselves clear of the water using wing-like pectoral fins, and in some cases pelvic fins, to plane close to the surface; the lower fork of the caudal fin may give a final thrust before take-off in calm conditions. Needle fishes and halfbeaks are also able to leap out of the sea, and skim the water's surface with their lower tail lobe.

AGILITY AND POWER

Sea mammals, the cetaceans, are agile and graceful swimmers of great power. Whales and dolphins in particular are

The compass jellyfish, Chrysaora hysoscella, rises slowly to the surface by means of the pulsating action of its bell (up to about 10 in. / 25 cm across). As it swims, sense organs around the edge of the bell enable the jellyfish to detect whether it is upright or not.

*LOCATION : Great Britain: England
CAMERA : Nikonos III with 15 mm lens;
f11-16; Agfachrome 100*

The beating action of minute cilia on the combs of this ctenophore moves the delicate animal slowly through the water. Many comb jellies (ctenophores) are no larger than a gooseberry but the animal here is about 0.5 in./ 14 cm in length.

LOCATION : *Red Sea: Egypt*
CAMERA : *Nikonos V with 28 mm lens plus close-up lens; Kodachrome 64*

torpedo-shaped and streamlined like fishes, with hind limbs lost and forelimbs reduced to flippers which control steering and balance while the paddle-shaped tail fluke propels with an up and down motion. Loss of body hair, external ear lobes and other projecting parts has produced a smooth outline to lessen water resistance but dolphins sometimes gain extra speed by leaping clear of the water, reducing drag even more. Pacific white-sided dolphins, in the North Pacific, are among the most acrobatic and fast swimming cetaceans and can reach speeds of 20 knots.

DRIFTING PLANKTON

Planktonic animals may be borne along largely at the mercy of water currents but they can also swim by various means. The bell

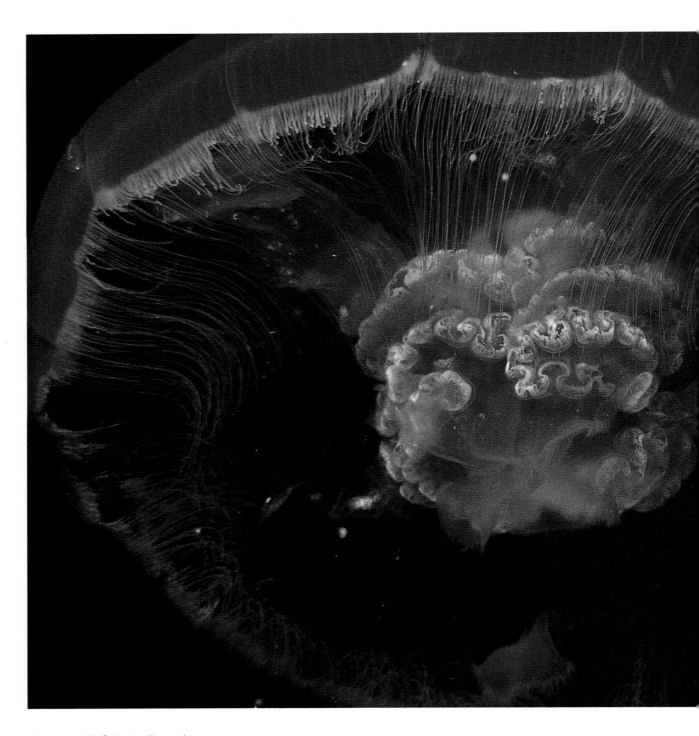

The moon jellyfish, Aurelia aurita,
(up to about 10 in. / 25 cm in
diameter) is sometimes seen in
large aggregations, drifting or
swimming slowly, near the surface
of temperate seas and the tropical
waters of the Indo-Pacific.

LOCATION : Red Sea: Egypt
CAMERA : Nikonos II with 35mm lens
plus close-up lens; f22; Kodachrome 64

of jellyfish pulsates in a slow swimming motion as its muscles alternately contract and relax. Most comb jellies are planktonic, including the sea-gooseberry of temperate waters and various delicate transparent species which feed on minute prey near the surface. They swim by beating tiny cilia arranged in eight rows of combs along the body; each comb beats in turn sending a pulse of iridescent colour down the row and some produce luminescence at night. Salps are gelatinous sac-like animals which drift singly or in chains, unlike their sedentary relatives the sea-squirts. Both feed and respire from the currents of water drawn through their inhalant siphons and expelled through exhalant siphons, and salps, with siphons at opposite ends of the body, derive a swimming action from the flow of water. Larval stages of many sedentary animals including corals and hydroids and those that crawl on the sea bed such as crabs, molluscs, echinoderms and polychaete worms are planktonic. Around coral reefs swarms of minute planktonic crustaceans such as copepods tend to migrate downwards to darker regions during the day and move upwards again at dusk.

BUOYANCY

Buoyancy aids of marine animals are as varied as swimming methods. Most bony fish have a gas filled swim bladder but sharks and their relatives lack this and have other adaptions to give some buoyancy: their skeleton of cartilage is less dense than bone and many sharks have large oily livers. Some swimming or open water dwelling invertebrates, particularly cephalopods, have buoyancy organs; the rare *Nautilus* has a shell partitioned into many gas filled chambers and cuttlefishes have a gas and fluid-filled cuttlebone. Most squids are not neutrally buoyant but cranchiids (deep-sea squids) have a body cavity filled with low density fluid.

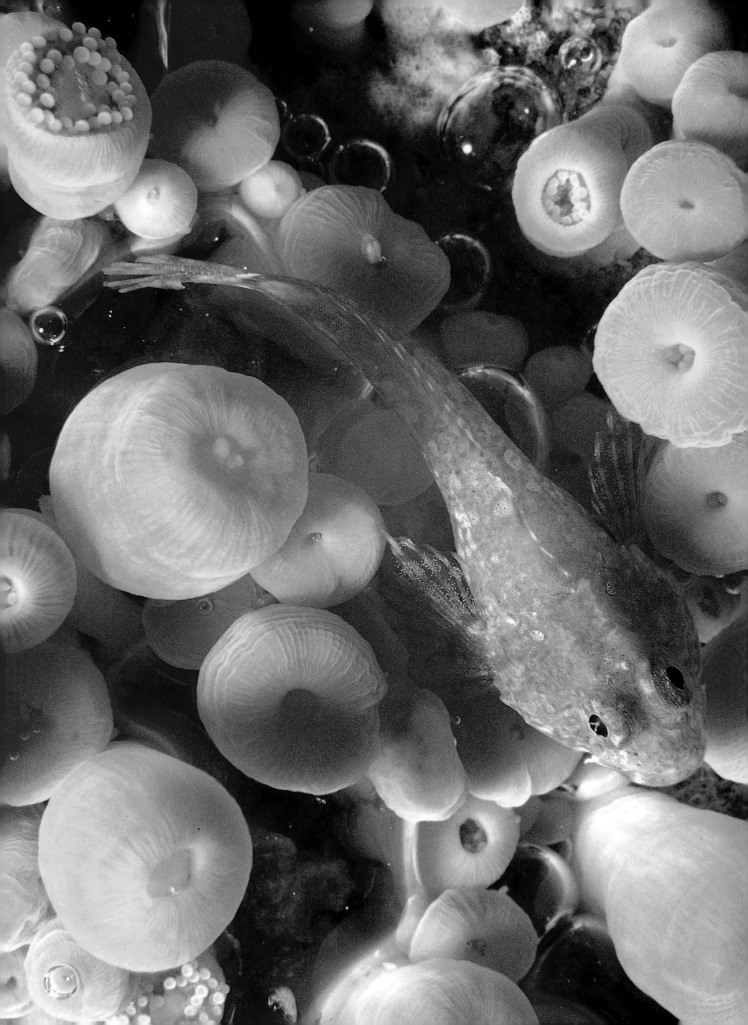

Colour Codes

From my first venture underwater I was enthralled by the colourful array of marine life, perhaps unsurprisingly since this was in the Red Sea, famed for its wealth of red *Dendronephthya* soft corals. Contrary to expectations, when I followed on to dive in British waters, and in even colder Canadian waters, I discovered a rich assortment of brightly coloured animals there too. There is a tremendous range in colour and pattern of animals in all tropical and temperate seas, with vivid examples in nearly every major group, including sponges, sea anemones, worms, crustaceans, molluscs, echinoderms and fishes. The colours of most invertebrates are due to pigments. Many fishes are also pigmented but structural colours give rise to the iridescence of others. In the rainbow runner *Elagatis bipinnulata*, these produce a shimmering effect by reflection, refraction and interference patterns. The majority of species have a characteristic colour pattern but some have several varieties and some individuals change colour in various circumstances. The significance of certain colour patterns is understood but the underlying reasons for other hues remain a mystery.

The numerous colour varieties of jewel anemones *Corynactis* are an attractive sight in temperate waters. These anemones divide asexually to cover rock faces in a patch of one variety next to a patch of another colour. On tropical reefs the widespread Christmas tree worm *Spirobranchus giganteus* is notable for the diversity of its brightly hued gills.

The flamboyant colours and patterns of many fishes and other animals might seem foolhardy when predators abound, so why is there such a vivid array in the sea? Some find safety in the camouflage of drab colours but for others the benefits of being colourful outweigh the risks. Colour and pattern are used to make a statement in a variety of social interactions, both between different species, to attract potential prey or to warn away predators, and within species for sexual or territorial displays.

Beneath the surface in temperate seas, the sheer, grey cliffs of St Kilda are transformed by colour. Here, a small sea scorpion Taurulus bubalis, about 2 in. / 5 cm in length, shelters in a bed of jewel anemones, Corynactis viridis.

*LOCATION : Great Britain: Scotland
CAMERA : Nikonos III with 35 mm lens; extension tubes 1:2; f16-22; Kodachrome 64*

WARNING COLORATION

Most animals prefer to avoid conflict even if they are well armed but deterrents are effective only if adversaries are aware of them. Bright colours can serve to advertise dangerous parts of the body such as sharp spines and are common in spiny echinoderms like the gulf star *Oreaster occidentalis* of the Galapagos Is. Surgeonfishes have a bony plate on either side at the base of the tail and unicornfishes have two or three pairs of these scalpel-like blades which may be used to slash any fish encroaching the territory. These small blades are often highlighted with a ring of colour to warn other fishes to keep their distance. Eye-catching colours or patterns all over an animal usually indicate that it is venomous or poisonous. Such colour patterns are soon learnt by predators that have tested and spat out distasteful prey and other members of the species will then be left alone.

Colourful sponges are generally poisonous and are avoided by most animals though some sea-slugs (nudibranchs) and others are adapted to feed on them. Brilliant yellow, orange, red, and magenta sponges commonly encrust rock faces beneath overhangs and a few other species even contain fluorescent pigments, which may explain why the Caribbean yellow tube sponge *Aplysina fistularis* appears vivid even at depth. Another equally beautiful Caribbean species, the azure vase sponge *Callyspongia plicifera*, has pink walls overlaid with a fine mesh of fluorescent blue.

A few basic types of pattern that are particularly striking, such as contrasting stripes or spots in yellow or orange and black, are classic warning signals that communicate the same message throughout the animal kingdom. Nudibranchs (sea-slugs) as a group are noted for the vivid colours that many possess, and the majority of sea-slugs are distasteful since they store noxious chemicals from the animals that they feed on. Yellow and black in the stripes of the pyjama nudibranch *Chromodoris quadricolor* and some phyllid sea-slugs on Indo-Pacific reefs appear to be obvious warning colours though questions remain about the significance of colour in cryptically marked members of this group which are distasteful also. The vertical stripes of lionfishes (*Pterois*) and the horizontal stripes of the goldstriped soapfish *Grammistes sexlineatus* advertise the toxic nature of these Indo-Pacific fishes: lionfishes are armed with venomous spines and soapfishes are named from their slimy covering of bitter tasting mucus.

Tropical reefs are noted for the bright colours of many animals that live in these diverse communities. Soft corals Dendronephthya, in shades of red, orange and pink, and gorgonian sea-fans, in a variety of colours, are common on many Indo-Pacific reefs.

LOCATION : Red Sea : Egypt
CAMERA : Nikonos V with 15 mm lens; f5.6-8; Fujichrome Velvia

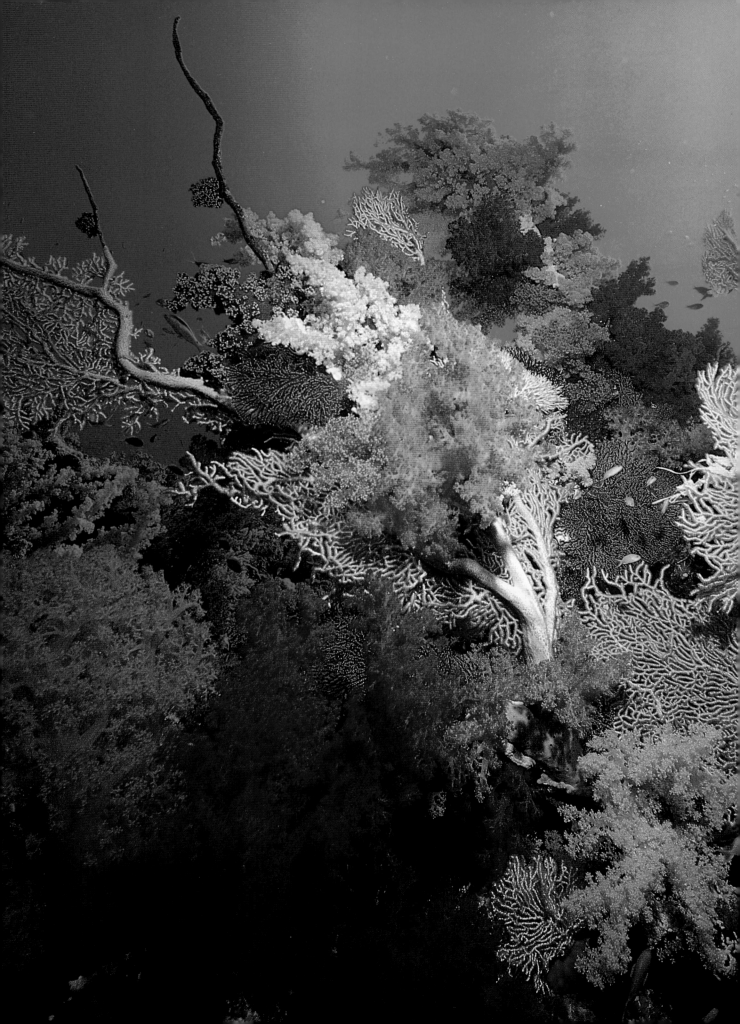

MIMICRY

Certain palatable animals mimic the colours of dangerous species but only a few can benefit from this pretence or the system would break down. Few instances of this (known as Batesian mimicry) have been seen in fishes though several of these associations involve blennies. In one such mimicry complex three tiny Red Sea blennies: the model, a sabretooth blenny *Meiacanthus nigrolineatus* armed with venomous fangs, mimicked best by the mimic blenny *Ecsenius gravieri* and less successfully by *Plagiotremus townsendi*. The mimic blenny is a close colour match for the model, showing a similar variation across its geographic range, and behaves similarly. Unusually for a Batesian mimic the mimic blenny is about as abundant as its model. Another mimic blenny *Aspidontus taeniatus* mimics the cleaner wrasse in the Indo-Pacific and the Midas blenny *Ecsenius midas* also in the Indo-Pacific is reputed to mimic the small shoaling basslet *Pseudanthias squamipinnis*.

Shimmering pale blue highlights on the ridges of the sculptured surface of the azure vase sponge, Callyspongia plicifera, are due to fluorescence. This sponge may grow to a height of about 16 in. / 40 cm.
LOCATION : *Cayman Islands.*
CAMERA : *Nikonos V with 35 mm lens; extension tubes 1:2; f16-22; Kodachrome 25*

Opposite Above : Tiny bead-like tips of the tentacles contrast with the general colour of the jewel anemone, Corynactis viridis, (diameter up to about 1 in. / 3 cm with tentacles extended).
LOCATION : *Great Britain: Scotland*
CAMERA : *Nikonos V with 35 mm lens; extension tubes 1:2; f16-22; Kodachrome 64*

Opposite Below : Another colour variety of jewel anemone.
LOCATION : *Great Britain: England*
CAMERA : *Nikonos V with 35 mm lens; extension tubes 1:2; f16-22; Ektachrome 64*

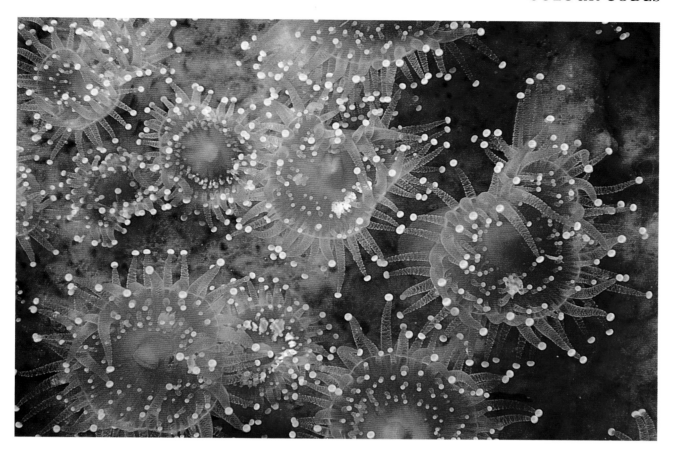

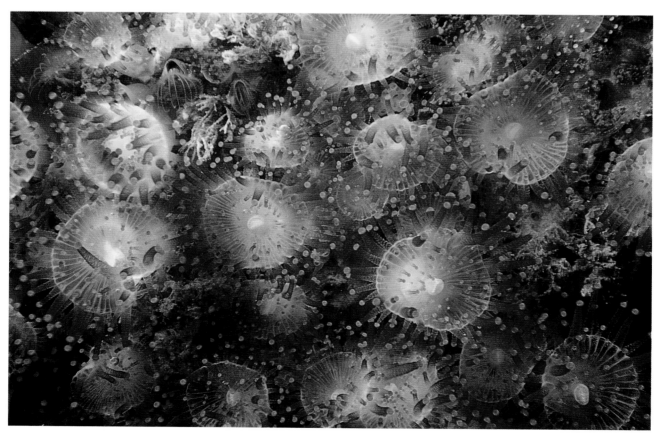

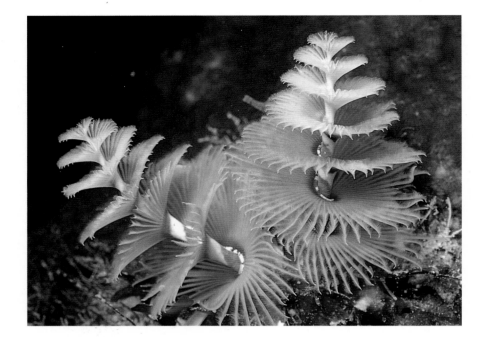

The Christmas tree worm,
Spirobranchus giganteus,
(1.5 in. / 4 cm in height),
a common tube worm in the
Indo-Pacific Ocean and Caribbean,
has many colour varieties including
red, yellow and blue. The tentacles
(gills) of some individuals
are multi-coloured.

LOCATION : Cuba
CAMERA : Nikonos V with 35 mm lens;
extension tubes 1:2; f16;
Fujichrome Velvia

COLOURFUL LURES

Colour patterns of predators may help them to attract prey. Many
sea anemones have conspicuously coloured tentacles, often with
slightly swollen tips in a contrasting colour, and tiny fishes are
lured to their death when they mistake these for morsels of food
suspended in the water. More often the key factor in an animal's
colouration is the avoidance of predation.

MISLEADING PATTERNS

If an animal runs the risk of being seen and attacked by a predator,
vulnerable and vital parts, particularly the head and eyes, need to
be safeguarded. Patterns can help in two ways, either by hiding
the eyes or by deflecting attention to another, less important area
of the body. A dark stripe running through the eye, from the top
of the head towards the underside, is common in a variety of
tropical reef fishes including butterflyfishes, the Picasso triggerfish
Rhinecanthus assasi and batfishes or spadefishes. Various other fishes
such as the slow-moving masked puffer Arothron diadematus have a
horizontal eye-stripe. Eye-spots on different parts of the body,
such as on the dorsal fin of the two-eyed lionfish Dendrochirus
biocellatus, may distract, confuse or startle a predator. Several
species of butterflyfish have a conspicuous black spot towards the
hind end of body or dorsal fin, possibly for social reasons but
perhaps also as a false eye to save the head from attack. Some of

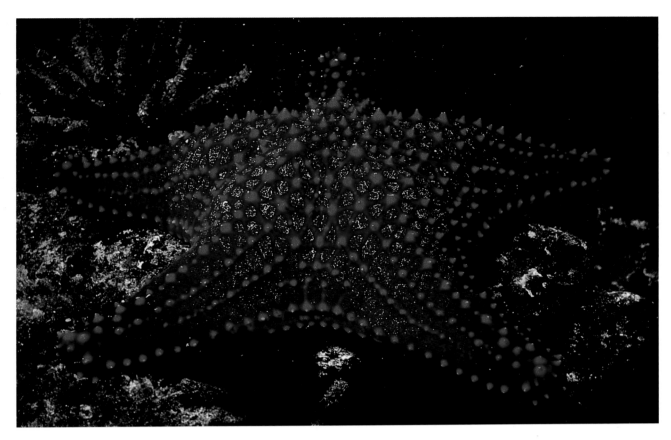

The bright red colour of the thorn-like spines of certain starfishes draws attention to their defensive armoury. This signals predators to back off. The gulf star, Oreaster occidentalis, (about 1 ft / 30 cm across).

LOCATION : Galapagos Islands.
CAMERA : Nikonos III with 28 mm lens plus close-up lens; f16-22; Kodachrome 64

these fishes have been reported to swim backwards at times but they then dart forward if threatened, avoiding the predator's lunge. A few animals that are cryptically coloured at rest display a flash of colour when they are disturbed, designed to confuse the predator momentarily. The Red Sea devil scorpionfish *Scorpaenopsis diabolus* has glaringly coloured pelvic fins that are hidden from view until it moves and these may serve not only to startle but warn that the fish bears venomous spines.

Some colour patterns may serve different functions in different circumstances. Stripes may act as camouflage from a distance but send a warning signal to a predator at close quarters. Bright colours may be for warning or social purposes in certain situations yet at other times they may match their surroundings on a colourful coral reef.

RED NOCTURNAL ANIMALS

Red shades abound on tropical reefs yet the colour we imagine to be so vivid appears dark and inconspicuous in many underwater situations. One reason is that water absorbs various parts of the spectrum at different rates, reds being the first to go, at about

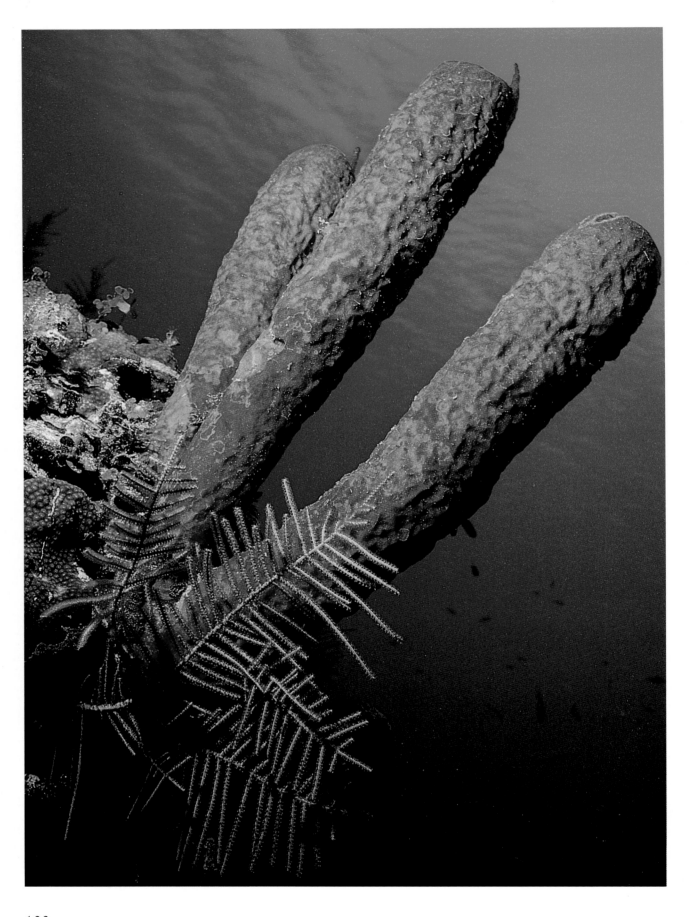

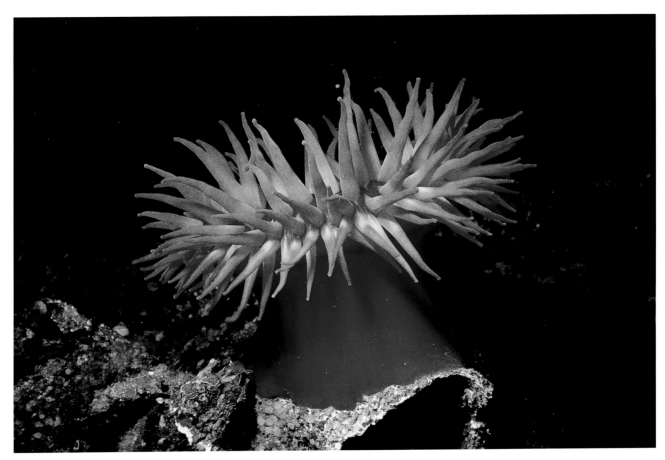

Vibrantly coloured animals grow in abundance on the undersea rock faces of British Columbia (Canada). Large sea anemones include the rose anemone, Tealia piscivora, (detail shown here) which may grow to 8 in./ 20 cm in diameter.

CAMERA : Nikonos V with 35 mm lens plus close-up lens; f16-22; Kodachrome 64

The vivid colour of yellow tube sponges Aplysina fistularis (up to 2 ft/ 60 cm or more in height) is apparent even at depth, and is probably due to fluorescent pigments. These sponges grow in groups on Caribbean walls and reef tops.

LOCATION : Cayman Is.
CAMERA : Nikonos V with 28 mm lens; f8-11; Kodachrome 64

twenty feet/ six metres. At depth, particularly in low-light conditions, red appears black although a diver's light will reveal the 'true' colour. Red colours are particularly associated with nocturnal, deep water or cave dwelling animals, such as squirrelfishes and soldierfishes which gather in caves or under overhangs on tropical reefs during the day and emerge at night. Why red rather than black is the prevailing colour in these circumstances is not fully understood though it is possible that red pigments may be produced more easily.

COLOUR AND SEX

Colour and pattern have a social role in many reef fishes. Butterflyfishes are amongst the most brightly coloured of these and each species has a different pattern often with distinctively contrasting bands or chevrons against a yellow background. Such differences allow species to recognise each other and are used for territorial displays. Many butterflyfishes form strong pair bonds and colour patterns can play a part in courtship.

Recognition of species may be complicated by the presence of

123

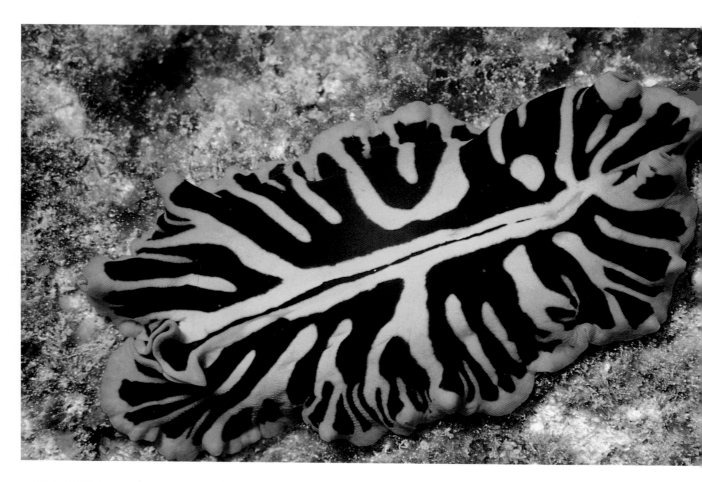

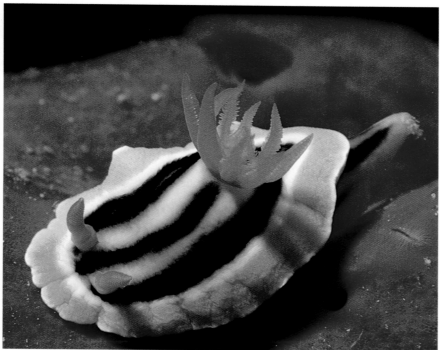

Many flatworms are distasteful
and tend to be rejected by fishes or
other predators. The eye-catching
markings of some species such
as Pseudoceros zebra
(up to almost 3 in. / 7 cm) serve
as warning coloration.

LOCATION : Kenya
CAMERA : Nikonos V with 35 mm lens;
extension tubes 1:2; f16;
Fujichrome Velvia

The bold stripes of the pyjama
nudibranch, Chromodoris
quadricolor, (up to 2 in. / 5 cm in
length) warn predators that this
sea-slug is likely to be distasteful.

LOCATION : Red Sea: Egypt
CAMERA : Nikonos II with 35 mm lens;
extension tubes 1:1; f16-22;
Ektachrome 64

The outline of the nudibranch Phyllidia (up to about 4 in. / 10 cm in length) may be disguised amongst the assorted colours of the reef. However, the sea-slug's distinctive markings would appear obvious, and might act as a warning signal, if seen against a plain background. An animal's colour pattern may serve different functions in various situations.

LOCATION : (Indonesia: Flores)
CAMERA : Nikonos V with 35 mm lens; extension tubes 1:2; f16-22; Fujichrome Velvia

various colour patterns within a species or even in the same fish at different times. Subtle geographic variations occur in wide ranging species but far more dramatic differences are seen between males and females, and juveniles and adults of certain fishes. Sexual dimorphism is common among wrasses and parrotfishes with mature (terminal) males usually more brightly coloured than the females, and sex reversal often takes place whereby some females turn into terminal males. Terminal males of parrotfishes are mainly green or turquoise. In orange sea-perches *Pseudanthias squamipinnis*, small relatives of groupers, each magenta male maintains a harem of orange females; if the male dies the most dominant female in the group changes into a male to replace him. Colour patterns can indicate sexual status and seasonal breeding colours are marked in various male wrasses such as the northern European corkwing wrasse *Symphodus melops* at times of spawning and nest guarding.

Colour patterns are social signals, enabling species recognition amongst territorial butterflyfishes. In addition, the black bar across the head of the striped butterflyfish, Chaetodon fasciatus, helps to obscure the shiny vulnerable eyes. Butterflyfishes may attain about 9 in. / 22 cm in length.

LOCATION : Red Sea: Egypt
CAMERA : Nikonos with 28 mm lens plus close-up lens; f16-22; Kodachrome 64

JUVENILE COLOURS

Differences between juveniles and adults are particularly striking in angelfishes of tropical reefs many of which have distinct vertical stripes of dark blue or black alternating with white or yellow when young but later develop other patterns. The change from juvenile to adult colour pattern often reflects a change in life style in angelfishes, several Caribbean species of which start out as cleaner fishes while others are aggressively territorial as youngsters. In both cases a brightly contrasting pattern draws attention to the displays of the young fish. Many wrasses change appearance during their growth, notably the clown coris *Coris aygula* whose juvenile form has a pair of orange-red spots immediately below a pair of black eye-spots while the adult is more drab.

CHANGING COLOUR

More rapid colour changes occur in response to different situations such as the day and night patterns of certain reef fishes, and alterations to match background, particularly in the European turbot, brill and various other flatfishes. The most rapid changes in intensity of colour are connected with behaviour and mood, in sexual displays or defensive postures. Some fishes vary between a disruptive pattern of transverse bars when resting and a more

The large diamond-shaped blotch extending from the eye of the masked butterflyfish, Chaetodon semilarvatus, gives this species a distinctive appearance.

LOCATION : Red Sea: Egypt
CAMERA : Pentax LX with 50 mm lens; Hugyfot housing; f8-11; Kodachrome 64

uniform pattern or longitudinal stripes which are less obvious when the fish is moving. Nassau groupers *Epinephelus striatus* from Florida to the Caribbean adopt stronger disruptive markings when they are nervous and making for shelter on the reef and the Indo-Pacific coral grouper *Cephalopholis miniata* is also capable of rapid colour change. A mixture of light and dark shades may be seen in a shoal of surgeonfishes or in big-eyes *Priacanthus hamrur* where individuals do not change colour simultaneously.

Some invertebrates including European chameleon prawns (*Hippolyte*) can change colour to blend with the environment. Another instance is seen in the sea-hare *Aplysia punctata*, a mollusc common around Britain and the North-east Atlantic where it varies in colour with age from rose-red to olive green as it migrates from shallow to deeper waters matching differences in the surrounding algae on its route. These responses are slow in comparison with those of cephalopods though.

COMPLEX SIGNALS

Cuttlefish, squids and octopuses have a remarkably sophisticated repertoire of signals relying on posture and movements of the animal combined with rapid changes in colour and brightness of pattern. Some octopuses and cuttlefish can also vary their skin texture from smooth to a mass of large raised 'warts' or 'horns'.

127

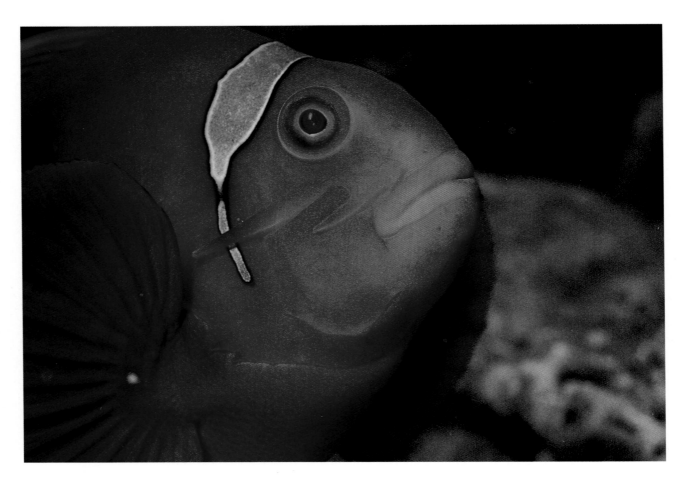

Colour patterns are composed in pointillist style by pigment cells in the skin, each with a dot of pigment which can be expanded or contracted in an instant so that colours appear to pulse and flash over the surface of the cephalopod. Other cells produce iridescence in the skin. The overall effect may change from very pale (which signifies fear and renders the animal less visible in its favoured habitat of sandy or sunlit shallows) to almost black (a sign of aggression and conspicuous against a light background). Patterns vary from plain to longitudinal or transverse stripes, blotches, borders and other markings. Such displays allow complex communication in situations of competition, predation, defence and courtship.

In addition many squids and a few other nocturnal or deep-water cephalopods have light producing organs, in some cases for sexual or social communication, in others for defence, and one deep-water squid even produces luminescent ink. Cuttlefish, squids and octopuses have complex and efficient eyes rivalling those of vertebrates although they lack colour vision.

*Strong colours reinforce the bold stand made by the spine-cheek anemonefish **Premnas biaculeatus** as the small fish, about 4 in. / 10cm in length, warns aggressors of all sizes away from the tentacles of its sea anemone partner.*

LOCATION : Papua New Guinea: West New Britain
CAMERA : Nikonos V with 35 mm lens; extension tubes 1:2; f16-22; Fujichrome Velvia

*The coral grouper, **Cephalopholis miniata**, (usually about 10 in. / 25cm in length) is not always so brightly coloured. As the fish moves between its lair amongst corals and the open reef, its colour pattern may change to a series of brownish bands.*

LOCATION : Red Sea: Egypt
CAMERA : Nikonos V with 28 mm lens plus close-up lens; f16-22; Kodachrome 64

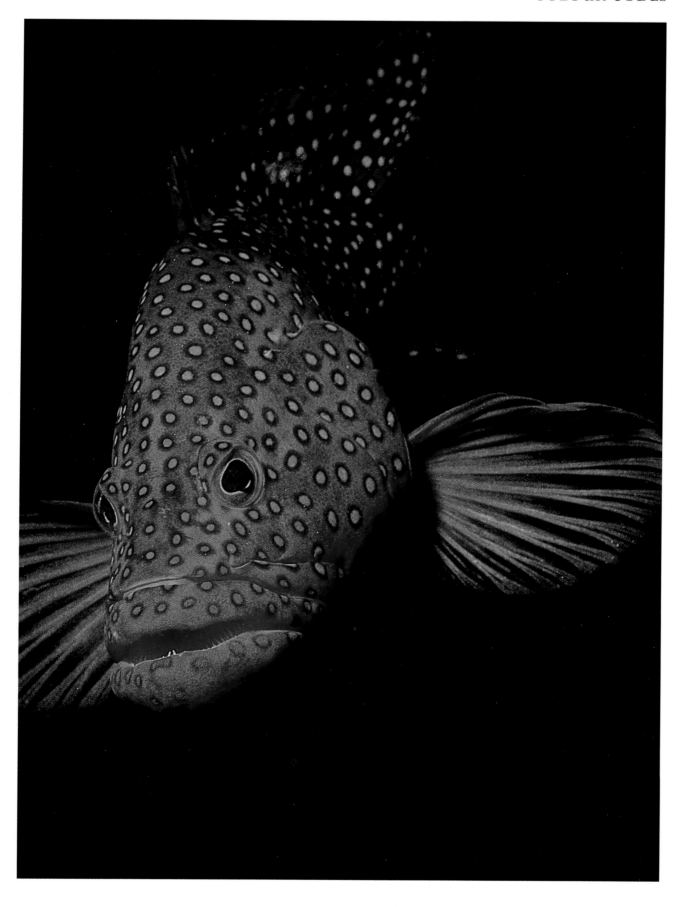

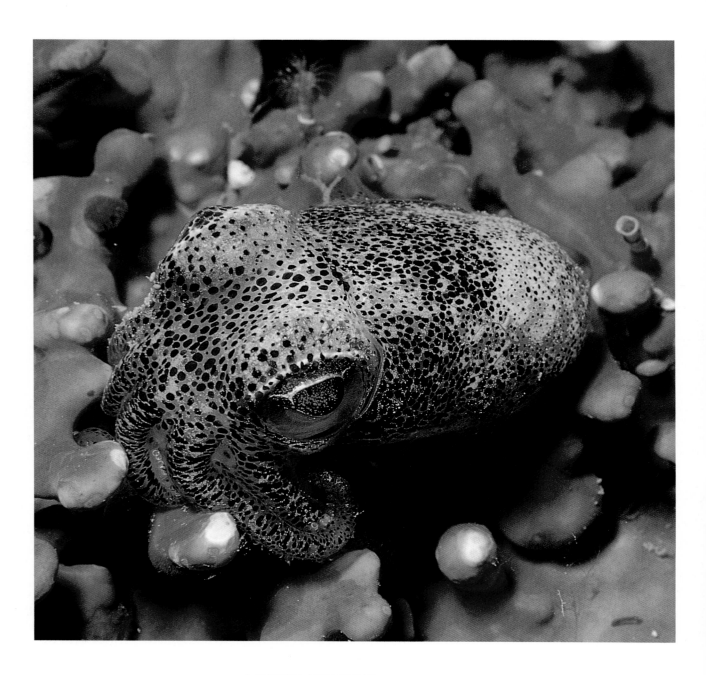

AFTER DEATH

The cuttle Euprymna, resting on pink coralline algae, is less than 2 in./5cm in length. The shimmering colours can change rapidly in response to the cuttlefish's moods and are controlled by pigment cells and other cells in the skin.

LOCATION : (Papau New Guinea) : West New Britain
CAMERA : Nikonos V with 35 mm lens; extension tubes 1:2; f16-22; Fujichrome Velvia

Colours usually fade rapidly when the animal dies. Stony corals for instance are pigmented in the living tissues covering the skeleton, and dead colonies rapidly bleach to white, but this is not the case with all marine animals. Some gorgonian corals such as the sea-fan, precious coral *Corallium rubrum* have a pigmented skeleton which retains its colour after death. In life the rose-red structure of this coral is covered in contrasting white polyps. Mollusc shells also keep their decorative pattern after the animal itself, which may be colourful or drab, has died and lost its colour.

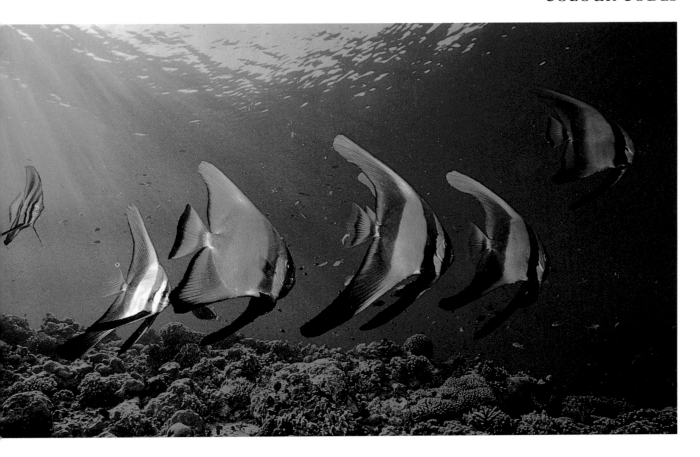

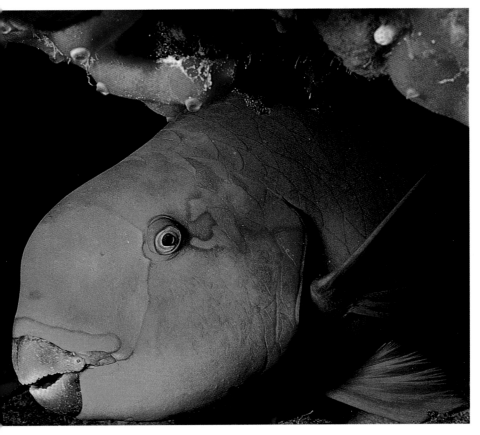

Stripes form a disruptive pattern which helps to break up the outline of batfishes, Platax, and disguises their eyes. Adults attain about 20 in. / 50 cm
LOCATION : Sabah : Sipadan
CAMERA : Nikonos V with 15mm lens; f8; Fujichrome Velvia

Bluish green colouring is typical of sexually mature males in various species of parrotfishes, Scarus, (generally about 1 ft-20 in. / 30-50 cm in length).
LOCATION : Red Sea: Egypt
CAMERA : Nikonos with 28 mm lens plus close-up lens; f16-22; Kodachrome 64

Overleaf: Magenta or dull purplish males are vastly outnumbered by their harems of orange females in a shoal of orange sea-perches, Pseudanthias squamipinnis, (about 3 in. / 8 cm in length).
LOCATION : Red Sea: Egypt
CAMERA : Nikonos V with 15 mm lens; f8; Fujichrome Velvia

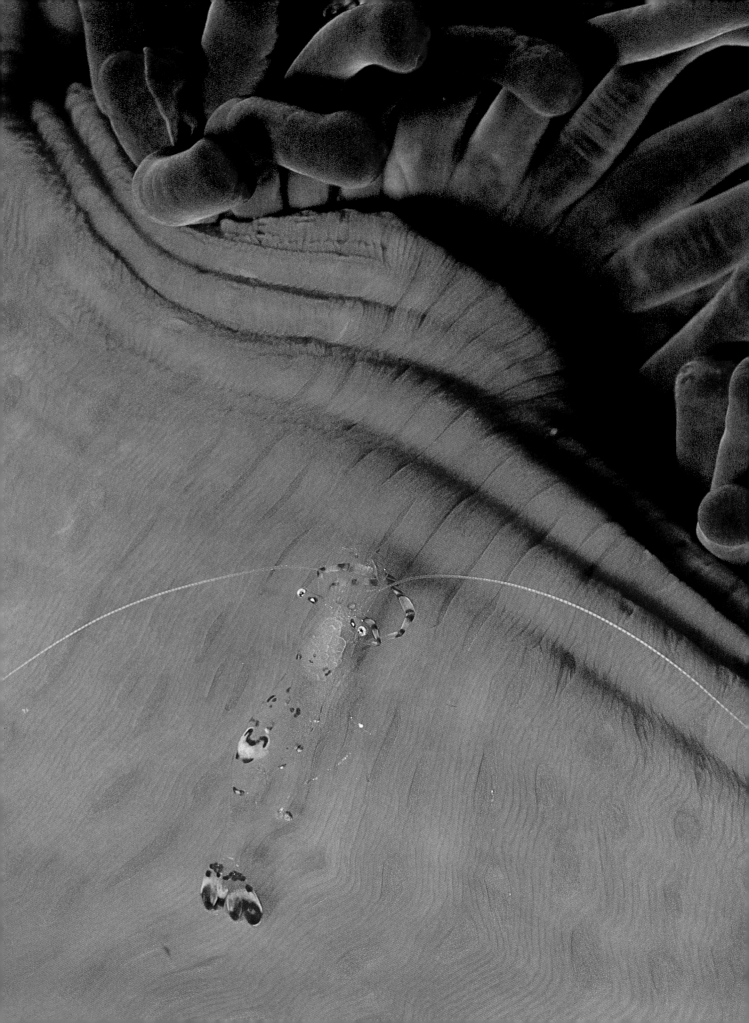

Disguise

One of the most successful lines of defence is to avoid being seen. Camouflage enables many fishes and other marine animals to go about their daily business in the open without having to risk conflict or waste energy on swimming away when predators approach. An amazing array of adaptations in surface structure, texture, colour and pattern imitate the animal's background and a life style of long periods of inactivity completes the deception. Not all such animals are harmless though; venombearing spines are commonly employed as a backup in case the disguise fails, and many predators use camouflage in order to ambush their victims.

DISGUISED AS ROCK OR SAND

Scorpionfishes live on tropical reefs and in temperate waters, where they lie on the bottom waiting to snap up any small fishes or crustaceans that pass by. Their bulky rugged shape and mottled pattern blend well with rock or reef and small spines or other projections help to break up the outline. A beard formed from frills of skin makes the mouth of certain species less obvious. Scorpionfishes can be a danger to swimmers who may mistake them for a lump of rock and touch the venom-loaded spiny rays of the dorsal, anal or pelvic fins. The Indo-Pacific stonefish *Synanceia verrucosa* is even more rock-like in appearance and its dorsal rays are extremely venomous, capable of causing an agonising death. Many members of the bullhead and sculpin family abundant on rocky reefs of the northern Hemisphere have a style of camouflage similar to that of scorpionfishes, though less extreme and without the venom. These include cabezons and Irish lords off the Pacific coast of North America and northern European sea scorpions many of which, like scorpionfishes, occur in a range of colour varieties to match their surroundings.

Scattered speckles are conspicuous against the purple column of a large sea anemone but the outline of the shrimp is less apparent. This Periclimenes shrimp 0.75 in. / 2 cm in length was seen living on the anemone Heteractis magnifica.

LOCATION : Indonesia: Flores
CAMERA : Nikonos V with 35 mm lens; extension tubes 1:2; f16-22; Fujichrome Velvia

135

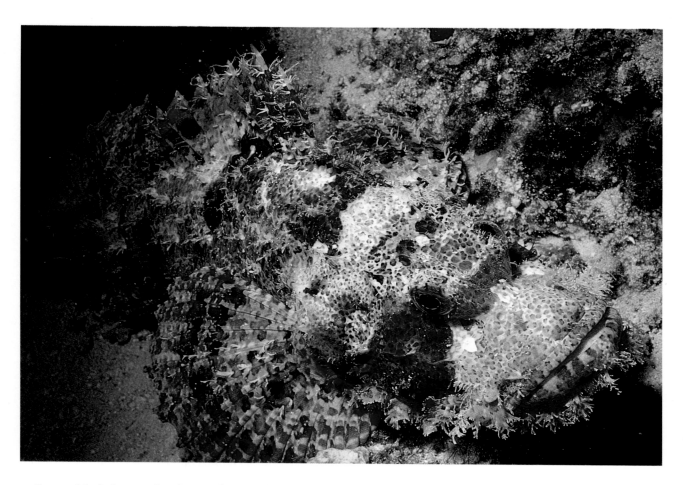

Crocodilefishes and other Indo-Pacific flatheads lie on areas of sand or coral rubble where they are camouflaged by their flattened shape and mottled light brown colouring. The frilled edges of their pectoral and pelvic fins merge with the sand and, eyeflaps form a delicate mesh to veil the gleam of the eyes. The crocodilefish looks as menacing as its name suggests, as it lies in wait for prey, but it does not produce any venom and is not dangerous to man; in fact it responds to being handled with docile indifference.

The success of this energy-saving life style is evident from the numerous and diverse fishes that have adopted it. These include wobbegongs, Australasian sharks with tassels of skin fringing the mouth, and highly adapted flatfishes which can change their colour and pattern to match various backgrounds such as sand, mud or pebbles.

Flatfishes and rays have a flattened shape edged with flanges or fins which slope to merge with the sand, thus reducing the shadow thrown by their outline. They often conceal themselves further by lying half buried in the sand with only their eyes protruding

The scorpionfish Scorpaenopsis (about 1 ft / 30 cm in length) is armed with venomous spines, but they are used only as a last resort. These rock-like fishes rarely swim, preferring to lead a sedentary existence on the sea bed.

LOCATION : Sabah: Sipadan
CAMERA : Nikonos V with 28 mm lens plus close-up lens; f16-22; Kodachrome 64

136

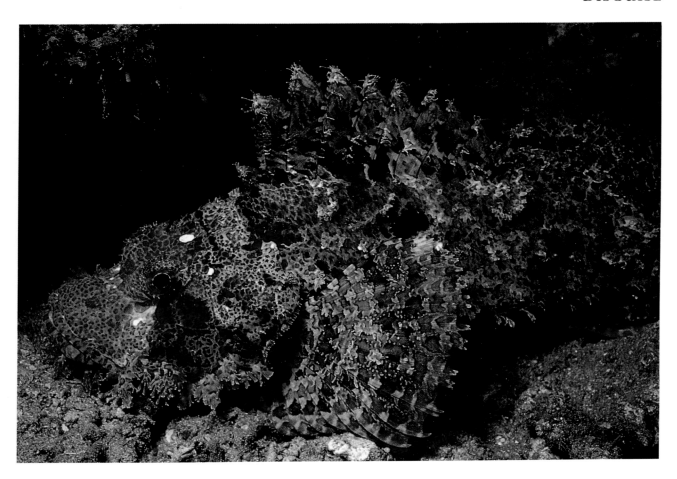

*A scorpionfish, Scorpaenopsis,
known locally as the demon stinger
or bearded ghoul.*

*LOCATION : Indonesia: Flores
CAMERA : Nikonos V with 28 mm lens
plus close-up lens; f16; Fujichrome Velvia*

conspicuously. Flatfishes such as plaice *Pleuronectes platessa* are
prevalent in temperate waters and familiar to us as food-fish since
disguise is no defence against dredgers with weighted nets!
If disturbed, flight is the only defence for flatfishes but stingrays,
as their name suggests, have a dorsal venom-bearing spine with
barbed sides, in the tail.

LURES

Smaller and slow-moving species in particular benefit from the
protection disguise offers, while a wide range of fishes use
disguise to gain opportunities for predation. Cryptic concealment
is sufficient for most bottom dwelling fishes but a few have a
further development, a lure to attract unsuspecting prey. In
anglerfishes (Lophiidae) and frogfishes the first ray of the
dorsal fin is greatly modified to a form a spine (the fishing
rod) tipped with fleshy lobes (the 'bait') which can be waved
invitingly above the mouth. These fishes differ in other respects

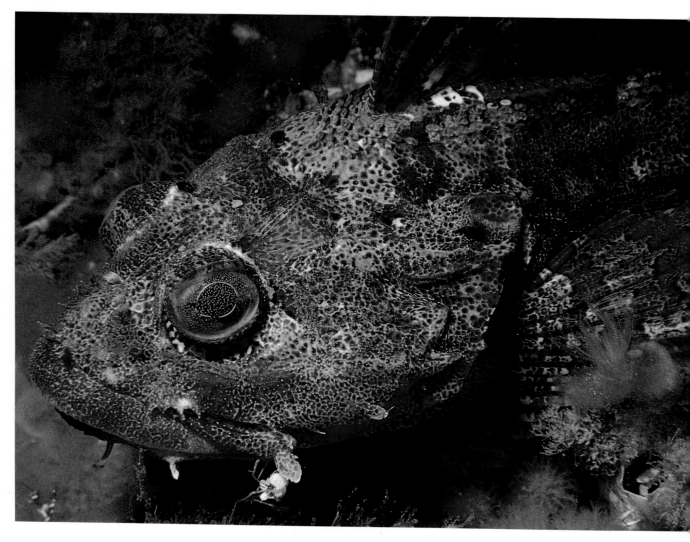

Although brightly marked, the
red Irish lord, Hemilepidotus
hemilepidotus, (up to 20 in. / 50 cm
in length) is inconspicuous from a
distance, in its equally colourful
surroundings.

LOCATION : British Columbia, Canada
CAMERA : Nikonos V with 35 mm lens
plus close-up lens; f16-22;
Kodachrome 64

Various tiny animals, covered in
debris, grow over the carapace and
legs of a decorator crab (about
0.75 in. / 2 cm across carapace).

LOCATION : Indonesia: Flores
CAMERA : Nikonos V with 35 mm lens;
extension tubes 1:2; f16-22;
Fujichrome Velvia

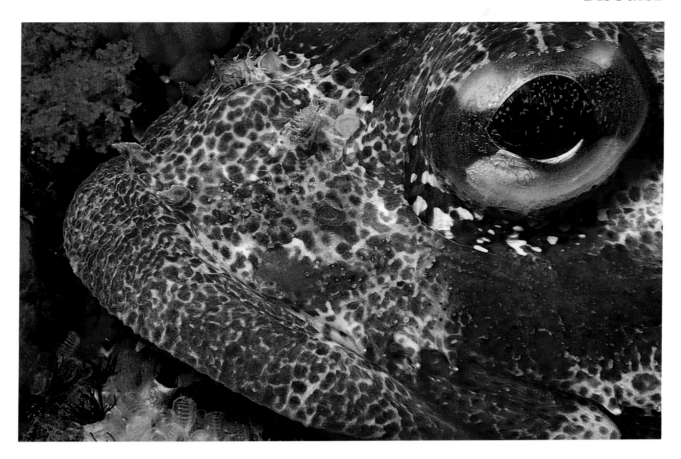

Rainbow-hued flecks across the eye of the red Irish lord add to the mottled camouflage of this sculpin.

LOCATION : Canada: British Columbia
CAMERA : Nikonos V with 35 mm lens; extension tubes 1:1; f16-22; Kodachrome 64

since anglerfishes (of European and Northeast American coasts) are flattened and have an enormous mouth, while frogfishes frequent warm waters (mainly Indo-Pacific and Caribbean) and are more rounded and sponge-like. The common name 'anglerfish' can lead to confusion though as it is also applied to one or two frogfishes and their relatives and to several families of deep sea forms with nightmarish appearance.

AMBUSH

Camouflage is not confined to fish on the sea bed. The longnose hawkfish living in Indo-Pacific gorgonian corals and black coral bushes has an attractive pattern of red cross-hatching that hides the fish effectively amongst the fine network of coral branches. The dainty appearance of the hawkfish belies its predatory nature but the disguise is a means of ambush, enabling the fish to remain unseen until it darts out to devour small fish and shrimps passing by.

Caribbean trumpetfishes *Aulostomus maculatus* are criss-crossed with markings to blend with their surroundings but it is their

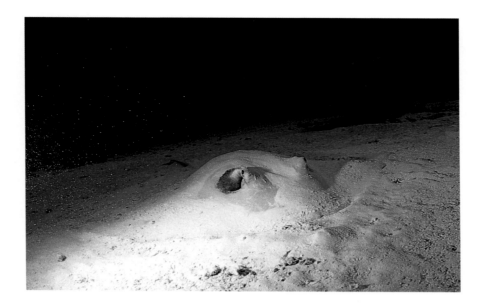

*Motionless but on the lookout,
a stingray, about 2 ft / 60 cm in
width, lies beneath a concealing
layer of sand. The tail is armed for
defence with a dorsal barbed spine
capable of injecting venom.*

LOCATION : *Red Sea: Egypt*
CAMERA : *Nikonos with 15 mm lens;
f8-11; Kodachrome 64*

unusual behaviour that completes the disguise. They have a habit
of swimming slowly about a gorgonian coral in a head-down pose
aligning their narrow elongated bodies in imitation of the slender
branches. This enables trumpetfishes to sneak up on small
fast moving fishes and suck them in through the tube-like snout.
Not content with this, trumpetfishes even use a stalking horse to
hunt in the open; they swim alongside a larger non-predatory
fish, keeping close in, then dart out from behind this cover to
seize small fishes. Slow swimming vulnerable pipefishes are
similarly built but smaller than trumpetfishes and commonly hide
amongst seaweed where they sometimes align themselves against
the fronds. This can be effective camouflage but they are vastly
outdone by Australian leafy and weedy seadragons, members of
the pipefish family that are spectacularly modified to look like a
piece of seaweed by having leaf-like skin flaps extending from
various parts of the body and tail.

BOLD DISGUISES

Mottled patterns in neutral shades that match the surrounding
rock or sand hide bottom-dwelling and slow-moving animals but
many active fish have other disguises better suited to their
lifestyles. Bold stripes or blotches extending right across the body
are common patterns and these are often continued over the fins
as well. Such markings might appear strikingly visible against a
background of open water but they help to break up the outline of
the animal, making it difficult for a predator to register a

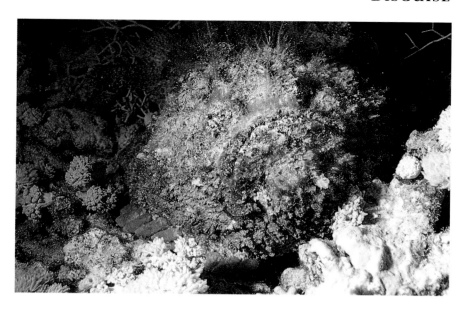

*The stonefish, Synanceia verrucosa,
(up to about 1 ft / 30 cm in length)
sometimes buries itself in the sand.
Its warty skin tends to become
coated with debris and algae may
grow on it. The dorsal venom
glands are the largest known in
fishes and the venom may cause
excruciating pain and even death.*

*LOCATION : Red Sea: Egypt
CAMERA : Pentax LX with 50 mm lens;
Hugyfot housing; Kodachrome 64*

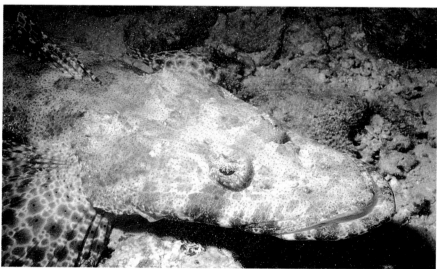

*The crocodilefish or flathead,
Cociella crocodila, (about 3 ft / 1 m
in length) rests on the sea bed in
characteristic pose, on outspread
pectoral and pelvic fins. Flatheads
are sluggish predators, relying on
their excellent camouflage to aid
their strategy of ambushing fishes.*

*LOCATION : Red Sea: Egypt
CAMERA : Nikonos V with 28 mm lens
plus close-up lens; f22; Kodachrome 64*

*The plaice, Pleuronectes platessa,
(up to about 2 ft / 60 cm in length)
may adapt its colouring to match
the sand or gravel on which it lies.
The plaice's distinctive orange spots
do not change but they may be
hidden by silt that is stirred up
and settles over the fish when it
flaps its fins.*

*LOCATION : Great Britain: England
CAMERA : Nikonos V with 28 mm lens
plus close-up lens; f22; Ektachrome 100*

141

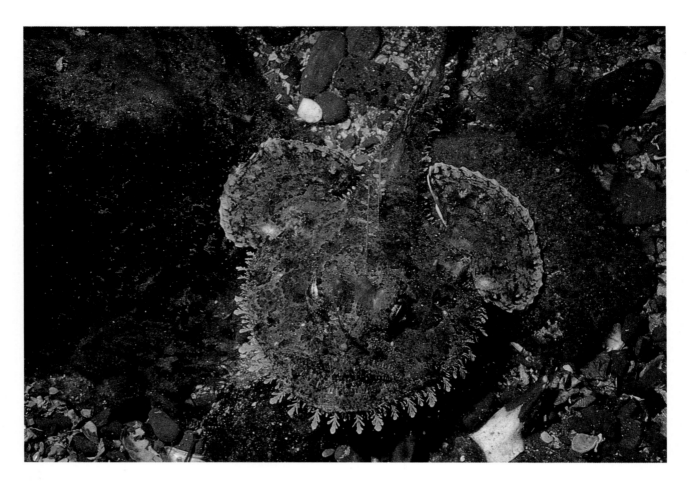

fish-shape, particularly as fish flit in and out of the jumble of
shapes and shadows that make up a reef. A wide range of reef fish
including the Caribbean Nassau grouper *Epinephelus striatus* and
several Indo-Pacific damselfishes such as the sergeant major
Abudefduf have disruptive stripes and some can change their
pattern from plain to striped in certain situations.

HIDING IN THE OPEN

Open water fishes are more plainly patterned. Silver is a
predominant colour among these and though a shoal may glint
occasionally in shallow water as the mirror-like scales reflect
sunlight, for most of the time silver fishes appear dull grey and
inconspicuous since there is limited natural light for their scales to
reflect. Animals that swim in open water often have a subtle
colour pattern, countershading, in which the back of the fish is
dark blue, green, grey or black and the underside is paler, whitish
or silvery. A pale underside counteracts the ventral shadow that
makes an object stand out when light falls on it, and the dark

*The anglerfish, Lophius
piscatorius, waits to engulf fishes
that are attracted by the lure above
its huge mouth. Despite its size, up
to 4 ft / 1.2 m, the anglerfish is
easily overlooked because its
mottled form blends well with the
shingle sea bed.*

*LOCATION : Great Britain: Scotland
CAMERA : Nikonos II with 28 mm lens
plus close-up lens; f22; Ektachrome 64*

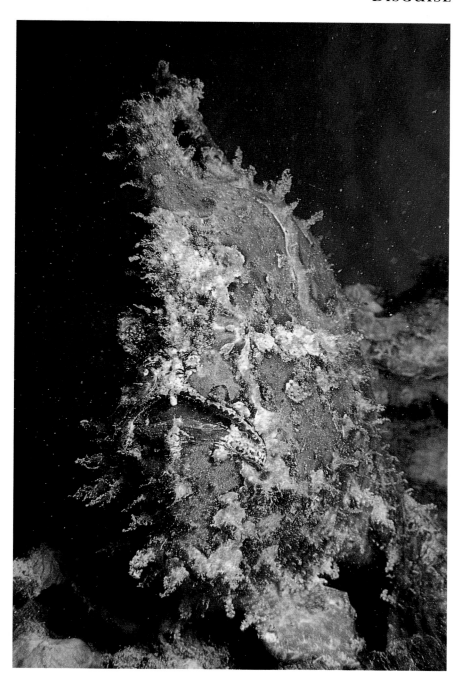

*The frogfish or anglerfish,
Antennarius maculatus, (up to
4 in. / 10 cm in length) is well
disguised by a covering of frills
and flaps of loose skin. Look for the
red spot if you cannot see its eye
in the photograph.*

*LOCATION : Indonesia: Flores
CAMERA : Nikonos 111 with 35 mm lens
plus close-up lens; f16; Fujichrome Velvia*

upper side when viewed from above merges with the gloomy
depths. Countershading works particularly well when the tones
are graded to eliminate the way light shades a three dimensional
object. Plain bands of colour as in tuna and herring are the most
effective but patterned bands such as the vertical stripes of
mackerel work if seen from a distance. Countershading makes
both hunter and hunted less visible and occurs in many other fish
including sharks, manta rays, rainbow runners and also in sea
snakes, turtles and cetaceans.

Only the keenest eyes will
notice the ghost-like form of a
transparent shrimp, slightly more
than 0.5 in. / 15 mm in length, at
the base of the tentacles of the sea
anemone Heteractis magnifica.

LOCATION : Maldive Islands
CAMERA : Nikonos V with 35 mm lens;
extension tubes 1:1; f16-22;
Kodachrome 64

TRANSPARENT OR COLOURFUL

Various delicate animals escape detection by being almost transparent, especially plankton such as comb jellies, salps and small jellyfish, and also some shrimps of reef or rocky habitats and certain sedentary sea-squirts. Many *Periclimenes* shrimps combine a remarkable transparency with blotches or stripes which are often strikingly obvious but appear disembodied. Other shrimps that live in association with a particular animal may be brightly coloured to match their host such as the tiny red shrimp *Periclimenes imperator* which lives on the surface of the beautiful Spanish dancer, a large Indo-Pacific sea-slug. Several gobies and other tiny slender-bodied fish that lie along the branches of whip corals, gorgonians or soft corals are the same colour as the coral that they live on; providing they remain in the right setting their vivid hues are inconspicuous.

CULTIVATING A COVER

Some animals make use of a borrowed covering for defensive concealment. The hermit crab's shell is a fortress which is unlikely to be subjected to attack because it appears to be no more than a piece of rubble; its surface has worn away and it may have been colonised by algae or other growths. Decorator crabs, various members of the spider crab family, deliberately select fragments of sponge, seaweed or hydroids which they pluck and snip with their front pincers and attach to tiny hooked bristles on their body and legs. They are often almost unrecognisable as crabs whether they match their surroundings or not. Such coverings are good deterrents since many sponges contain toxins, and hydroids have stinging cells. Dromiid sponge crabs of temperate and tropical seas are shielded and hidden beneath a single large chunk of sponge held against the carapace by the hind legs. However, if a suitable sponge is unavailable they will make do with some other object and I have seen a sponge crab marching along, obscured by a hefty branch of soft coral.

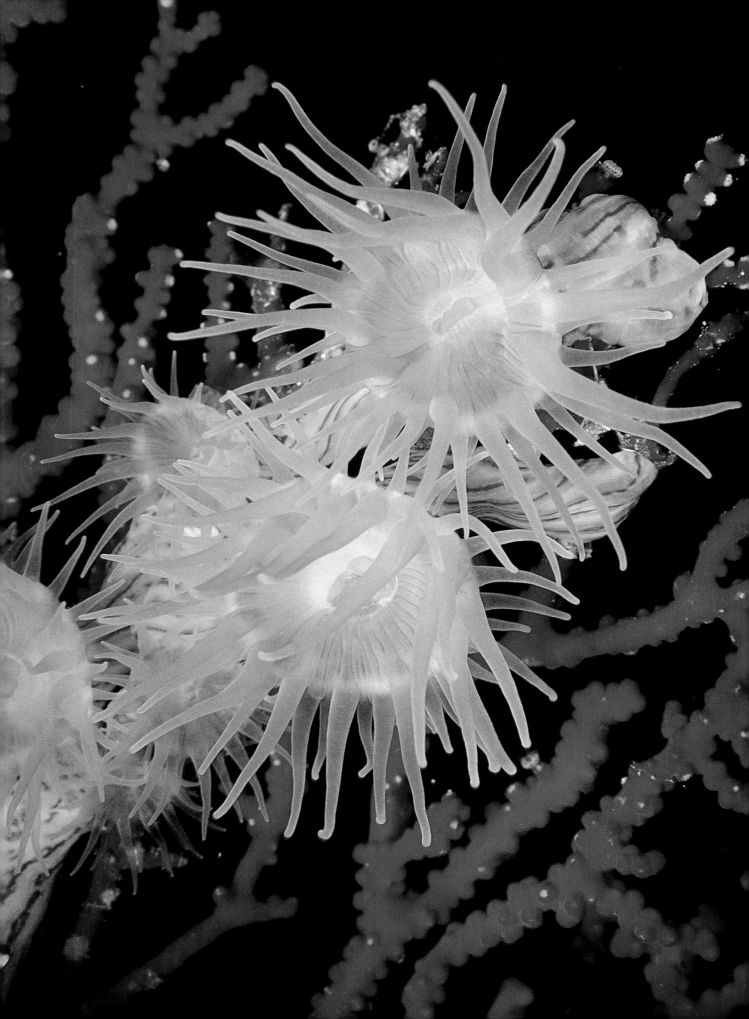

Nightshift

At dusk, when the day-active species seek shelter for the night, a new set of animals takes over. Most corals extend the tentacles of their polyps to catch food at night, various other invertebrates crawl out of their hiding places to hunt their prey. Night is an ideal time for many animals to feed since upper levels of the seas around coral reefs are rich in plankton at this time and vulnerable animals can take advantage of the food source with less risk of being seen and attacked than in broad daylight. Diving at night, especially in the tropics, provides excellent opportunities to see many invertebrates that are not out and about during the day though they are generally sensitive to light and will often curl up and back away from a powerful beam such as a diver's light. Certain groups of fishes are also nocturnal though more rest at night.

CHANGING SHIFTS

The difference between day and night shifts is most pronounced on coral reefs, where the changeover is almost complete. Shortly before sunset the swarms of fishes hovering and feeding above the reef move in close to the corals and seek shelter. Some species commute between different reef areas, feeding at one site by day, then returning to another site to sleep. Nocturnal fishes tend to move off the reef to feed at night and often form shoals on sheltered parts of the reef to rest in the daytime. There is a distinct sequence in which day-active fishes go to rest. Wrasses and small parrotfishes tend to be the first to seek night shelters, then small damselfishes and butterflyfishes and finally surgeonfishes and large parrotfishes, with the sequence being reversed in the morning. Most diurnal fishes are well hidden at night but parrotfishes are often visible sleeping in the shelter of corals. Certain parrotfishes secrete a flimsy mucus cocoon as a protective covering which masks their scent.

Hormathiid anemones (about 1 in./ 3 cm in diameter), with tentacles fully expanded for feeding at night, may be seen growing over the branches of gorgonian corals. Certain other hormathiids live attached to the shells of hermit crabs.

LOCATION : Red Sea: Egypt
CAMERA : Nikonos V with 35 mm lens; extension tubes 1:2; f16-22; Fujichrome Velvia

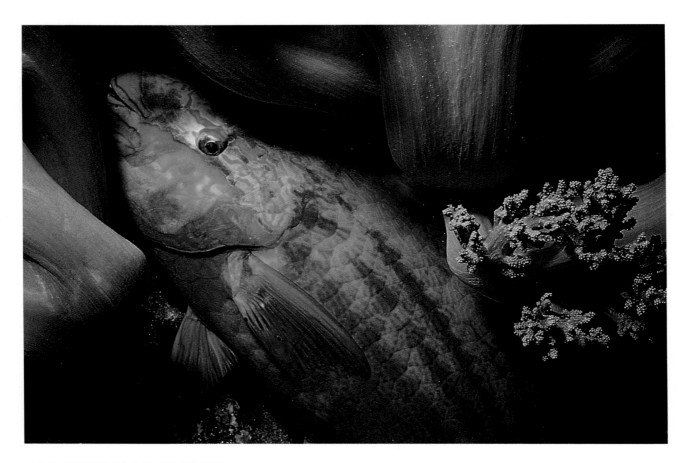

NOCTURNAL FISHES

Many night-active fishes on tropical reefs are reddish or deep red
and have large eyes although they are classed in three separate
families and only share these similarities because of their way of
life. Red shades appear black at night, disguising the fish amongst
the shadows, and larger eyes are an aid to hunting in low light
conditions. Big-eyes (Priacanthidae), squirrelfishes and
soldierfishes (Holocentridae), and cardinalfishes including the
flamefish (Apogonidae) usually gather in small groups in caves or
close to the reef during the day and disperse after dark to hunt.
Overhangs in such areas as the Maldive Islands and Hawai'i may
shelter large daytime schools of soldierfishes. Bluestripe snappers
Lutjanus kasmira behave similarly although their colour is
predominantly yellow without a trace of red. Other nocturnal
fishes include sweetlips *Plectorhynchus* and tiny shoaling sweepers
Parapriacanthus which move away from their sheltered daytime
haunts on the reef to forage in open water.

Parrotfishes, Scarus (generally about 10-20 in. / 25-50 cm in length), sleep in crevices in the reef at night and may also be seen nestling amongst large soft corals.

*LOCATION : South China Sea: Malaysia
CAMERA : Nikonos with 28 mm lens plus close-up lens; f16-22; Kodachrome 64*

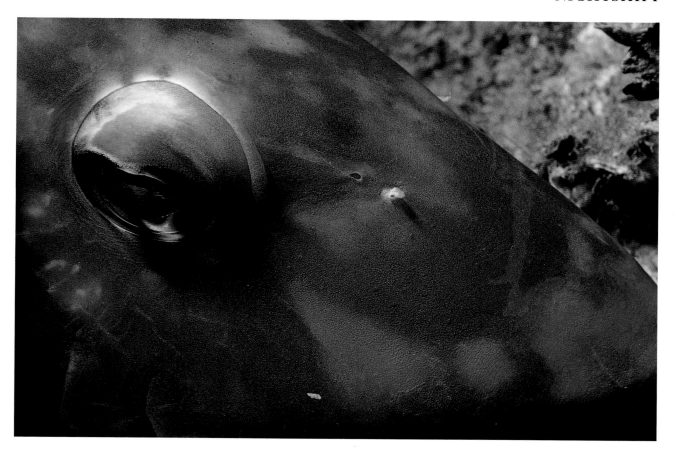

Detail of a parrotfish Scarus resting at night in a crevice.

*LOCATION : Cayman Islands.
CAMERA : Nikonos with 35 mm lens;
extension tubes 1:2; f16-22;
Kodachrome 25*

NIGHT-FEEDING CORALS

While the polyps of some stony corals are extended by day and night others extend their tentacles to catch the minute organisms they feed on only after dark. The appearance of the colony changes when the polyps are fully extended, the skeleton is less apparent and the outline is softened by the fur-like covering of tentacles. Bubble or grape corals (*Plerogyra*), widespread in the Indo-Pacific, are named for the clusters of balloon-like vesicles which cover the colony during the day but these swellings contract at night to allow the tentacles to be used for feeding. The most beautiful transformation on tropical reefs is seen in dendrophylliid corals though. Reef walls that are shaded by overhangs appear relatively bare by day but at night clusters of dendrophylliid corals extend their bright yellow polyps, carpeting rock surfaces. Although they look like anemones they are stony corals whose polyps are normally retracted during the day leaving only the columnar cup visible.

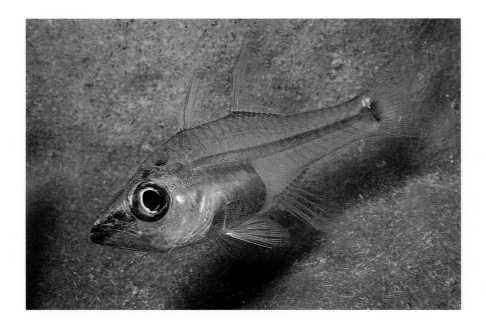

Cardinals Apogon (commonly about 2 in./ 5cm in length) have large eyes, an adaptation for nocturnal activities. Many species feed at night on tiny planktonic crustaceans.

LOCATION : Sabah : Sipadan
CAMERA : Nikonos V with 35 mm lens; extension tubes 1:2; f16-22; Kodachrome 64

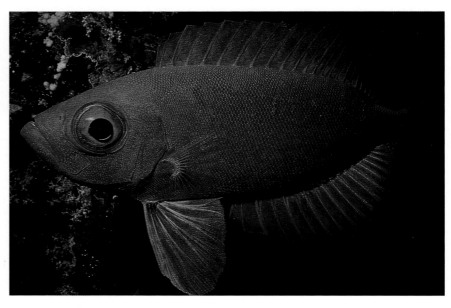

The large eyes of the big-eye, Priacanthus hamrur, a nocturnal fish approximately 1 ft / 30 cm in length, are an adaptation for hunting by night. The fish's deep red colour, revealed here by light from a flashgun, appears black at night.

LOCATION : Red Sea: Egypt
CAMERA : Nikonos with 28 mm lens plus close-up lens; f16-22; Kodachrome 64

GRAZERS AND PROWLERS

Crustaceans are particularly active at night and many tropical species are rarely seen in daylight since they hide in holes in the reef or under coral rubble. Divers are likely to encounter various large coral crabs including the red *Etisus splendidus* on Indo-Pacific reefs. Spider crabs range from small delicate species such as *Macropodia* and *Hyastenus*, fairly common in some areas of the Red Sea, to the Caribbean king crab *Mithrax spinosissimus* which can weigh up to 8 lbs. *Macropodia* crabs forage amongst the branches of large soft corals while Caribbean king crabs browse

The red night shrimp, Rhynchocinetes rigens, (about 2 in./ 5 cm in length) is rarely seen during the day but emerges from crevices in the reef at night. Its red colouring, that glows so vividly in the beam of a dive light, normally appears dark and inconspicuous at night.

LOCATION : Cayman Islands.
CAMERA : Nikonos III with 35 mm lens; extension tubes 1:2; f16-22; Kodachrome 64

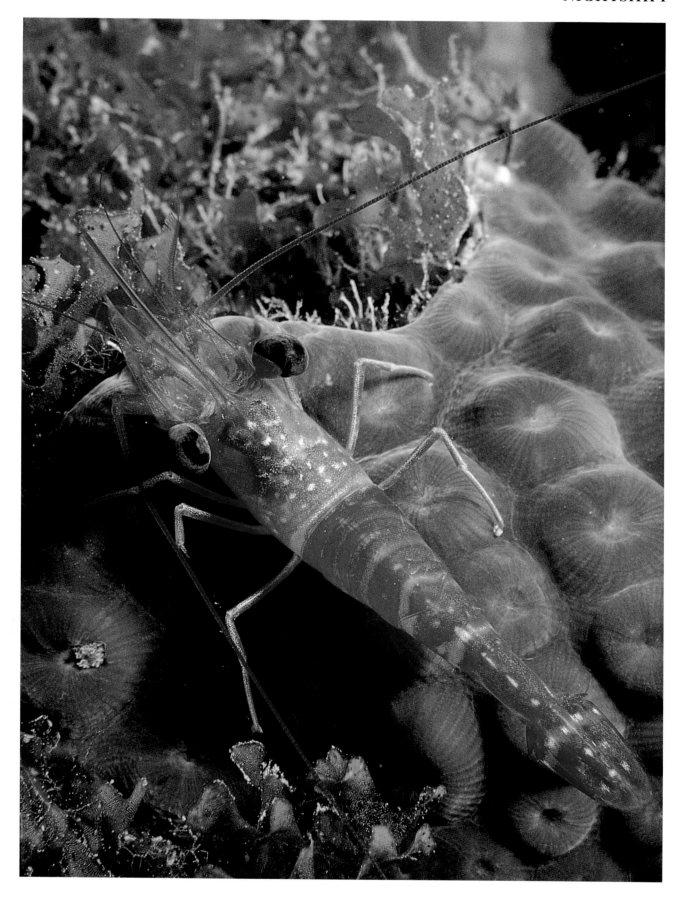

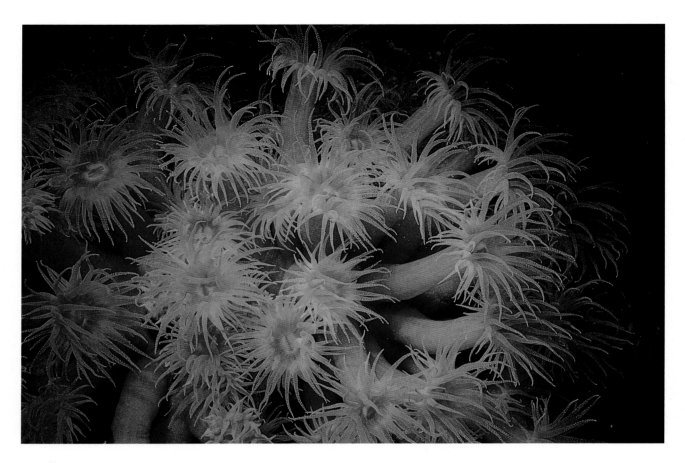

on algae growing on top of the reef. Spiny lobsters and slipper
lobsters crawl out from their caves onto the open reef in the
Caribbean and the Indo-Pacific, and numerous colourful hermit
crabs, and shrimps such as the Caribbean red night shrimp
Rhynchocinetes rigens, scavenge on tropical reefs. Red shades
abound in nocturnal crustaceans as well as in fishes. Although
crabs and other crustaceans of temperate waters are more inclined
to venture out during the day than their tropical counterparts,
some prefer to hunt by night. These include the common lobster
Homarus gammarus in the North-east Atlantic and the
Mediterranean Sea, and several species off the Pacific coast of
North America: the spiny lobster *Panulirus interruptus*, red crab
and rock crab *Cancer* species.
Many tropical echinoderms feed at night by filtering tiny
organisms from the water. The basket stars of coral reefs have
long finely branched arms which are curled up like a tangled ball
of twine when the animal is hiding in a crevice during the day. At
night the branches unravel to form an intricate fan-shaped mesh to
sieve food from the current. Red Sea feather-stars or crinoids
behave similarly, but in Indonesia and other parts of the far east,

*Dendrophylliid corals (fully
extended polyps about 1.5 in. / 4 cm
in diameter) often occur on reefs
but they are not reef builders.
Because they do not require light
as other corals do, they are able to
grow under overhangs and in cave
entrances. Their colourful polyps
are extended mainly at night.*

*LOCATION : Indonesia: Flores
CAMERA : Nikonos V with 28 mm lens
plus close-up lens; f16-22;
Fujichrome Velvia*

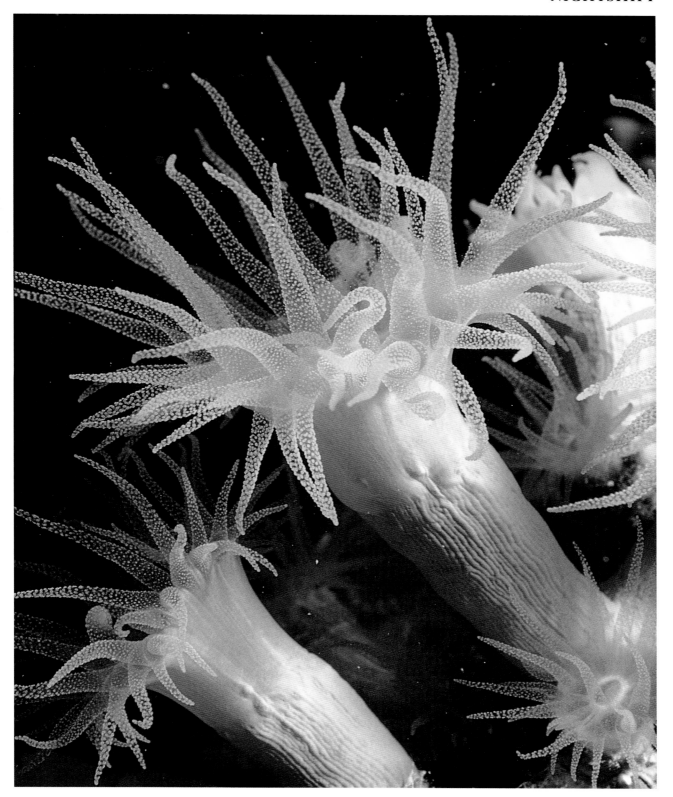

Dendrophylliid coral

LOCATION : Red Sea: Egypt
CAMERA : Nikonos II with 35 mm
lens; extension tubes 1:2; f16-22;
Kodachrome 64

153

day-active species are abundant also. Feather-stars, like basket stars, take up positions advantageous for feeding and crawl on top of prominent corals or barrel sponges that are exposed to the current. Most tropical shallow-water brittle stars, which are related to basket stars, are nocturnal and conceal themselves in the daytime. Tropical sea-urchins usually find havens in coral thickets or amongst rocks by day and tend to graze at night on algae growing over dead coral rock. Slate pencil urchins that pass the day wedged by means of their heavy spines in holes in Indo-Pacific reefs are among those that emerge at night and needle-spined *Diadema* urchins can be common on shallow reefs. Some sea-cucumbers are night-active including the Caribbean synaptid *Euapta lappa* which hides its worm-like body, up to three feet long, amongst coral during the day. Unlike most other sea-cucumbers, synaptids lack tube feet and their soft highly extensible bodies are sticky to the touch due to a covering of spicules. Another nocturnal Caribbean species, known as the tiger's tail *Holothuria thomasae*, is a more typical sea-cucumber although it too has an elastic body. The hind end of the body clings to the edge of the reef in a sandy basin while the sea-cucumber

Spider crabs, Macropodia, (about 0.33 in. / 8 mm across carapace) may be seen at night on the branches of the soft coral Dendronephthya. Their spindly legs are covered in minute hydroids.

LOCATION : Red Sea: Egypt
CAMERA : Nikonos with 35 mm lens; extension tubes 1:2; f16-22; Kodachrome 64

The night-active spider crab Hyastenus (generally 0.25 - 0.5 in. / 5-13 mm across carapace) crawls over Dendronephthya. The crab is sometimes seen on fern-like stinging hydroids and attaches snippets of these to itself for defensive purposes.

LOCATION : Red Sea: Egypt
CAMERA : Nikonos with 28 mm lens plus close-up lens; f16-22; Kodachrome 64

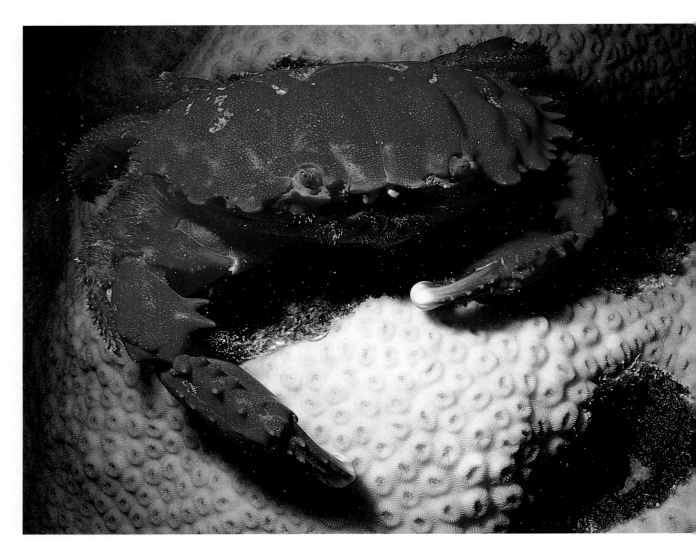

stretches forwards onto the sand to vacuum up food particles.

Various large and magnificent molluscs can be seen at night, including carnivores such as the trumpet triton *Charonia variegata* which preys on sea-cucumbers and other echinoderms, the venomous textile cone shell *Conus textile* which lives in shallow sandy lagoons and reefs in the Indo-Pacific, and helmet shells, hunters of sea-urchins. Omnivorous cowries such as the large tiger cowrie venture out at night and spread the two lobes of their mantle up the sides of the shell until the shell is fully covered by this skin. The shells are renowned for their brilliant gloss and ornamental pattern but the mantle may be equally strikingly patterned with lines and blotches and is usually covered with a forest of pointed or forked filaments. During the day or if disturbed at night, the animal withdraws rapidly into its shell. Octopuses roam mainly by night in temperate and tropical seas, seeking out their prey of crustaceans and molluscs.

The nocturnal red crab Etisus splendidus (about 5 in. / 13 cms across carapace) may be poisonous. It is one of the larger crabs on Indo-Pacific reefs.

LOCATION : Red Sea: Egypt
CAMERA : Nikonos with 28 mm lens plus close-up lens; f16-22; Kodachrome 64

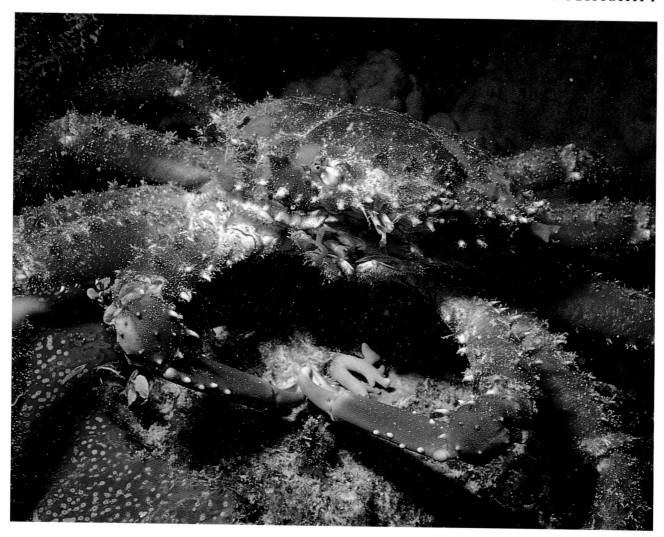

The king crab, Mithrax spinosissimus, with a carapace width of up to 6.5 in. / 17 cm, is the largest reef crab in the Caribbean. It hides during the day and crawls out onto the open reef at night to feed on algae.

LOCATION : Cayman Islands.
CAMERA : Nikonos V with 28 mm lens plus close-up lens; f16-22; Kodachrome 64

SHARKS

Reef fishes and octopuses fall prey to night-active sharks such as blacktip reef sharks *Carcharhinus melanopterus*. Another nocturnal hunter, the whitetip reef shark *Triaenodon obesus* is common in the Red Sea and elsewhere in the Indo-Pacific, cruising along its reef edge territory to prey on crustaceans in addition to fishes and cephalopods. Although it feeds to a certain extent during the day this shark is more inclined to rest until dusk and can often be seen lying in caves, facing away from the entrance, or lying in basins of coral rubble. Nocturnal sharks occur in temperate as well as tropical waters. Horn or bullhead sharks are small species which dwell on the sea bed off the coasts of California, Mexico, the Galapagos Islands and Japan where their strange corkscrew-like egg cases can be found wedged in crevices. The Port Jackson shark, a bullhead shark common off South Australia, feeds mainly

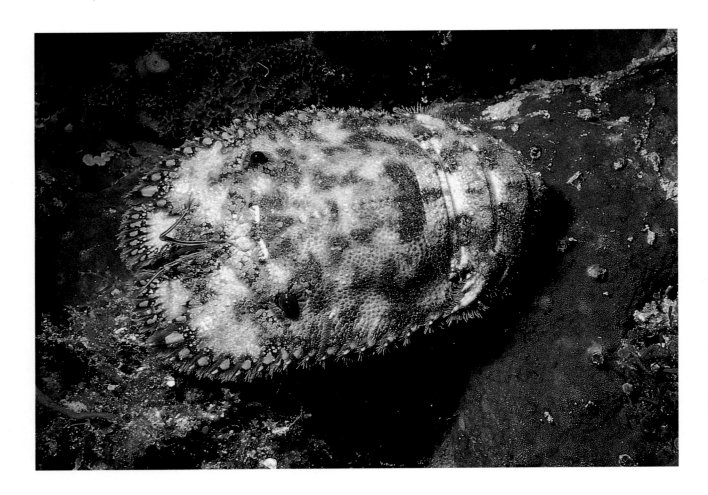

on shellfish, and sea-urchins and other echinoderms, by means of its crushing and grinding teeth. It has small eyes and relies more on its keen sense of smell to track down prey; the complex folds of its flared nostrils are well adapted for this.

LUMINESCENCE

Planktonic animals tend to rise from the depths to shallower water at night and some, including flagellate protozoa, are luminous. Certain squids hunt at night and a few of these together with the deep-sea species that live in perpetual gloom have light producing organs. One of the most spectacular adaptations is the luminescent organ of the flashlight fish *Photoblepharon* which lures the plankton that this small fish preys on at night in the Indo-Pacific. Plankton such as tiny crustaceans are attracted to a light source as I have found to my dismay on occasions in the Caribbean when I have had to contend with a swarm buzzing around my torch while I have been taking photographs at night. In the flashlight fish and its relative *Anomalops* the light organ is an

Nodules cover the flattened carapace of nocturnal slipper lobsters such as Parribacus antarcticus (up to 8 in. / 20 cm in length). The second pair of antennae are modified to form plate-like structures at the front of the head.

LOCATION : South China Sea: Philippine Islands.
CAMERA : Nikonos with 28 mm lens plus close-up lens; f16-22; Kodachrome 64

158

Protected by the shell it inhabits and also by the bristles overing its legs, the hermit crab Aniculus maximus ventures out onto reef at night.

LOCATION : South China Sea: Philippine Islands.
CAMERA : Nikonos with 28 mm lens plus close-up lens; f16-22; Kodachrome 64

oval bar, immediately below each eye, containing light emitting bacteria. The fish has no control over the bacteria but it can turn the effect on or off at will either by covering the organ with an eyelid-like tissue in *Photoblepharon* or by rotating the organ to hide the luminescent side in *Anomalops*. Blinking may be used to baffle predators since the fish changes direction while the light is out.

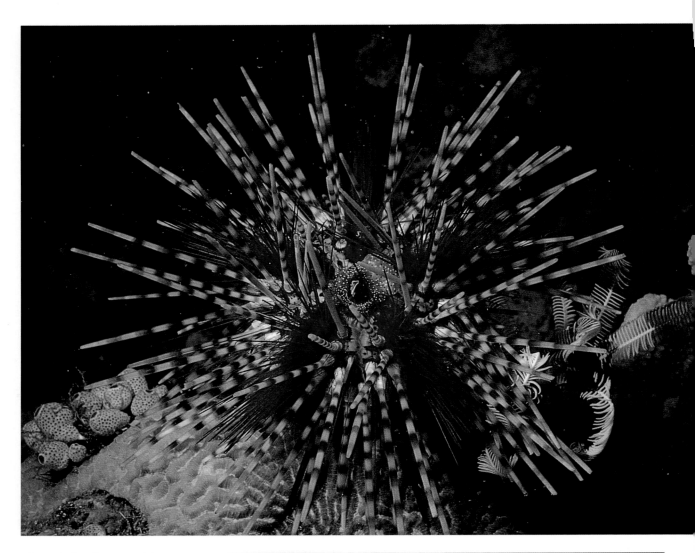

The Indo-Pacific sea-urchin
Echinothrix calamaris (up to
8 in. / 20 cm in diameter).
The small white-spotted sphere,
sometimes mistaken for an eye,
is the sea-urchin's anal cone.

LOCATION : Indonesia: Flores
CAMERA : Nikonos V with 28 mm lens
plus close-up lens; f16-22;
Fujichrome Velvia

The snake pipefish, Entelurus
aequoreus, aligns its slender body
with the strap-like branches of
thongweed, Himanthalia elongata.
This handsome banded fish grows
up to 2 ft / 60 cm in length.

LOCATION : Great Britain: England
CAMERA : Nikonos V with 28 mm lens
plus close-up lens; f16-22;
Kodachrome 64

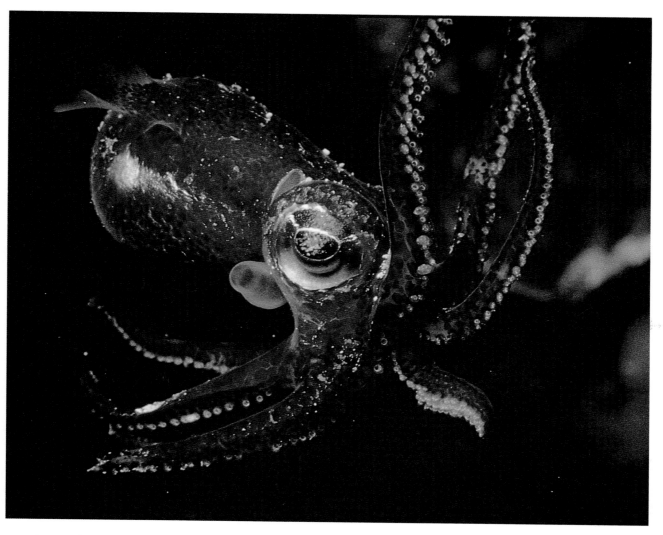

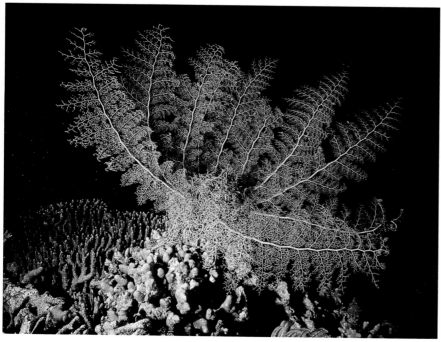

The sparkling colours of the small bottle-tailed cuttlefish, Euprymna, can be seen on Indo-Pacific reefs at night.

LOCATION : Papau New Guinea
CAMERA : Nikonos V with 35 mm lens; extension tubes 1:2; f16-22; Fujichrome Velvia

At night, basket stars Astroboa nuda (up to about 3 ft / 1 m in diameter) unfurl their intricately branched arms, which act as a net to trap tiny organisms.

LOCATION : Indonesia:Sulawesi
CAMERA : Nikonos V with 15 mm lens; f11; Kodachrome 64

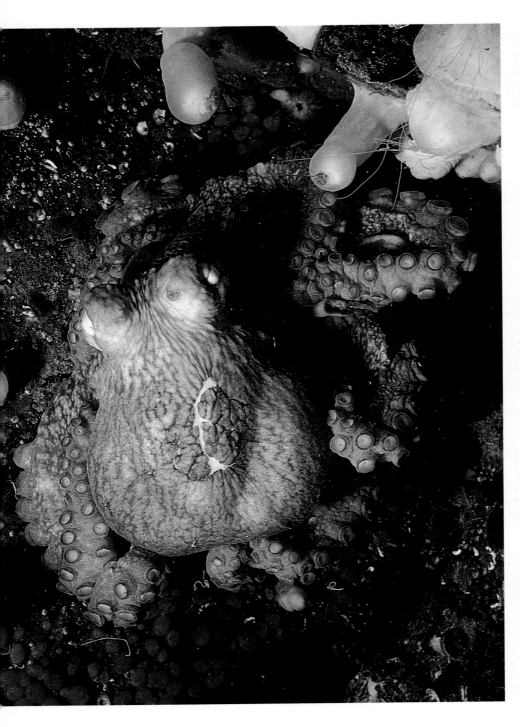

LOCATION : Canada: British Columbia
CAMERA : Nikonos V with close-up lens;
f16-22; Kodachrome 64

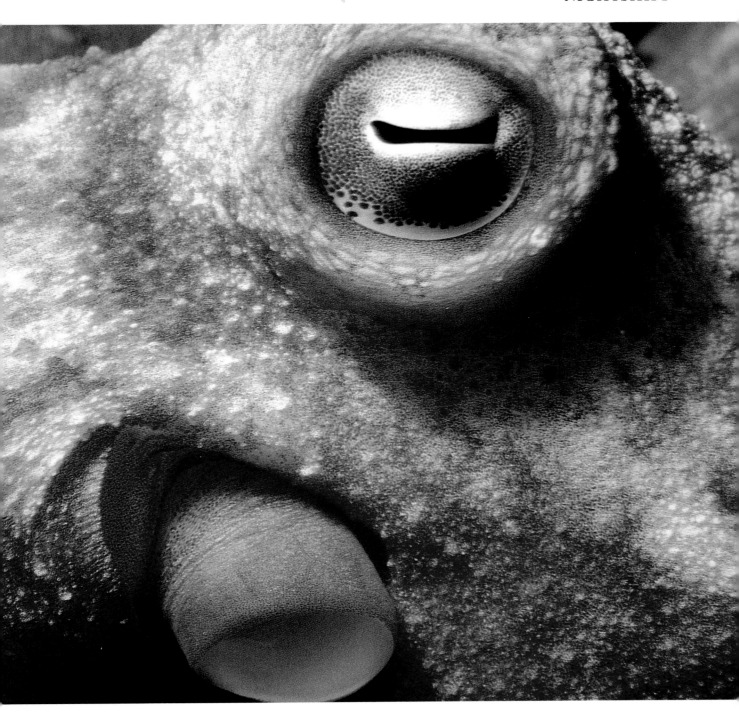

Octopuses (about 1 ft / 30 cm in
length, sometimes larger) hunt at
night for molluscs and crustaceans,
which they break open using their
horny beak. Octopuses are usually
shy rather than aggressive and they
are highly intelligent.

LOCATION : Cayman Islands
CAMERA : Nikonos III with 35mm lens;
extension tubes 1:2; f16-22;
Kodachrome 64

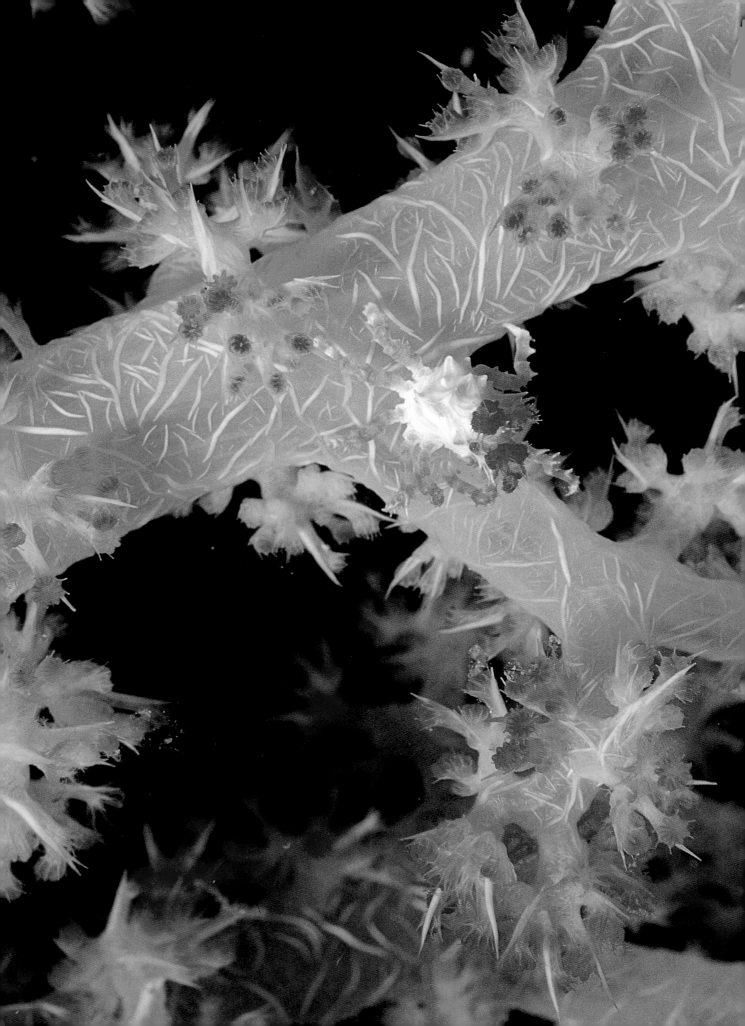

Guests & Squatters

Shrimps and starfishes, fishes and sea anemones, crabs and sponges: such partnerships may seem strange but they are only a few of the relationships that exist between different marine animals. Some animals are specially adapted to share unusual lifestyles with other species in symbiotic associations.
In the broad sense symbiosis means living together though the term is sometimes restricted to relationships where both species benefit.

Where one species benefits without affecting its partner it may be termed a commensal if it shares its partner's food supply, or an epibiont if it lives attached to its partner. Others are parasitic, harming the partner they live on. The exact nature of the interaction is not always clear; it may be permanent or transient, obligatory or optional and it can be for more than one purpose. Complex behaviour patterns are often involved such as those between cleaner fishes and the fishes they service.

FIRMLY ATTACHED

Many sessile animals such as sponges and hydroids grow over dead branches of coral as readily as over rock surfaces and also colonise living corals and other animals. While some damage the animal they grow on others are tolerated and can even give protective benefits. Sea-squirts that initially grow over dead corals may spread to living corals or other animals such as sponges, and can smother bivalved molluscs. In turn, large solitary tough sea-squirts may have animals growing on them, including smaller colonial sea-squirts, mollusc eggs and fish eggs, though certain other sea-squirts exude chemicals that repel boarders.

The branches of gorgonian sea-fans and black coral bushes are suitable attachment sites for wing oysters *Pteria* and cock's-comb oysters *Lopha cristagalli* and also for beautiful white or speckled

The spider crab Hoplophrys (about 0.5 in./15mm across carapace) lives amongst the branches of soft corals such as Dendronephthya. The crab enhances its excellent camouflage by snipping polyps from the soft coral and securing them to the thorn-like projections on its back.

LOCATION : Indonesia: Flores
CAMERA : Nikonos V with 35 mm lens; extension tubes 1:2; f16—22; Fujichrome Velvia

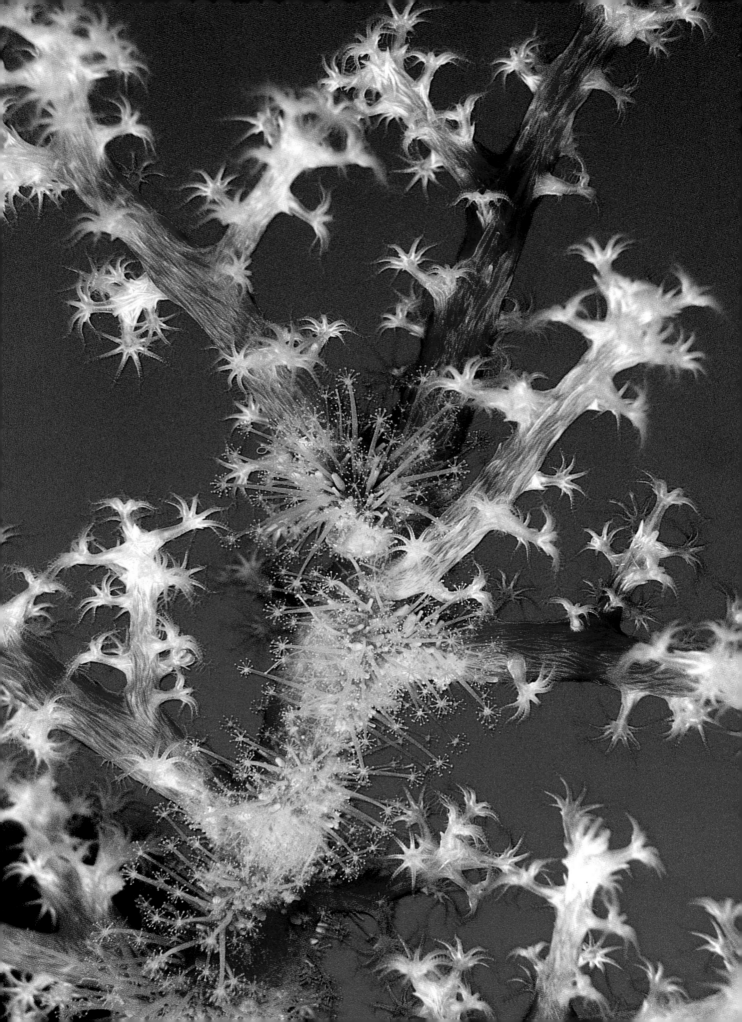

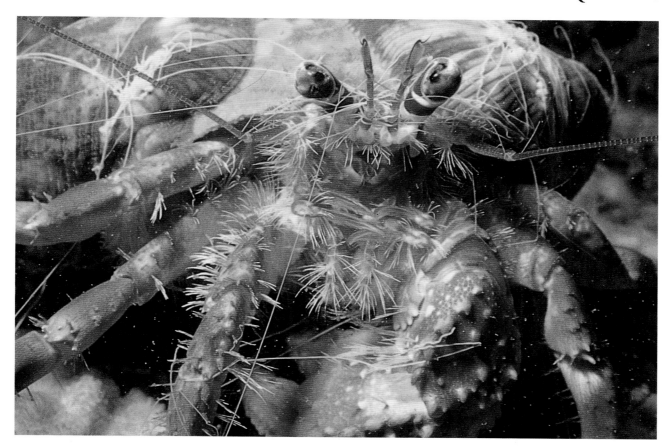

White threads (acontia) are extruded by the hormathiid anemones attached to the shell of a hermit crab, Dardanus. Stinging cells on the acontia serve to defend both partners in the relationship.

LOCATION : Indonesia: Sulawesi
CAMERA : Nikonos V with 35 mm lens; extension tubes 1:2; f16-22; Kodachrome 64

Tiny slender hydroids, about 0.20 in. / 5 mm in length, grow in profusion, attached to a branch of a soft coral.

LOCATION : South China Sea: Philippine Islands
CAMERA : Nikonos with 35 mm lens; extension tubes 1:2; f11; Fujichrome 100

hormathiid anemones. Other *hormathiids* such as the European parasitic anemone *Calliactis parasitica* and cloak anemones *Adamsia* are well known for their relationship with hermit crabs. The anemone, firmly attached to the crab's shell, defends itself and its partner against attack by extruding threads (acontia) bearing stinging cells (nematocysts). When the crab is feeding, the anemone is likely to gain leftover crumbs. Boxing crabs (*Lybia*) also use sea anemones for defence. The crab has very small claws but makes up for this by detaching a pair of anemones from the Indo-Pacific reef and holding one in each of its front claws to raise like boxing gloves against predators. Many spider crabs are known as decorator crabs because they cultivate a covering of sponges, hydroids and other animals. These organisms continue to live on the crab's carapace just as if they were still attached to the rock surface from which they were plucked.

ENCRUSTING ANIMALS

Boring sponges (*Cliona*) attack stony corals but another sponge/coral relationship can prevent this. The orange icing

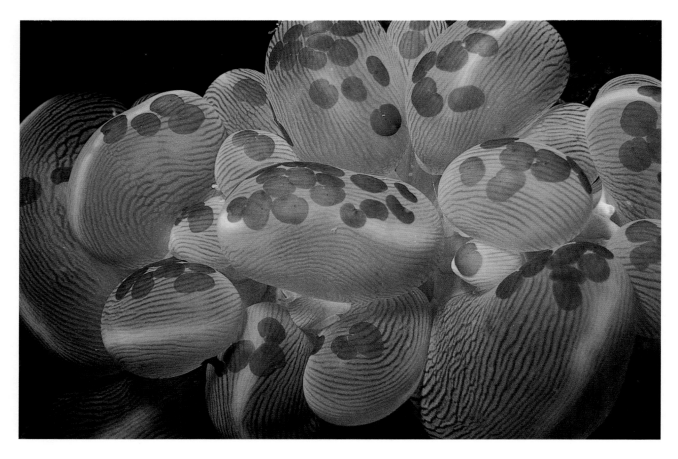

sponge *Mycale laevis* encrusts the undersides of flattish clumps of Caribbean corals, particularly *Porites* and *Montastrea*, stimulating the rim of the coral to grow in upturned folds. This increases the surface area for the sponge to grow on and the coral benefits since the presence of the sponge keeps borers at bay. Boring sponges can also cause serious damage to the shells of living molluscs by dissolving the outer layers of limestone. The yellow sponge *Cliona celata* is a common and widespread pest, attacking oysters in Europe, pearl oysters in the Red Sea and the red abalone off the Pacific coast of America.

Brightly coloured encrusting sponges such as the red *Microciona* can completely cover shells of bivalved molluscs in the Mediterranean and on tropical reefs. In the Indo-Pacific the zig-zag edged shell of the cock's-comb oyster is a favoured site. Tropical thorny oysters (*Spondylus*) have a similar life style to rock scallops (*Crassadoma*) that inhabit rocky Pacific shores of North America. Both are anchored to walls, sometimes beneath overhangs or in crevices, and are heavily encrusted by an assortment of sponges, sea anemones, bryozoans (sea mats), hydroids, and other animals. Sponges are sometimes the hosts of

Tiny platycteneids, are sedentary comb jellies, about 0.17 in. / 4 mm in length, here seen living on a colony of bubble coral, Plerogyra sinuosa.

LOCATION : Sabah
CAMERA : Nikonos with 35 mm lens; extension tubes 1:2; f16-22; Kodachrome 64

A red encrusting sponge grows on fire coral, Millepora, covering most of its surface.

LOCATION : Red Sea: Egypt
CAMERA : Nikonos V with 28 mm lens; f8; Fujichrome 50

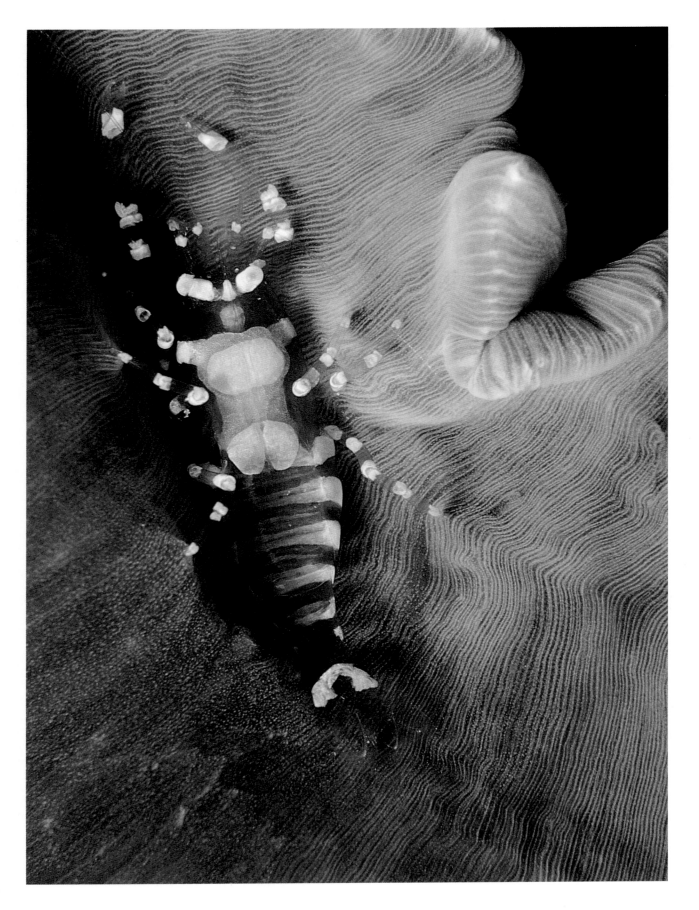

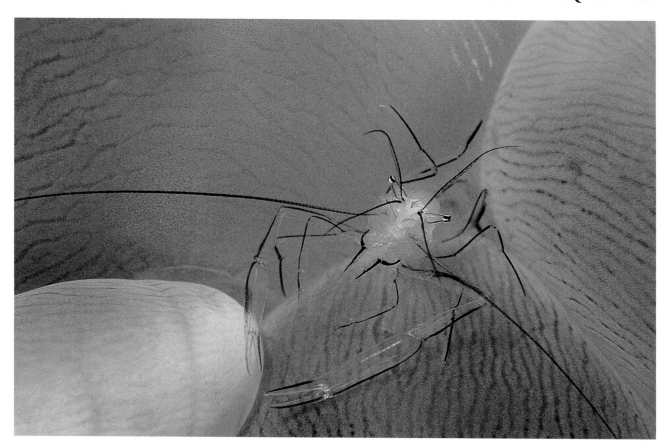

A transparent shrimp, Periclimenes species (about 0.75 in. / 2 cm in length) may be found amongst the balloon-like vesicles of bubble coral, Plerogyra sinuosa.

LOCATION : Indonesia: Flores
CAMERA : Nikonos V with 35 mm lens; extension tubes 1:1; f16; Fujichrome Velvia

The furtive shrimp, Pliopontonia furtiva, (0.75 in. / 2 cm in length) lives on the disc of a large corallimorpharian anemone. The shrimp takes cover at the rim, or amongst the short tentacles that project from the disc. The disc may be spread flat, or its edges may be drawn together to envelop the anemone's prey.

LOCATION : Sabah: Sipadan
CAMERA : Nikonos V with 35 mm lens; extension tubes 1:1; f16-22; Kodachrome 64

commensal animals, particularly the zoanthid anemones *Parazoanthus* which grow on axinellid sponges in Europe and on various tropical sponges. In the Caribbean, the outer walls of certain vase and boring sponges are frequently studded with zoanthids, coloured in striking contrast to the sponge or masking the sponge's true colour. White worm-like synaptid sea cucumbers can be seen in large numbers on barrel and tube sponges in Malaysia where they feed on the sponge's mucus and keep its pores free of sediment. Most comb jellies are planktonic but platycteneids are tiny flattened comb jellies that creep over corals. I have seen olive-brown clusters of these on the pale swollen vesicles of bubble corals *Plerogyra* in Malaysia where I mistook them at first for mere blotches on the coral surface until closer inspection revealed them to be living animals. Even active swimmers cannot entirely escape from encrusting animals. Whales may have barnacles and lice attached to them and fishes are sometimes debilitated by 'fish lice', parasitic isopods which clamp onto their victim, make a wound and suck blood.

REFUGES

Many active small animals live in close associations with an assortment of larger sedentary or slow moving invertebrates. Such partnerships commonly involve delicate shrimps that rarely stray from the shelter, concealment and protection that their coral, sea anemone, or mollusc provides. Shrimps and tiny crabs are often well camouflaged to match their specific host but some have disruptive markings in the form of bands or blotches that break up their outline and others may be conspicuously patterned in warning colours.

Various small *Periclimenes* shrimps and their relatives reside in particular species of sea anemones and other animals. One tiny transparent species hides between the expanded vesicles of bubble coral while another shrimp, *Periclimenes soror*, which is reddish brown or coloured similarly to its host, lives on the undersurface of the large pin-cushion star *Culcita novaeguineae* or on other echinoderms. Other hosts of *Periclimenes* include the upsidedown jellyfish *Cassiopeia*, a large sea slug (the Spanish Dancer *Hexabranchus*), the crown-of-thorns starfish and various sea-cucumbers. Another fascinating shrimp, the furtive shrimp *Pliopontonia furtiva* is rarely encountered but it is known to live in association with certain Indo-Pacific corallimorpharian anemones (not true sea anemones). I have seen the shrimp hiding in the curled rim of one of these large plate-like anemones in Borneo. The shrimp grips the skin of the anemone with its tiny claws and pulls it against its body for protection. Sea anemones may also shelter small porcelain crabs, relatives of squat lobsters, which reside unharmed amongst the stinging tentacles.

Associations of shrimps and crabs with anemones are not confined to tropical reefs. In one of the more conspicuous relationships seen in cooler waters, beautiful candy-striped shrimps *Lebbeus grandimanus* live on the column of the pink sea anemone *Cribrinopsis fernaldi* that occurs around British Columbia, Canada.

Brightly coloured anemonefishes or clownfishes (*Amphiprion*) live amongst the tentacles of large Indo-Pacific sea anemones, particularly stoichactid anemones. The fish defends its territory by hovering above the anemone but if its brave show fails to drive away aggressors the fish then dives for cover amongst the stinging tentacles. These are no threat to the fish because the layer of mucus on its skin gives it immunity. The dominant female continually

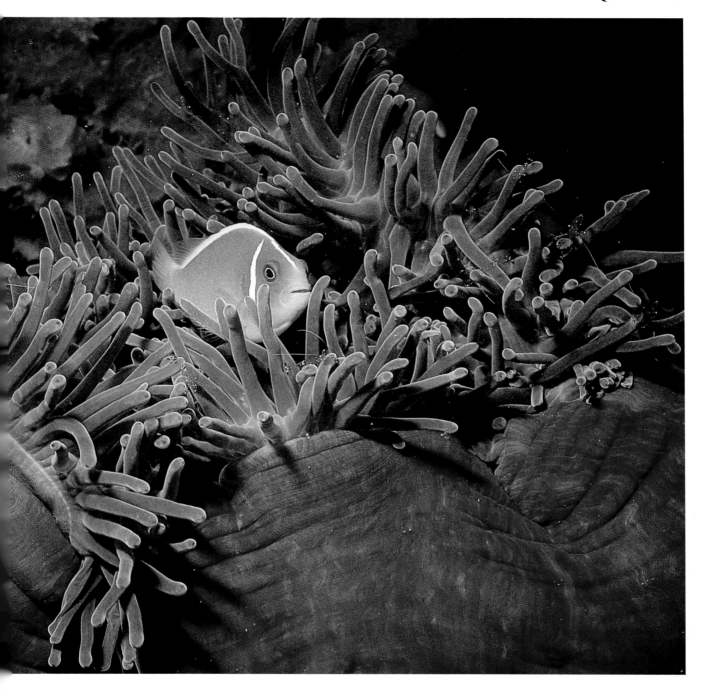

The pink clownfish, Amphiprion perideraion, (up to 4 in. / 10 cm in length) usually lives in association with the large sea anemone Heteractis magnifica but it may be found also in three other species of anemones.

LOCATION : Indonesia: Flores
CAMERA : Nikonos V with 28 mm lens plus close-up lens; f16-22; Fujichrome Velvia

173

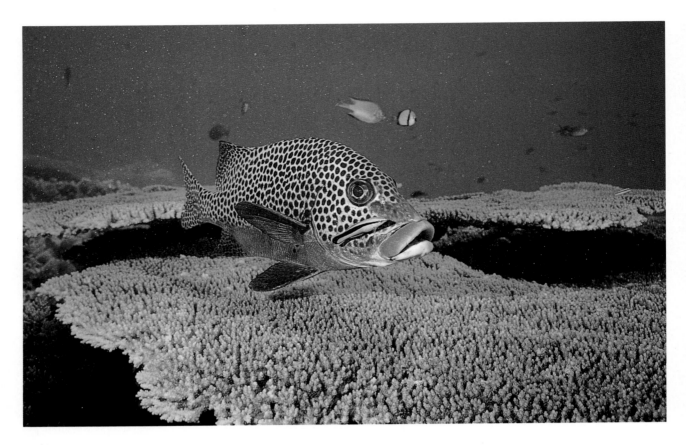

chases away males except her selected mate who grows larger than the other males around because he does not suffer the stress of being chased. The fishes may benefit the anemone by cleaning it of debris and they may even act as lures that attract potential prey. Young dominoes *Dascyllus trimaculatus* are sometimes also seen hovering amongst the anemone's tentacles.

Certain juvenile fishes shelter beneath the bell of jellyfish, darting in and out of the trailing mass of stinging tentacles. Young horse mackerel *Trachurus* are associated with various large European jellyfish and the man-of-war fish *Nomeus* of tropical oceans lives with the Portuguese man-of-war *Physalia*, a normally dangerous jellyfish-like siphonophore.

A cleaner wrasse, Labroides dimidiatus, (about 3.5 in / 8-9 cms in length) attends to a sweetlips, Plectorhynchus.

LOCATION : Sabah: Sipadan
CAMERA : Nikonos V with 28 mm lens; f8; Kodachrome 64

FEEDING TOGETHER

Tropical feather-stars (*crinoids*) perch on large sponges, prominent stony corals and, particularly, on gorgonian corals that project well enough from the reef face to give the feather-star a good position in the current for filter feeding. In their turn crinoids carry a wide range of tiny commensal animals including squat lobsters, shrimps and copepods and occasionally small

174

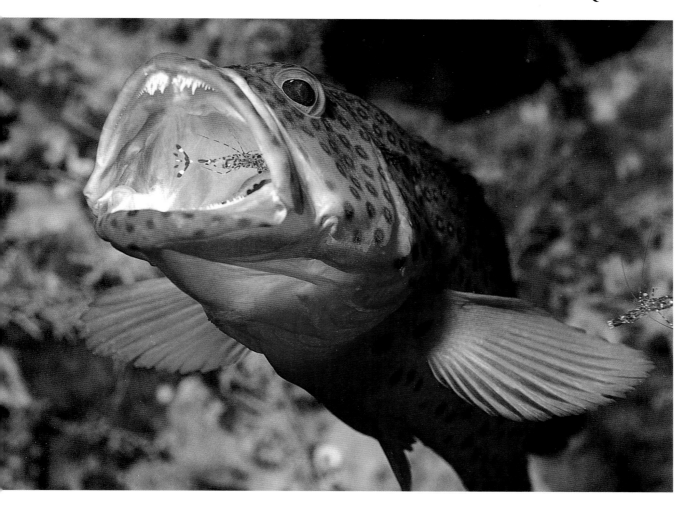

A coral grouper waits patiently with gaping jaws while a cleaner shrimp attends to the inside of the fish's mouth.

LOCATION : Maldive Islands
CAMERA : Pentax LX with 50 mm lens; Hugyfot housing; f11-16; Fujichrome Velvia

fishes.

The sponge brittle-star *Ophiothrix suensoni* is commonly seen draping its long spined arms across Caribbean sponges at night. Sponges feed by drawing water in though small pores all over their surface, straining food particles and then expelling the water; this sets up currents which are likely to bring food for the brittle-star too.

CLEANERS

Certain small fishes have a specialised way of life as cleaners, maintaining the health of other fishes by cleaning up their wounds and removing and eating small external parasites such as copepods (Crustaceans). They operate at 'cleaning stations', where other fishes come to be treated. Caribbean cleaning gobies *Gobiosoma* tend to sit on prominent coral heads to attract hosts, with an empty worm hole for retreat. Fishes wishing to be cleaned

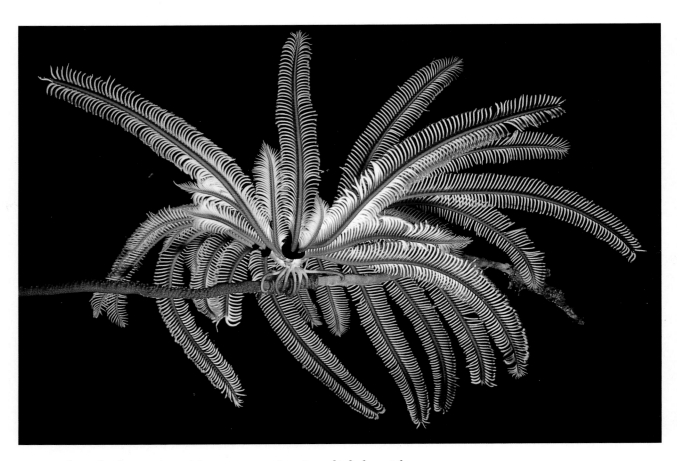

approach and adopt an inviting pose, quivering slightly with mouth open, fins outstretched and head held up or down. Several Caribbean fishes act as cleaners while they are juveniles, including four angelfishes and a hogfish (wrasse). The young French angelfish *Pomacanthus paru* is an adept at this, fluttering its fins to encourage fishes to approach for cleaning. More than 20 species of fish and several shrimps are cleaners and most are conspicuously marked with bright stripes, although the surgeonfishes *Acanthurus* that peck algae off the backs of green turtles are drab in colour. The Indo-Pacific cleaner wrasse *Labroides dimidiatus* has a distinctive stripe and characteristic behaviour but it is mimicked in both respects by the false cleaner or mimic blenny *Aspidontus dimidiatus*, except that the latter nips the fins and mucus of fishes instead of providing a service. The trick works best on juvenile victims, older fish have learnt.

The sharksucker, *Echeneis naucrates*, and other remoras attach themselves by means of a suction disc on top of the head to sharks, rays, various other large tropical fish and turtles. They will even fasten onto divers, as I have experienced in Malaysia, but abandon such unsuitable hosts when the diver leaves the water. Remoras act as cleaner fishes in feeding on parasites, which they

A feather-star, with arms spread to catch food, clings by its cirri (small jointed appendages) to a whip coral. The feather-star's arms are about 6 in./ 15cm in length.

LOCATION : Indonesia : Sulawesi
CAMERA : Nikonos V with 28 mm lens plus close-up lens; f16-22; Kodachrome 64

176

The sponge brittle-star, Ophiothrix suensoni, (length of arms about 3 in. / 8 cm) may benefit from the sponge's filter-feeding activities, which bring in water-borne nutrients. The brittle-star usually hides inside tube or vase sponges during the day and moves to the rim or outer walls of these sponges at night.

LOCATION : Cuba
CAMERA : Nikonos III with 35 mm lens; extension tubes 1:2; f16-22; Kodachrome 64

pick off the host. They save swimming energy when they are carried by the host but they are not constantly attached. Caribbean bar jacks, *Caranx ruber*, do not perform a cleaning service; instead, they take scraps from other fishes' food. Bar jacks often follow rays that dig for food in the sand.

Shrimp gobies live in burrows in a relationship with snapping shrimps (Alpheidae). The shrimp makes and maintains the burrow while the goby stands guard at the entrance and warns the poorly-sighted shrimp when predators approach. Both shrimp and goby disappear rapidly into the burrow at the slightest disturbance. Other gobies include tiny reef species that escape attention because they match the colour of the branches they lie against.

177

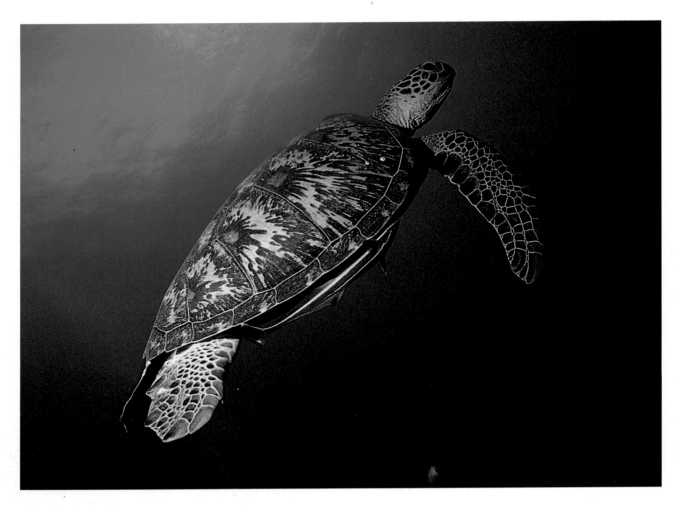

SYMBIOSIS WITH ALGAE

The symbiotic relationship of stony corals with single-celled algae (zooxanthellae) is well known but there are other animals too that have algae living inside them. The upsidedown jellyfish of tropical reefs contains zooxanthellae in the mouth-arms beneath its bell and rests or swims with arms uppermost to expose the algae to the sunlight that they need for photosynthesis. Tridacnid clams have zooxanthellae embedded in their mantles. Many sea-squirts or ascidians, particularly didemnids, of warm waters are inhabited by the green-pigmented alga *Prochloron* which can colour the animal vivid green or various other shades depending on the sea squirt's own pigments and structure; less common algae give a pink hue. The symbiotic partnership may be responsible for producing toxins in green colonies of *Lissoclinum* and certain other didemnid sea-squirts. These toxins probably have a defensive role for the sea-squirt but pharmacological research indicates that they may prove beneficial to us as anti-cancer drugs.

The sharksucker was once thought to live on scraps from its host's food but it is now known to feed on parasites from the host's body. The carnivorous fish is attached to the green turtle, Chelonia mydas, whose diet consists of algae.

LOCATION : Sabah:Sipadan
CAMERA : Nikonos III with 15 mm lens; f8-11; Fujichrome 100

Remoras, including the sharksucker, Echeneis naucrates, (up to 3 ft / 1 m in length but usually smaller, commonly about 1 ft / 30 cm) often attach themselves to large fishes. The sharksucker is seen here on the underside of the spotted eagle ray, Aetobatus narinari.

LOCATION : Maldive Islands.
CAMERA : Nikonos with 15 mm lens; f8-11; Fujichrome 100

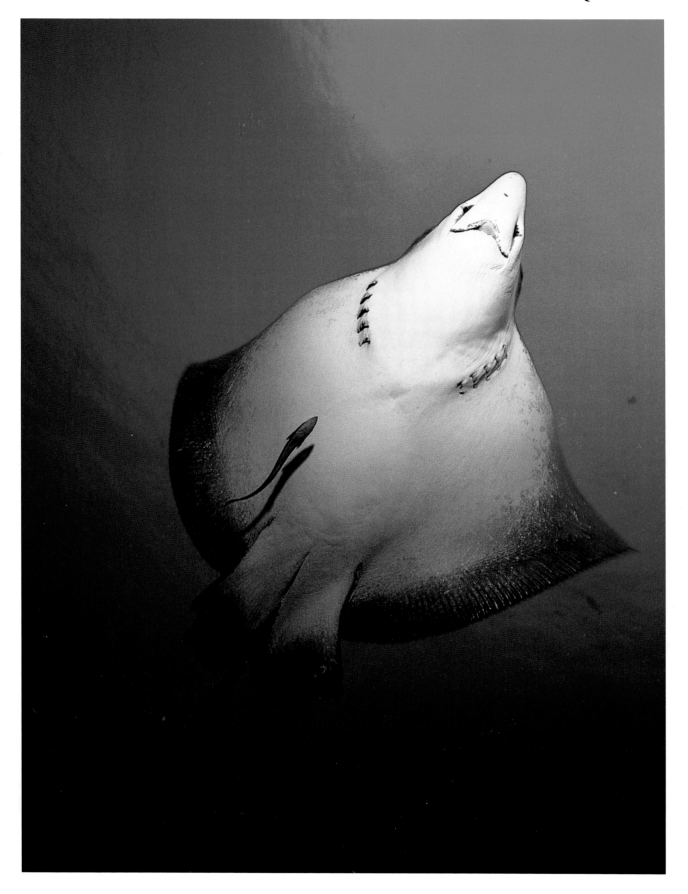

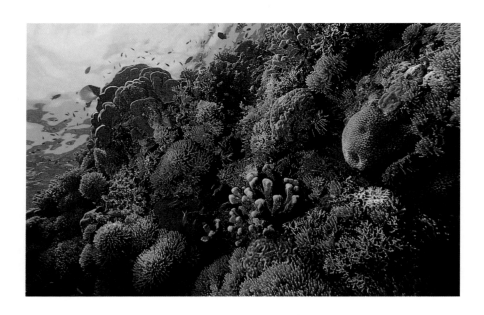

Conservation

The oceans are as important as the land for our well-being and that of the planet as a whole. They provide us with resources such as fish and other animals for food and with opportunities for recreation and tourism. The rich diversity of marine life includes many rare and endangered species. Their loss should be mourned if only for their beauty or interest value, but their potential worth goes far beyond this. Investigations of various species, including sharks and sea-squirts, are leading to the discovery of chemicals that may be useful for medicinal or other purposes. In a situation that parallels the plight of rainforests, we risk losing such beneficial species before we recognise them. The oceans play a role in the regulation of climate and other environmental factors, and the stability of many aspects of our environment depends on a finely tuned balance of living systems. The environment may be able to adjust to the loss of certain species and habitats but the destruction of others may have a 'domino' effect of far-reaching consequences. Our knowledge of the complex interactions of species within communities enables us to make too few accurate predictions.

THREATENED ENVIRONMENT

Our lifestyles threaten the health of the marine environment. The seas are polluted by toxic chemicals in industrial wastes, pesticides and sewage, and also by oil spills and the detergents used to disperse them. Too much pressure is put on the sea's resources. Overfishing results in dwindling yields and certain fishing methods have other destructive effects. The use of drift nets is one such example; these nets needlessly kill many animals, including dolphins and sharks, apart from the intended catch. Other fishing methods may destroy whole communities of marine life. Bottom trawling indiscriminately scours the animals and plants from the sea-bed, and dynamite is used on some coral reefs, particularly in southeast Asia. Divers on nearby reefs sometimes hear these unnerving blasts and feel the shock waves. Tropical reefs also suffer excessive exploitation of corals and molluscs for ornaments and jewellery, and fishes for the aquarium trade.

Coral reefs have little tolerance towards changes in temperature and salinity and are adversely affected by other factors such as sedimentation. Even so, mature healthy reefs with a high diversity of species are able to withstand most natural fluctuations. Tropical storms can cause tremendous damage to shallow parts of the reef, particularly in the Caribbean and the Great Barrier Reef, but the species of corals particularly at risk are capable of fairly rapid regrowth. However, the additional damage resulting from many human activities puts increasing pressure on reefs. As forests are chopped down soil erodes, and run-offs silt up shallow reefs nearby. Silt can also spread from dredging operations. Coral is sometimes mined as a building material, and the development of coastal towns and ports in general, for local populations or to encourage growth in tourism, can put reefs at risk.

PROTECTING THE OCEANS

Developed countries consume four-fifths of the world's resources and cause 70% of the pollution. Our technology needs to adopt less damaging practices and to become more efficient, reducing waste and pollution. Fishing should be limited to sustainable levels and more use should be made of non-destructive methods of farming fish. Tourism is an increasingly important resource in

tropical countries but overdevelopment of coastal sites puts at risk the reefs and other marine life that attract visitors in the first place. Developing countries need support from the industrialised nations to enable them to manage their natural resources and to protect them for the future benefit of our planet. Existing national laws and programmes and international agreements provide some measure of protection but fail to provide an adequate safeguard for the marine environment as a whole. An increasing number of sites have been designated as marine reserves but many more areas are in need of protection from pollution, exploitation and other threats. Of course, no region of the sea exists in isolation. Establishing a reserve in one place is no protection if pollutants are released into neighbouring waters or if fish populations are decimated when they migrate beyond a boundary drawn on a chart. Legislation alone is not enough; the means to implement it is essential if it is to have any effect. The most successful reserves seem to be those that operate a system of graded zones. These give maximum protection in certain areas while regulating the use of other areas to allow for periods of recovery.

A few of the larger species of marine animals such as whales and seals capture the public imagination and media coverage frequently arouses our concern for their plight. However, vast numbers of less conspicuous or less popular animals are equally threatened and the seas as a whole are in need of protection to preserve their riches for the future. More research is needed to give us a better understanding both of individual species and of the structure of the communities and whole living systems in the sea.

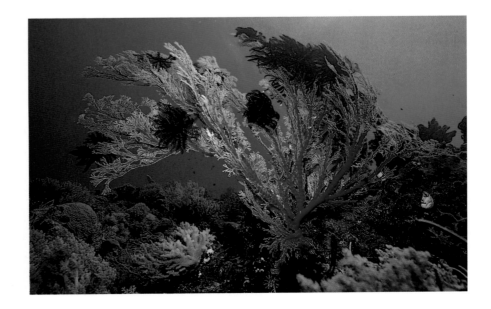

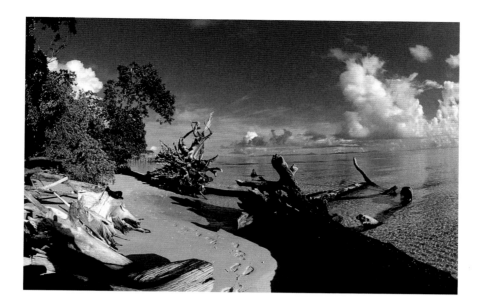

Major Locations Featured

UNITED KINGDOM

British marine life is diverse and surprisingly colourful although this may not always be appreciated in conditions of limited visibility. Beneath the kelp line, rocks are usually covered with encrusting sponges, anemones and other sedentary animals. Crabs and lobsters, various echinoderms and molluscs are often encountered in the open during the day whereas many of their tropical counterparts are active only at night. Bottom-dwelling fishes such as flatfishes and sea scorpions are among those commonly seen by divers. The visibility underwater is best off rocky shores, particularly in the colder waters of northwestern Scotland. Coastal waters appear greenish but the clear oceanic water around the vertical walls of the remote islands of St Kilda appears blue.

Inqisitive grey seals often approach divers there, and also at the Isle of Man (Irish Sea) and the Farne Islands (North Sea). Gigantic plankton-feeding basking sharks can be seen around the Isle of Man in July. Other interesting scenic sites include Lundy Island (in the Bristol Channel) and St. Abb's Head (North Sea).

BRITISH COLUMBIA

British Columbia, off the Pacific coast of Canada, offers spectacular diving in clear cold water. Anemones and other sedentary species grow in profusion over the current-swept undersea rock walls around Vancouver Island. The marine life appears similar in some respects to that of northern Europe but many of the animals are bigger and more brightly coloured than their European counterparts. Plumose anemones and sea-pens may grow to a height of two feet or more, and purplish red sea-urchins, starfishes and Puget Sound king crabs are often large and conspicuous. Camouflaged bottom-dwelling sculpins, slow-swimming rockfishes and kelp greenlings are commonly seen, and giant octopuses and wolf-eels are found at certain sites. At sites near Port Hardy, at the northern end of Vancouver Island, there is an excellent range of marine life. In open waters around that area schools of Pacific white-sided dolphins are frequently encountered and killer whales may also be seen.

GALAPAGOS ISLANDS

The Galapagos Islands, in the Pacific Ocean west of Ecuador, are surrounded by a mixture of temperate and tropical waters. This gives rise to a remarkably varied marine life, ranging from cool water species such as the rare Galapagos penguin to tropical species including a parrotfish and an angelfish. Small patches of reef-building corals grow in a few sites but there are no sizable reef developments. Much of the terrain is volcanic rock which is

scattered with large colourful starfishes and other invertebrates. Schooling fishes line up in the currents and many pelagic species may be seen, including jacks, barracudas, rays, and hammerheads and other sharks. Green turtles are commonly seen and agile Galapagos sea lions swim around divers in shallow water.

CAYMAN ISLANDS

The Cayman Islands have some of the finest fringing coral reefs in the Caribbean, particularly around the small islands of Cayman Brac and Little Cayman. Spreading elkhorn corals, flexible gorgonians, and purple sea-fans are a feature of many moderately shallow reefs. There are fewer species of corals on Atlantic reefs than in the Indo-Pacific but the growth forms of the corals are varied and beautiful. The colours tend to be delicate pastel shades; the vivid red soft corals seen in some parts of the Indo-Pacific do not grow in the Caribbean. Bright yellow grunts shoal on shallow reefs, and yellowtail snappers and Nassau groupers are common and approachable. Great barracudas are often seen. The visibility is usually excellent, particularly on the steep walls. The Isla de la Juventud (Isle of Youth), Cuba, has similar marine life to that of the Cayman Islands.

RED SEA

The Red Sea, part of Africa's Great Rift, extends from the northwestern end of the Indian Ocean to the Gulfs of Aqaba and Suez. Fringing reefs are well developed along much of the coast and some barrier and other offshore reefs exist in places. The reefs range from gently sloping coral 'gardens' to vertical walls where the top of the reef is almost at the surface at most sites. Dive centres in Sharm el Sheikh, Hurghada

and Safaga offer access to some of the finest sites in the Egyptian Red Sea and pelagic fishes are sometimes seen in large numbers off the coast of Sudan and towards the southern end of the Red Sea. Other countries bordering the Red Sea have diving operations, including those in Eilat (Israel) and Aqaba (Jordan). The Red Sea has a rich diversity of corals and fishes, some of which are endemic while others occur elsewhere in the Indo-Pacific. Brightly coloured red or pink nephthiid soft corals and shoals of small orange sea-perches are abundant. The visibility underwater may be excellent. The water is relatively cool for tropical seas, with a surface temperature of approximately 20-26°C in the northern Red Sea.

EAST MALAYSIA

The water is clearer around oceanic reefs than at sites close to the mainland. The little-explored Royal Charlotte and Louisa Shoals have some fine, well-developed reefs with particularly clear water. These remote reefs, lying in the South China Sea off the west coast of Sabah, are visited by pelagic fishes including schooling jacks and hammerhead sharks. Off the east coast of Sabah, the tiny oceanic island of Sipadan is notable for its rich marine life concentrated in a small area. Divers and snorkellers can expect to see numerous turtles (mainly green turtles and hawksbills) at all times and green turtles come ashore to lay their eggs on the island. One of the most spectacular features of Sipadan is the large shoal of barracudas which is regularly seen close to the reef top.

MALDIVE ISLANDS

The atolls of the Maldive Islands span the equator in the Indian Ocean. About 1200 of the islands have vegetation and

many of those inhabited are simple fishing communities. Several tiny islands are managed as resorts for diving. Coral reefs fringe the islands, many fine submerged reefs or tillas exist, and the abundant fish life is a major attraction for divers. Bluestripe snappers gather in large shoals on the shallow flat tops of many tillas, and coral overhangs shelter squirrelfishes, soldierfishes, and sweetlips. Cleaning stations, where fishes are attended to by cleaner wrasses and shrimps, are numerous and provide excellent opportunities for lengthy observation of fishes at close quarters. Pelagic fishes including eagle rays, manta rays and sharks patrol some reefs and jacks school along current-swept walls.

INDONESIA

Indonesia, an archipelago of more than 13,000 islands with over 80,000 kilometres of coastline, contains 10-15 per cent of the world's coral reefs. Many Indonesian reefs have been little explored and even at the sites that are more often visited zoologists frequently discover new species amongst the wealth of marine life. Some of the most spectacular reefs are around the islands off Manado, at the northern tip of Sulawesi, where the visibility underwater is excellent. Huge colourful sea-fans project from the steep walls and feather-stars or crinoids abound. There are dive services at several other locations including Flores, which has a variety of fine reefs, and Bali. The dry season is usually from May to September and seas may be rough when the seasons change in April and October.

Bibliography

The following list is a selection of some of the books that I have found particularly useful and recommend for further reading or for enjoyment of the photographs.

Allen, G.R. & Steene, R.C. 1987. Reef Fishes of the Indian Ocean. Neptune City, T.F.H.

Campbell, A.C. 1976 . The Hamlyn Guide to the Seashore and Shallow Seas of Britain and Europe. London, Hamlyn.

Carcasson, R.H. 1977. A Field Guide to the Coral Reef Fishes of the Indian and West Pacific Oceans. London, Collins.

Cardone, B.J. (Ed.). 1989. Nikonos Technique '89; dedicated to the art and science of underwater photography. Garden City, New York, Nikon, Inc.

Church, J. & Church, C. 1986. The Nikonos handbook. Gilroy, J. & C. Church.

Coleman, N. 1991. Encyclopedia of marine animals. London, Blandford.

Colin, P.L. 1988. Marine Invertebrates and Plants of the Living Reef. NJ, T.F.H.

De Couet, H.-G. & Green, A. 1989. The manual of underwater photography. Weisbaden, Verlag Christa Hemmen.

Dipper, F. 1987. British Sea Fishes. London, Underwater World Publications.

Doubilet, D. 1990. Light in the Sea. Shrewsbury, Swan Hill Press.

Doubilet, D. 1990. Pacific: an undersea journey. Boston/ Toronto/ London, Bullfinch Press.

Dubinsky, Z. (Ed.). 1990. Coral Reefs. Ecosystems of the World 25. Amsterdam; Oxford, Elsevier.

Erwin, D. & Picton, B. 1987. Guide to Inshore Marine Life. London, Immel.

George, D. & George, J. 1979. Marine Life. London, Lionel Leventhal.

Gotshall, D.W. & Laurent, L.L. 1979. Pacific Coast Subtidal Marine Invertebrates. Los Osos, California, Sea Challengers.

Harrison, R. & Bryden, M.M. (Consulting Eds) 1988. Whales dolphins and porpoises. London, Merehurst Press.

Humann, P. 1988. Galapagos. Santiago, Chile, Editorial Kactus.

Humann, P. 1989 [reprinted 1991]. Reef Fish Identification; Florida Caribbean Bahamas. Jacksonville, New World Publications, Inc.

Humann, P. 1992. Reef creature identification; Florida Caribbean Bahamas. Jacksonville, New World Publications, Inc.

Jones, O.A. & Endean, R. (Eds) 1976. Biology 2. Biology and geology of coral reefs. 3. New York, Academic Press.

Kuiter, R.H. 1992. Tropical reef-fishes of the western Pacific Indonesia and Adjacent waters. Jakarta, Gramedia Pustaka Utama.

Lamb, A. & Edgell, P. 1986. Coastal Fishes of the Pacific Northwest. BC, Harbour.

Liburdi, J. & Sherman, C. 1988. How to use Sea & Sea. Redondo Beach, Orca Publications.

Lythgoe, J. & Lythgoe, G. 1990. Fishes of the Sea. London,Blandford.

Macdonald, D. (Ed.) 1984. The encyclopaedia of mammals. 1. London, George Allen & Unwin.

Morris, R.H., Abbott, D.P. & Haderlie, E.C. 1980. Intertidal Invertebrates of California. Stanford, Stanford University Press.

Murphy, G. 1989. Underwater Photography; Camera basics; Equipment care. Santa Ana, PADI.

Murphy, G. 1989. Underwater Photography; Macro. Santa Ana, PADI.

Newbert, C. 1984. Within a Rainbowed Sea. Honolulu, Beyond Words Publishing Co.

Randall, J.E. 1968. Caribbean Reef Fishes. Neptune City, T.F.H.

Randall, J.E. 1983 [reprinted 1986]. Red Sea Reef Fishes. London, Immel.

Randall, J.E., Allen, G.R. & Steene, R.C. 1990. Fishes of the Great Barrier Reef and Coral Sea. Honolulu, University of Hawaii Press; Bathurst, Crawford House Press.

Roessler, C. 1978. The Underwater Wilderness - Life around the Great Reefs. New York, Chanticleer Press.

Roessler, C. 1984. The Undersea Predators. New York, Facts on File.

Roessler, C. 1986. Coral Kingdoms. New York, Abrams.

Sefton, N. & Webster, S.K. 1986. A Field Guide to Caribbean Reef Invertebrates. Monterey, Sea Challengers.

Stafford-Deitsch, J. 1991. Reef. London, Headline.

Steene, R. 1990. Coral Reefs, Nature's Richest Realm. London, Letts.

Stevens, J.D. (Consulting Ed.). 1987 [reprinted 1988, 1989, 1990]. Sharks. London, Merehurst Press.

Thompson, T.E. 1976. Biology of opisthobranch molluscs 1. London, Ray Society.

Thompson, T.E. & Brown, G.H. 1984. Biology of opisthobranch molluscs 2. London, Ray Society.

Veron, J.E.N. 1986. Corals of Australia and the Indo-Pacific. NSW & London, Angus & Robertson.

Vine, P. 1986. Red Sea Invertebrates. London, Immel.

Wells, S. & Hanna, N. 1992. The Greenpeace book of coral reefs. London, Blandford.

Wheeler, A. 1985. The World Encyclopedia of Fishes. London/Sydney, Macdonald.

Wong, M.P. 1991. Sipadan: Borneo's Underwater Paradise. Singapore, Odyssey Publishing.

Wood, E. (Ed.). 1988. Sea Life of Britain & Ireland. London,Immel.

Acknowledgements

Special thanks are due to the following people:

Members of the British Society of Underwater Photographers have given me advice, encouragement and inspiration ever since I took up underwater photography. My colleagues at The Natural History Museum, London, particularly the specialists in the Department of Zoology and the staff of the Libraries, including Nick Arnold, Paul Clark, Carol Gokce, Paul Cornelius, Oliver Crimmen, David George, Gordon Howes, Paula Jenkins, Nigel Merrett, and Kathie Way, and also consultant marine biologist Elizabeth Wood, have given support in the course of the research for this book. Above all, I wish to thank my husband, Brian, for his help and support during the preparation of the book, and for continuing to dive with me even after the many occasions when I have insisted on staying to take 'just one more photograph'.

The following, and others, have organised diving for me: Etienne de Backer ('Nortada', Galapagos); Max Benjamin (Walindi Plantation, Papau New Guinea) Warren Blake ('Four Friends', South China Sea); Robert Bryning and Sam Harwood (Maldives Scuba Tours);

Bill Bunting ('Likely Lad', England); Dave Burton ('Jean de la Lune', Scotland); Mike Campbell (Exta Sea Charters, Canada: British Columbia); el Colony, Cuba; Steve Curtis (Aqua Ventures, Kenya); Tom Dickie, Mike Glover and Ken Watterson (Isle of Man); Alex and Tamara Double ('Lady Jenny V', Red Sea: Egypt); Cyril Gubby ('Bubbles II' and 'Triple Brande', England); Loky Herlambang (Nusantara Diving Centre, Sulawesi, Indonesia); Ron Holland (Borneo Divers, Sabah: Sipadan); Peter Hughes, Craig Burns (Dive Tiara, Cayman Is.); Bob Johnson, Alain Sobol and Claude Antoine (Aquamarine, Red Sea: (Egypt); Ivor Johnson ('Osborne Bay', Wales); Rudy Kneip ('Number One', Red Sea: Egypt); Ibrahim and Marie-Pierre El Mestekawy-Lecat, and Rouby Deuvletian (Oonastours, Red Sea: Egypt); James Organ (Flores Sao Resort, Indonesia); John and Shaunne Shaw (Aquaserve, Lundy, England); Freddy Storheil, Mikael Eriksson ('Colona IV', Red Sea: Egypt); Thornton Heath BSAC (Great Britain).

For the publishers:
Grant Bradford for his help in making the final selection of pictures and for the design of this book.
Finally many thanks to Harry Ricketts the publisher.

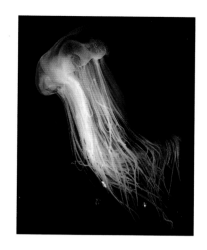

Index

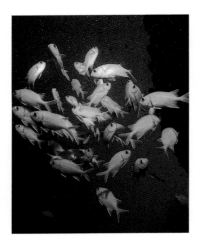